COLORADO II

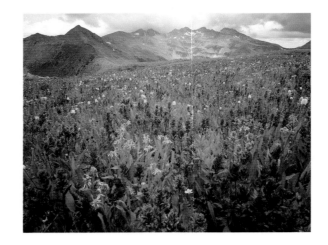

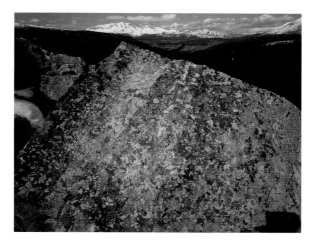

COLORADO II

PHOTOGRAPHY BY
DAVID MUENCH

TEXT AND DRAWINGS BY
ANN ZWINGER

GRAPHIC ARTS CENTER PUBLISHING®

COLORADO II

International Standard Book Number 0-932575-31-5
Library of Congress Catalog Number 86-83242
© MCMLXXXVII by
Graphic Arts Center Publishing Company
P.O. Box 10306 • Portland, Oregon 97210 • (503) 226-2402
Editor-inChief • Douglas A. Pfeiffer
Designer • Bonnie Muench
Design Consultant • Robert Reynolds
Cartographer • Tom Patterson
Typographer • Harrison Typesetting, Inc.
Book Manufacturing • Lincoln & Allen Company
Printed in the United States of America
Eighth Printing

DEDICATION
To lovers of wild places and things.

David Muench

COLORADO

	Major Highways
	National Wildlife Refuges
	National Forests
	National Grasslands

0 10 20 30 40 50 75 Miles

0 50 100 Kilometers

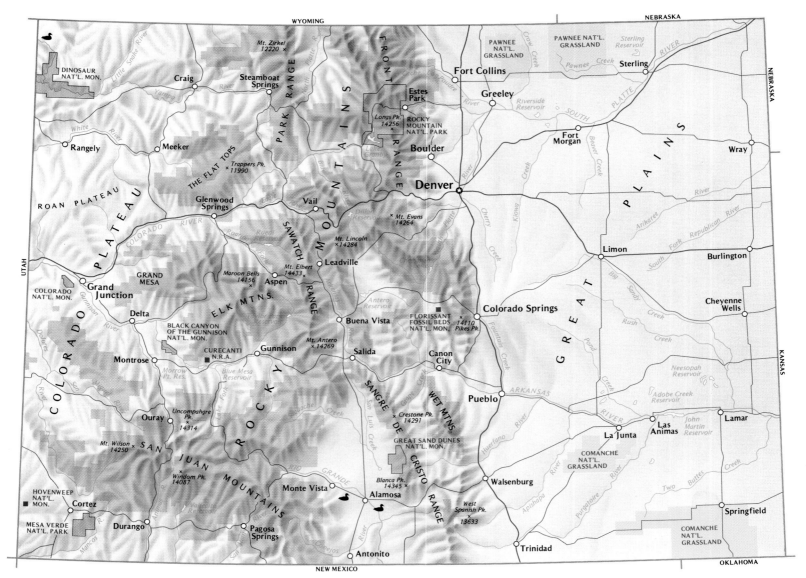

PREFACE

By David Muench

Colorado. The very word conjures up images of mountain grandeur, of untouched wilderness. But Colorado also means grasslands and mesas, forests and lakes. The original COLORADO book included some of the beauty man has contributed to the state. In COLORADO II, the present volume, I have chosen photographs in joyous celebration of the unique beauty that is the Colorado wilderness. This is my attempt to communicate in words what I feel, surrounded and immersed in this primal landscape.

For inspiration, I look to the power, the mystery, and the beauty of nature. In seeking out places untouched since creation, I find one more small piece of my own identity.

To retain what constantly slips away—a timeless moment, ever changing—is my personal challenge. For me, the photographs are reference points along a pathway, the beauty inspiring them essential to my very existence. The camera is the critical and important medium in recording these fleeting glimpses of a landscape filled with natural rhythms, contrasts, and mysteries. The camera keeps a faithful record, whether it is a Linholf Teknika 4 × 5, my primary field camera, or a Leica 35mm format.

Of the numerous ways in which images can be conveyed, working with those transitory moments which pass over the land has been my primary direction. The first ray of sunlight after a brutal storm, the flicker of an ephemeral rainbow, the great waterfalls on canyon walls after a heavy rain—all are examples of those decisive instants when Nature speaks to us of powerful changes brought about through the millennia of time. The tools I use in creating photographs are illusive: light, an intense awareness, an intuition for tuning in to the cycles of Nature's forces. To attempt affirmation and harmony with the great forces of the unknown is a never-ending quest for the unattainable.

Colorado is expansive, dramatic, elemental. I have attempted first to absorb and understand the unique elements flourishing throughout the state before conveying impressions of this landscape in the photographs.

Climbing up high rocky places or down deep canyons, sloshing through glacial lake waters, or sitting quietly by a reflective alpine pool for hours has played a most critical role in the making of these photographs. That special sense of place, that essence that says "Colorado," is communicated by utilizing certain qualities: an accurate perception of distance, a solid middle ground of shapes and form, and a heightened impression of foreground.

To know this land and grasp its complexities, one must see and touch. The fluid qualities of life itself are held in an intricate flower or a delicate lichen. One's reward for finding this hidden beauty is contained in the discovery itself, each revelation serving to whet the appetite to seek out new vistas. They can serve as spiritual landmarks in a pilgrimage that each one alone must undertake.

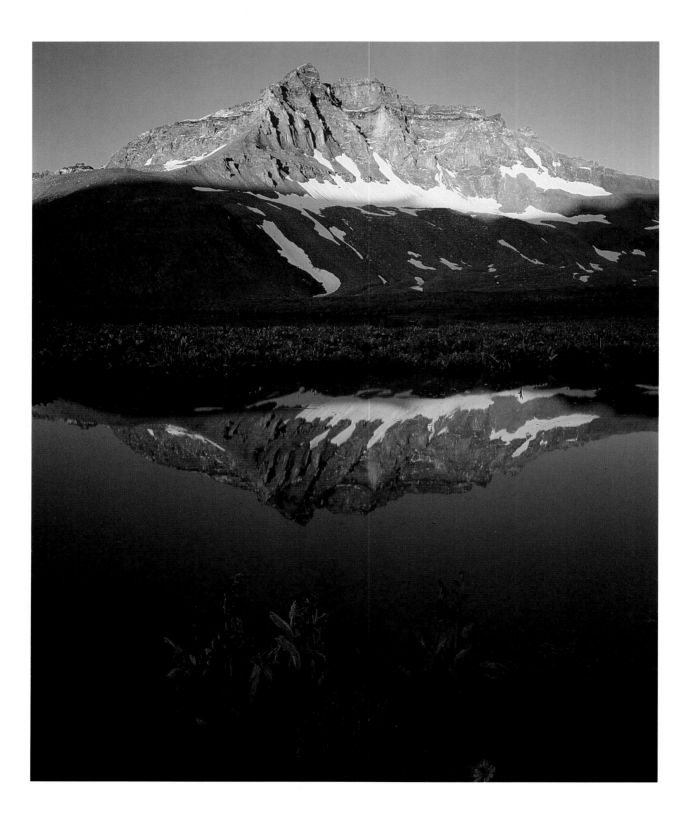

Mount Gilpin reflection and Yankee Boy Basin. *August*

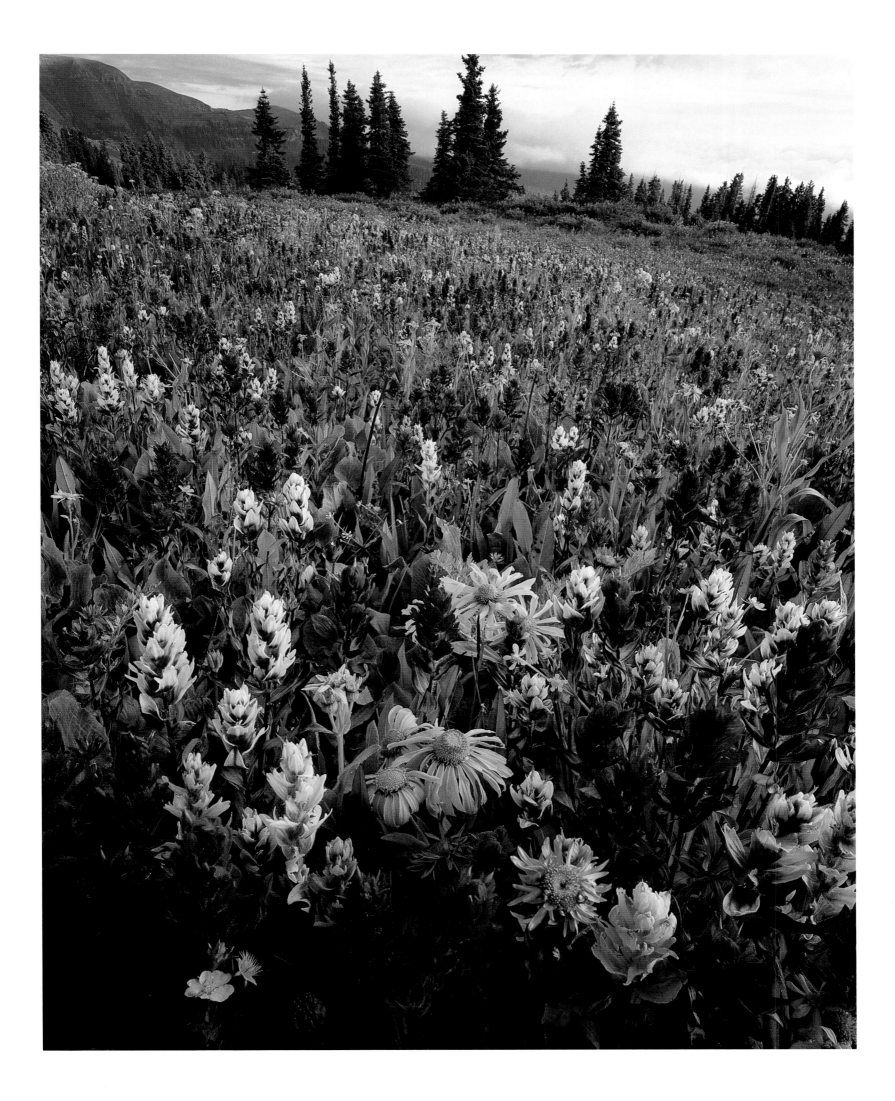

Plethora of paintbrush, astor, and sunflower. La Plata Mountains. *August*

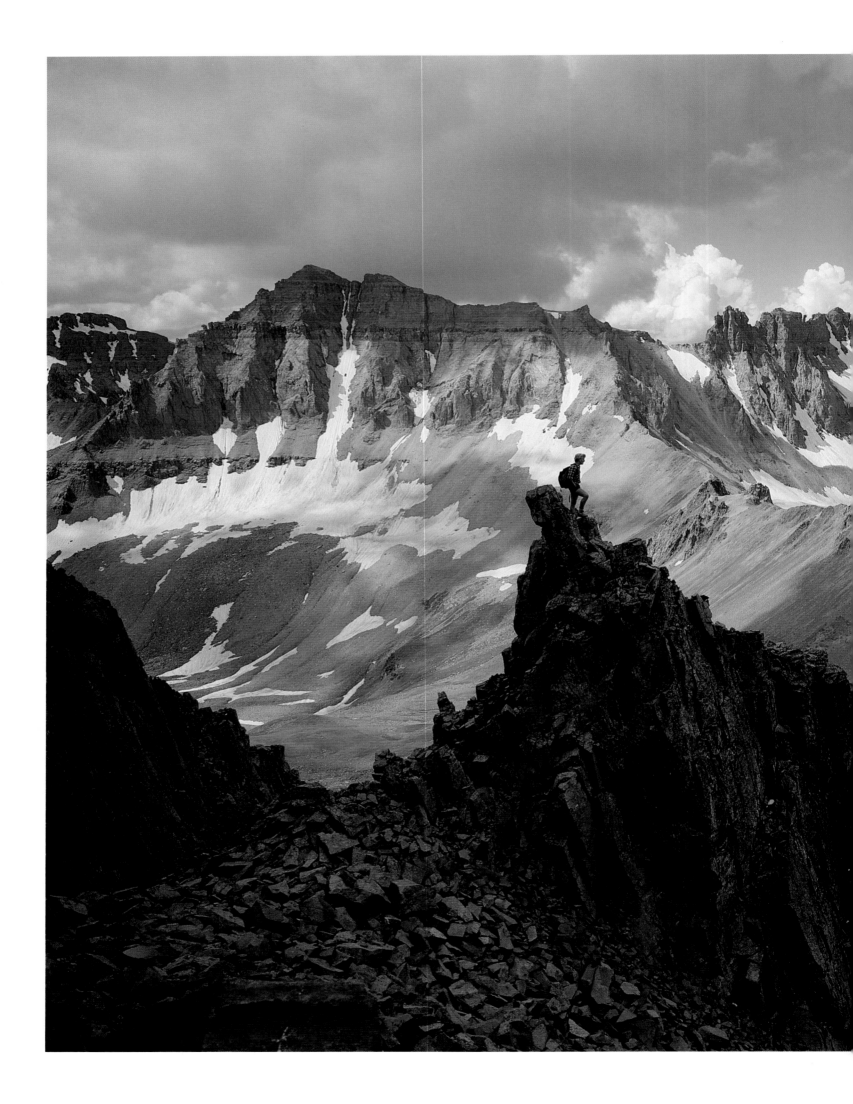

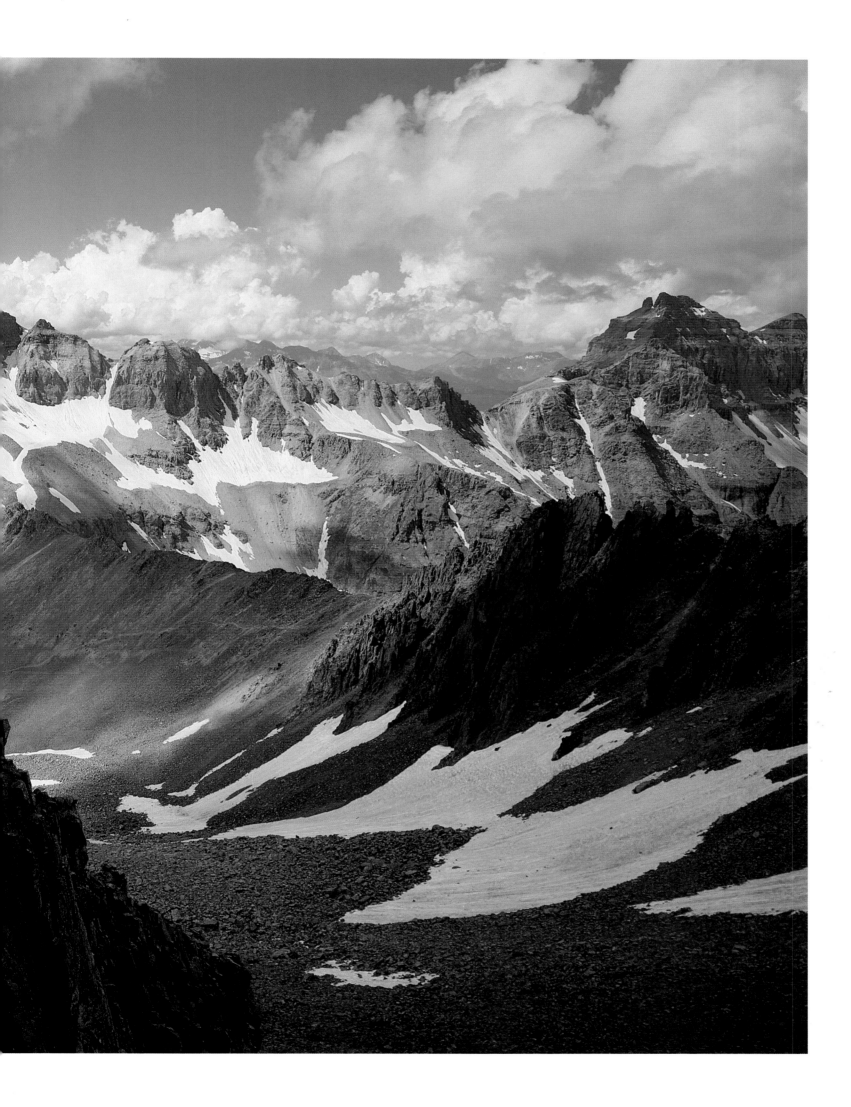

Hardrock on south slope of Mount Sneffels. Sneffels Wilderness. *July*

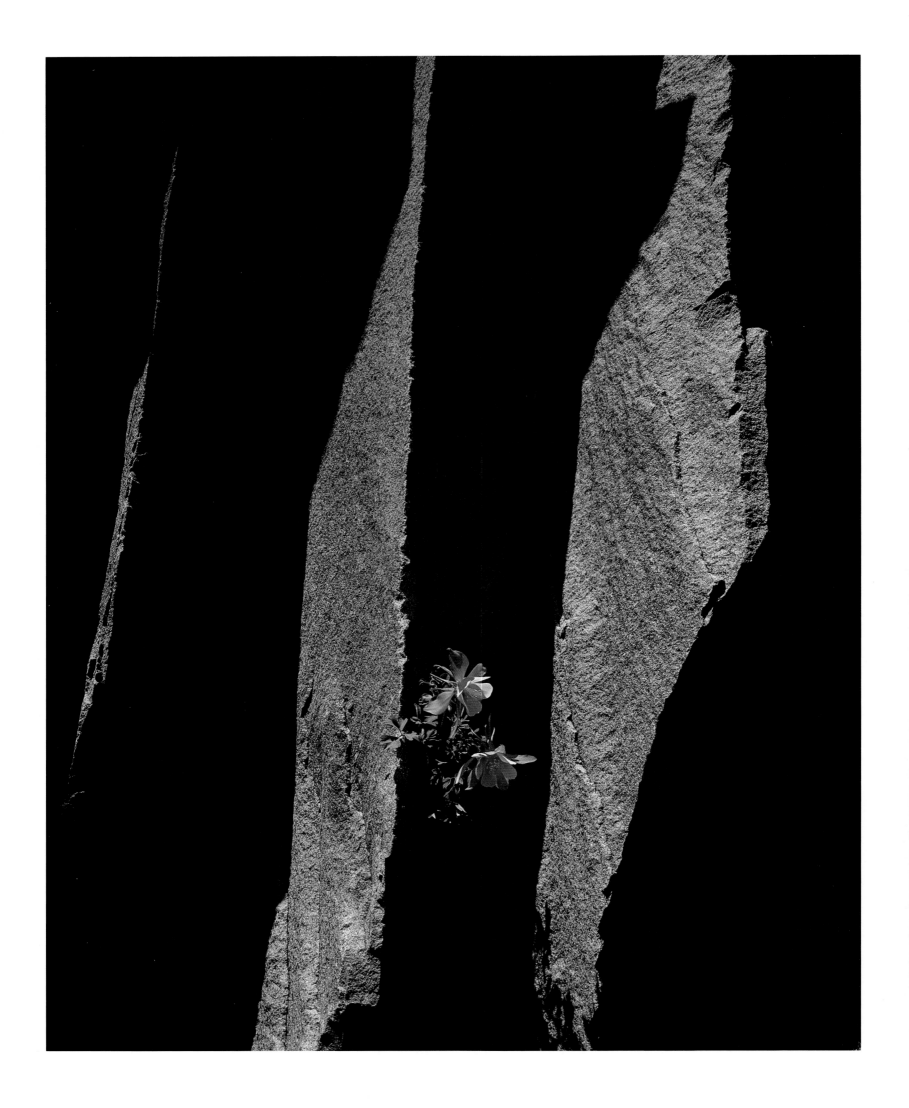

Ice-fractured rock wall on Diorite Peak. La Plata Mountains. *August*

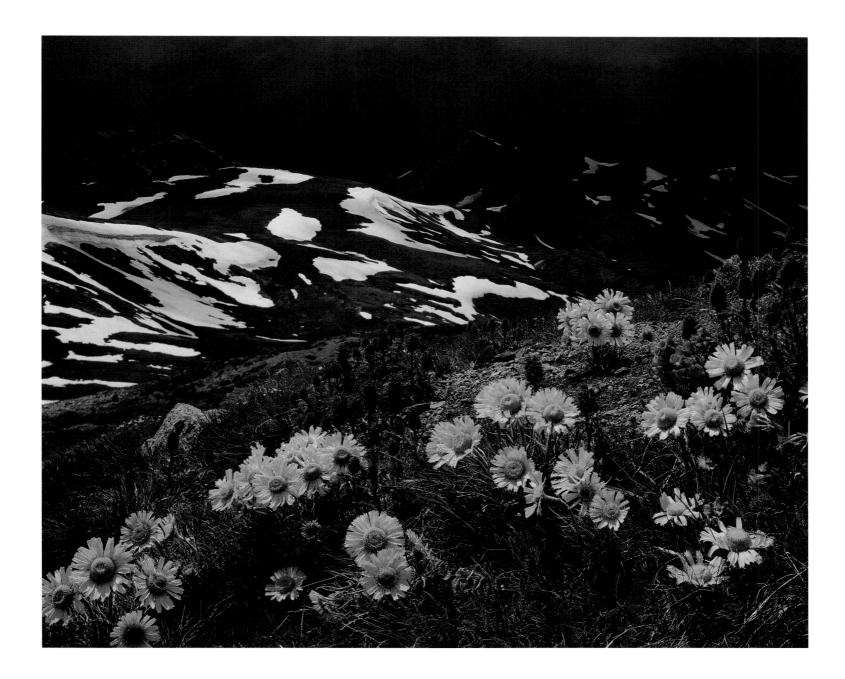

Approaching storm and alpine rydbergia. Engineer Mountain. *July*

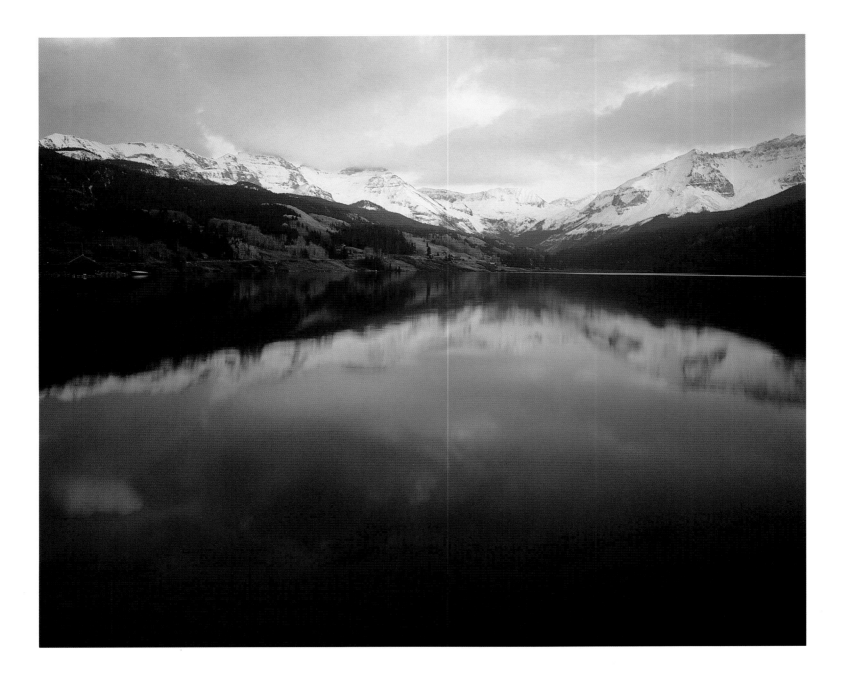

Evening reflections on Trout Lake. *October*

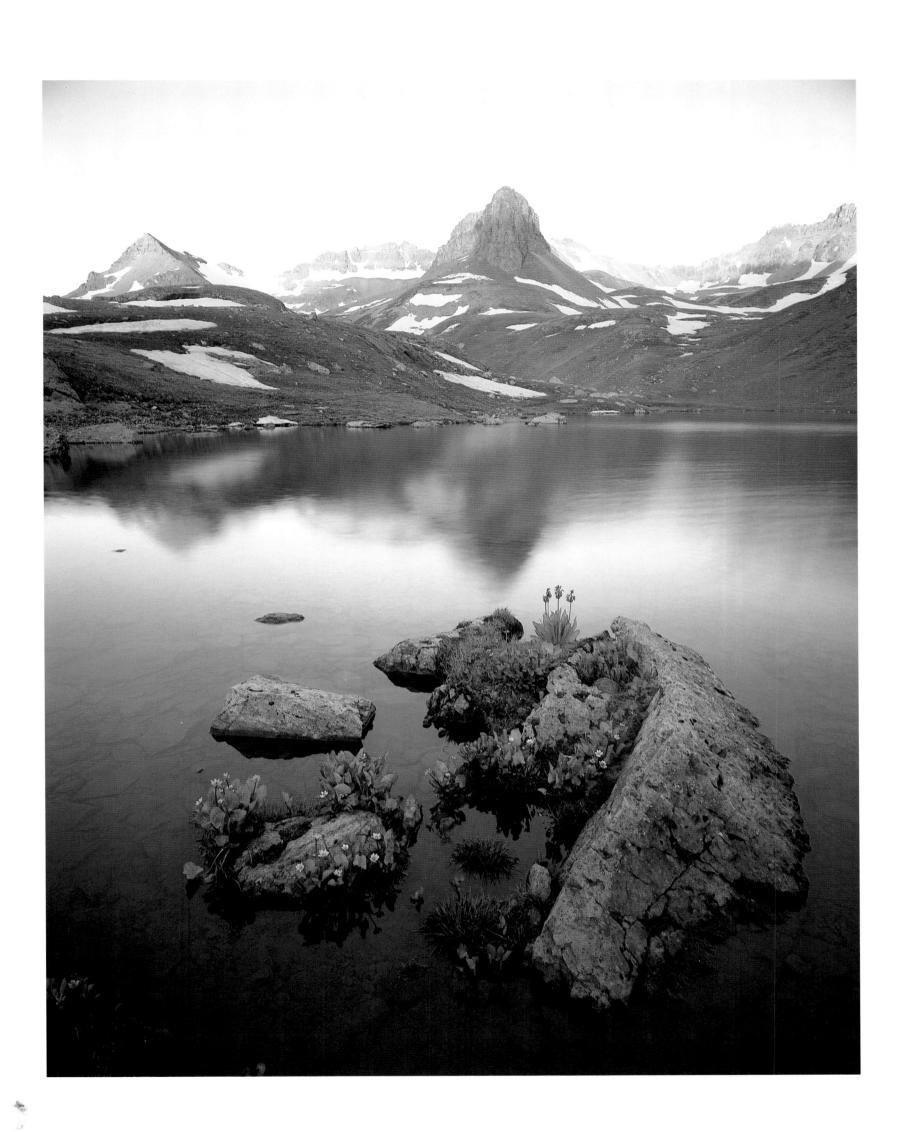

Dawn reflections of Ice Lake. *August*

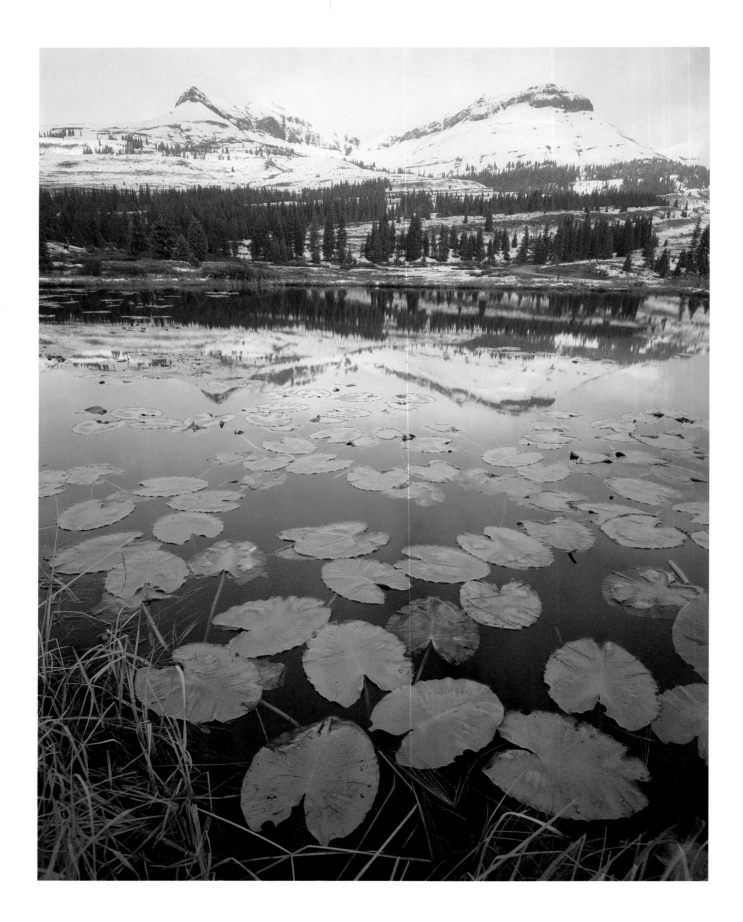

Autumnal pool of lily pads. Molas Divide. *October*

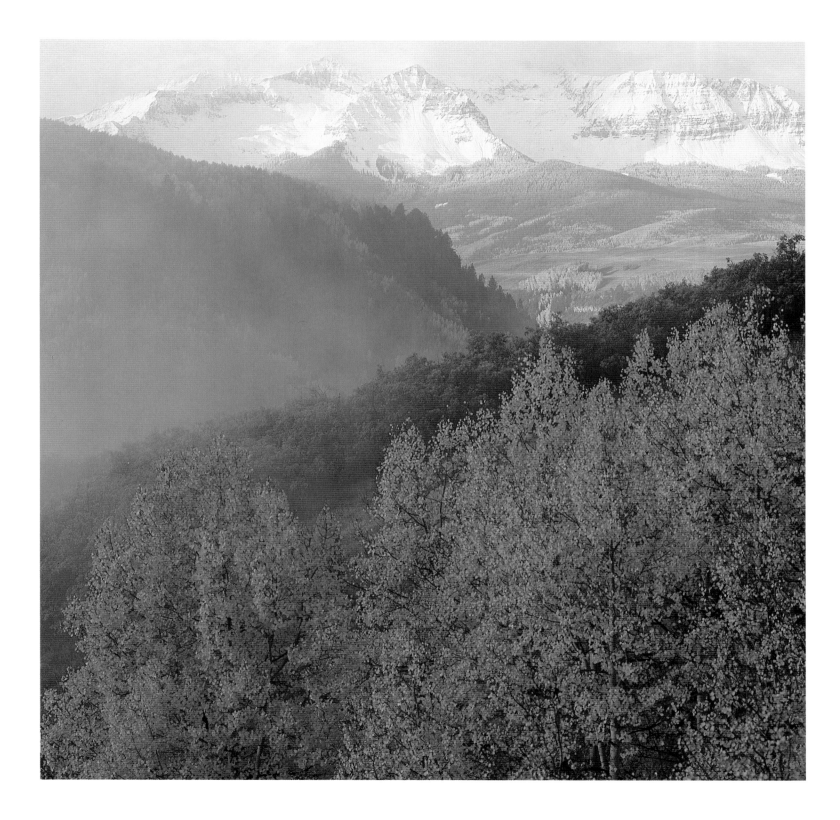

Aspen and first snow. San Miguel River Canyon. *September*

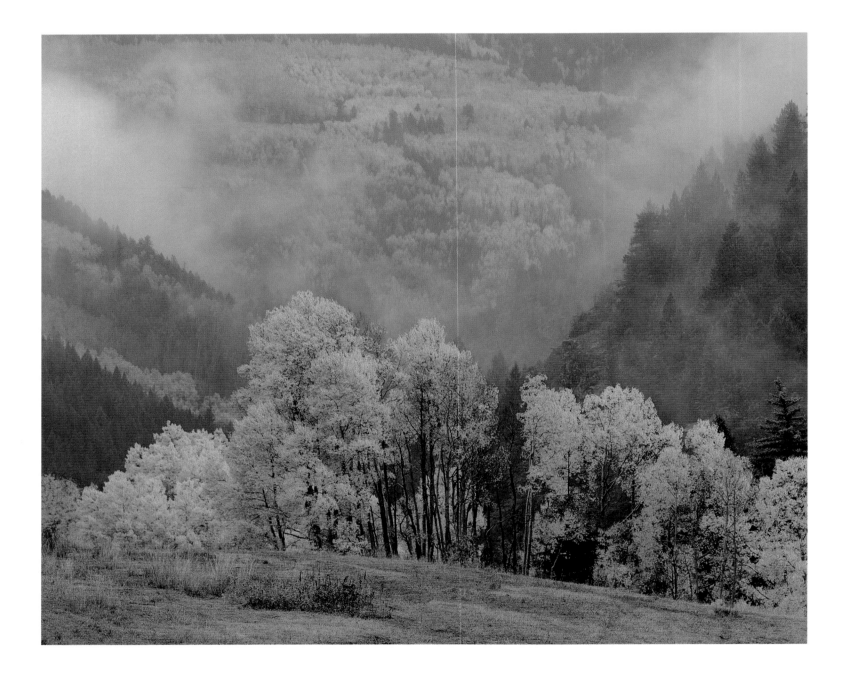

Aspen and fog above San Miguel River Canyon. *September*

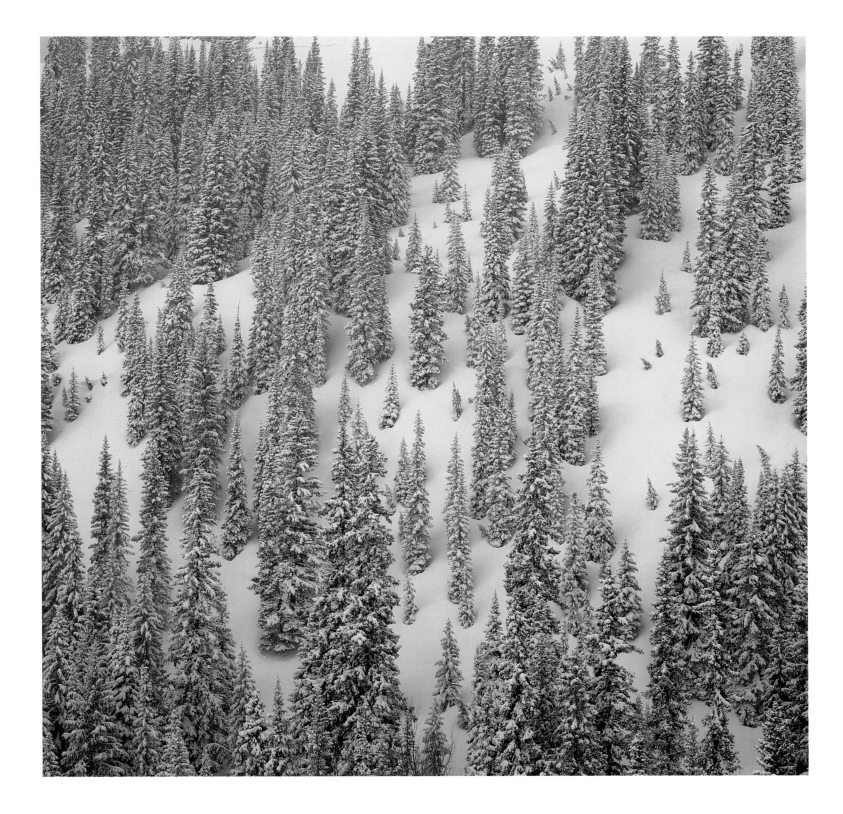

Spruce and fir forest in winter. Lime Creek. *March*

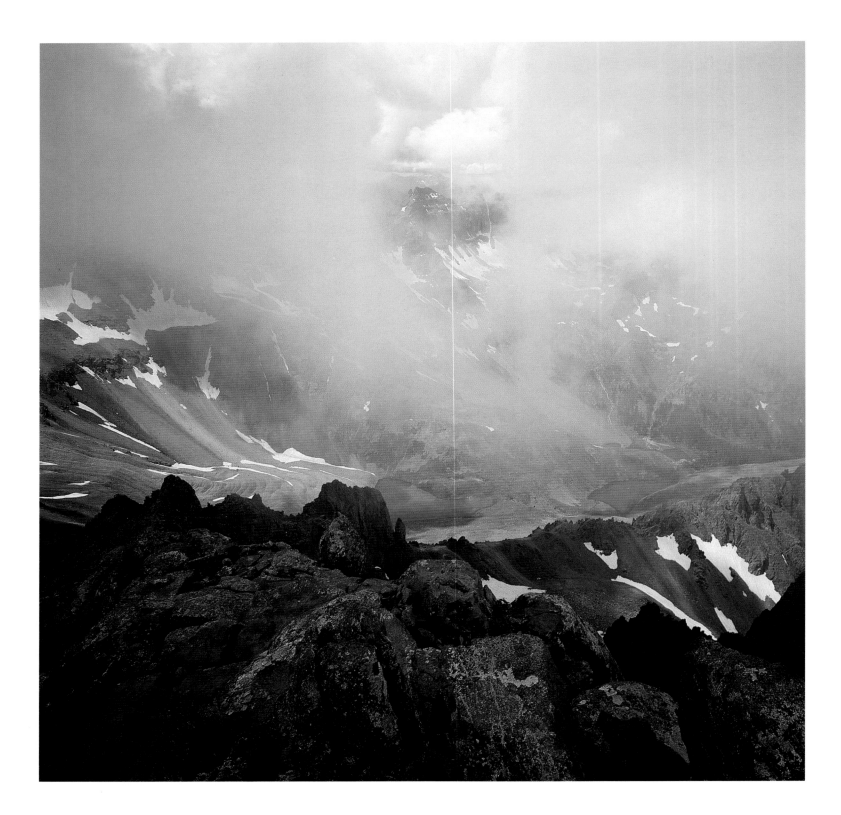

Cloud and rock on top of Mount Sneffels. Sneffels Wilderness. *August*

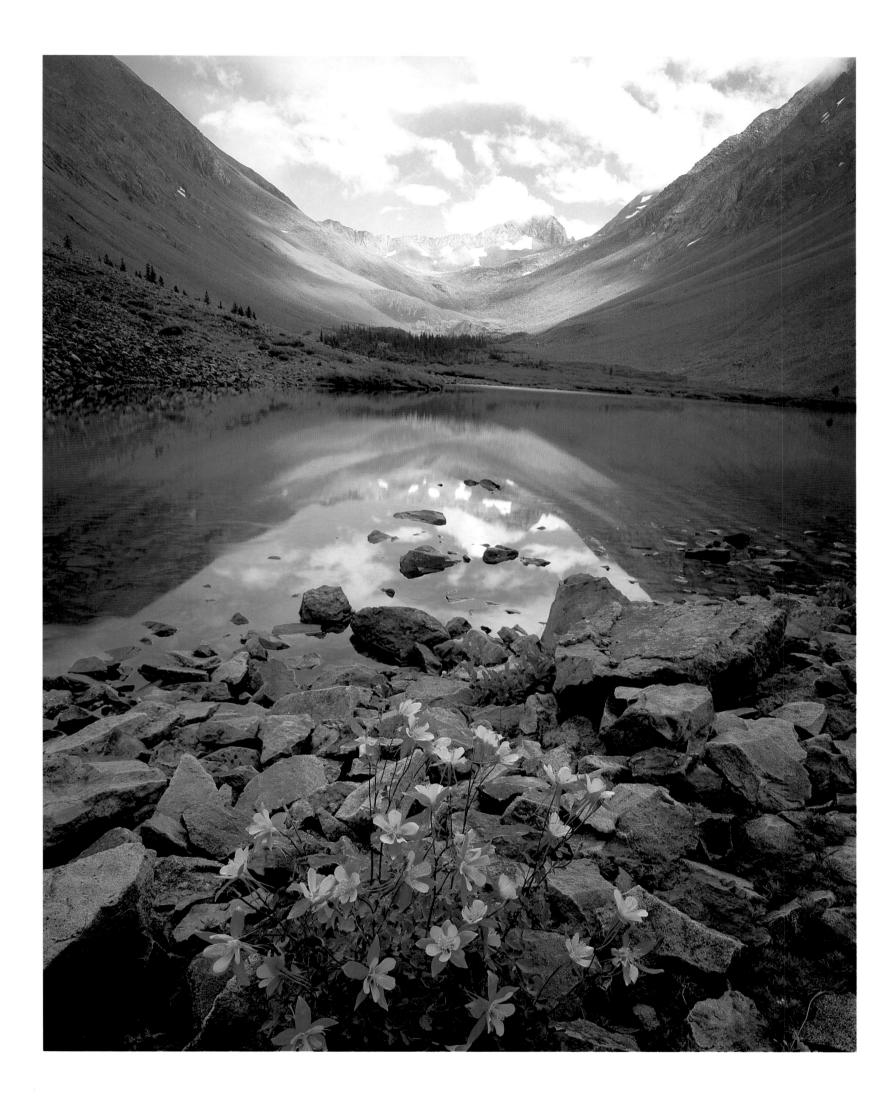

Columbine and Navajo Lake. Lizard Head Wilderness. *August*

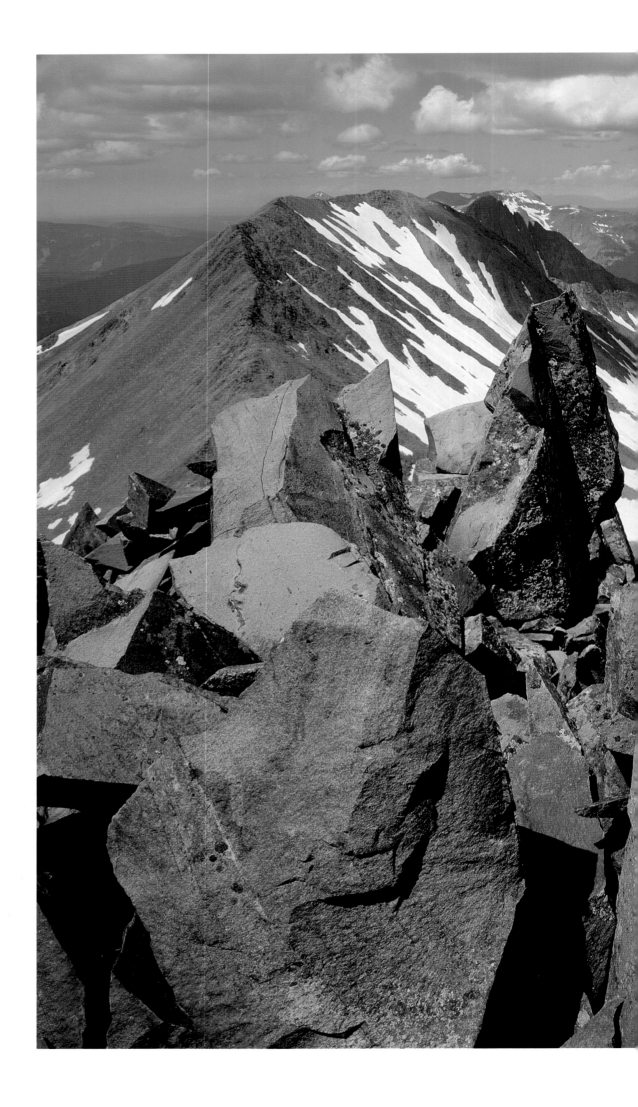

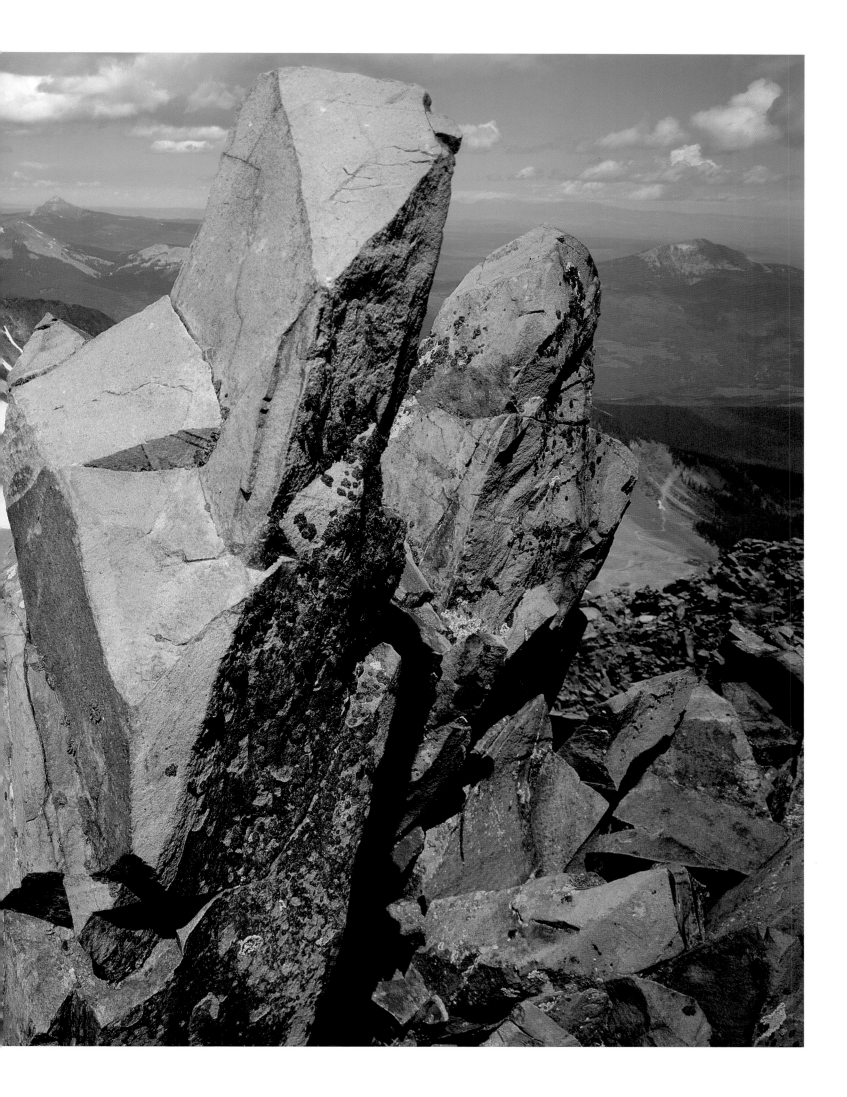

Ice-fractured toprock of Wilson Peak. Lizard Head Wilderness. *July*

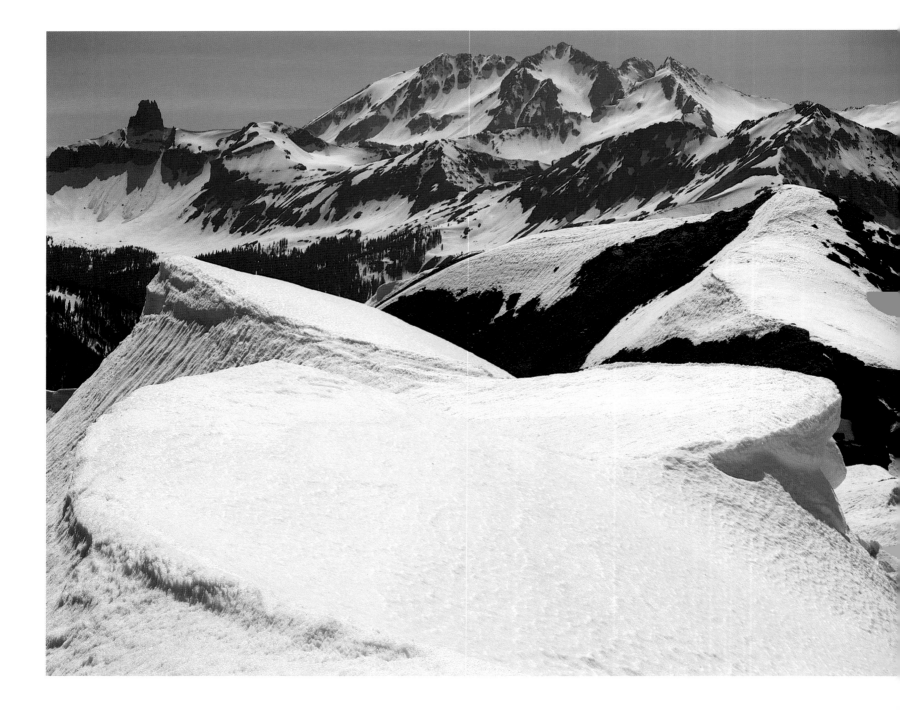

Lizard Head Peak and Wilson Peak above wind-sculpted drifts. *May*

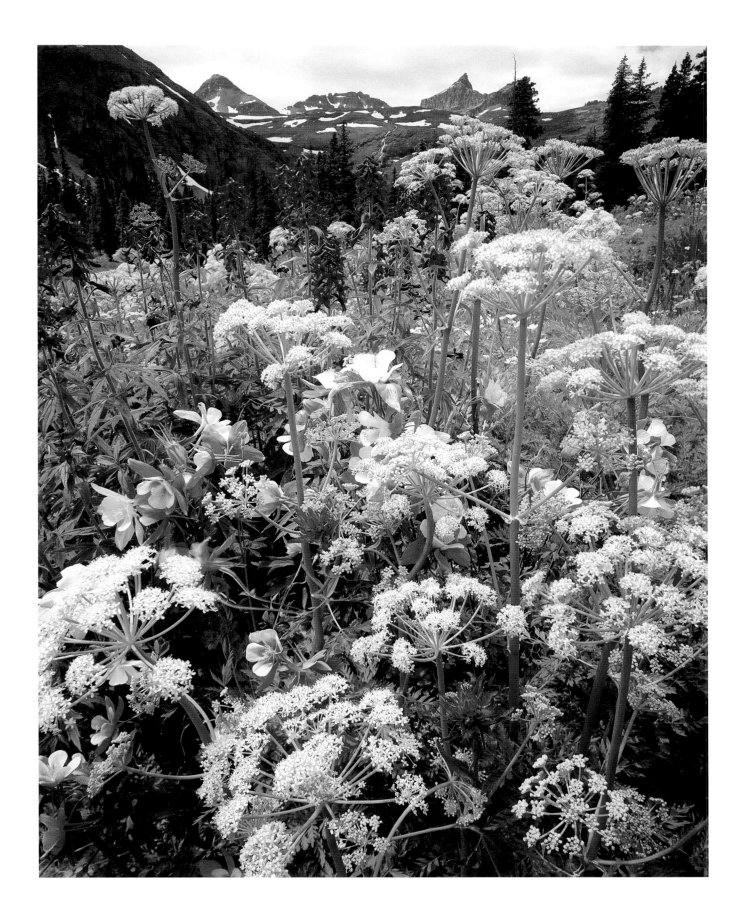

Columbine, paintbrush, Queen Ann's lace. Mineral Creek Canyon, South Fork. *July*

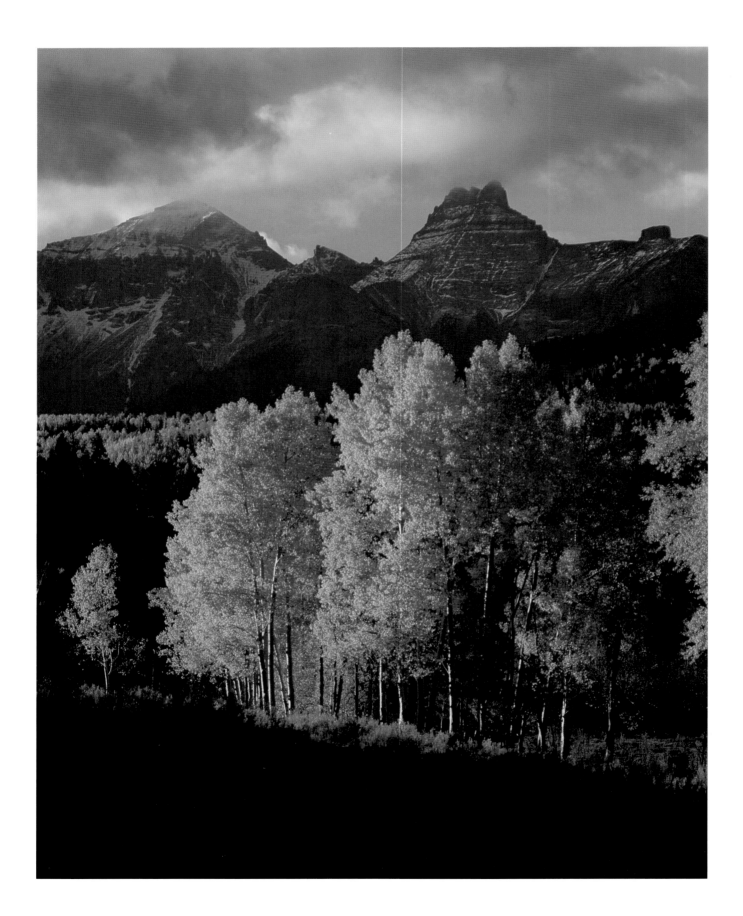

Aspen on north slope of Sneffels Range. Sneffels Wilderness. *October*

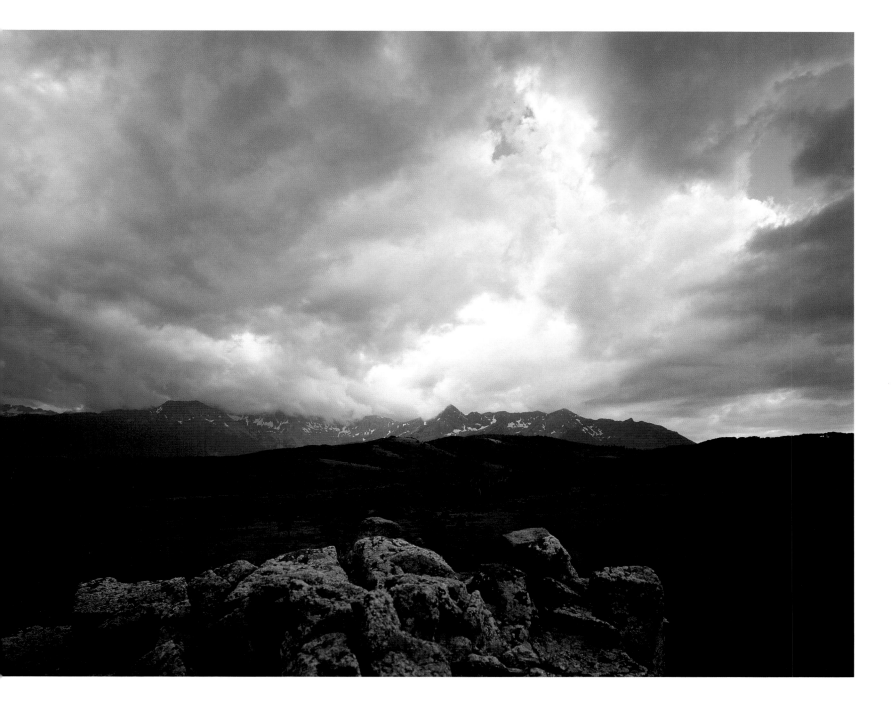

Evening storm on west end of Sneffels Range. Dallas Divide. *August*

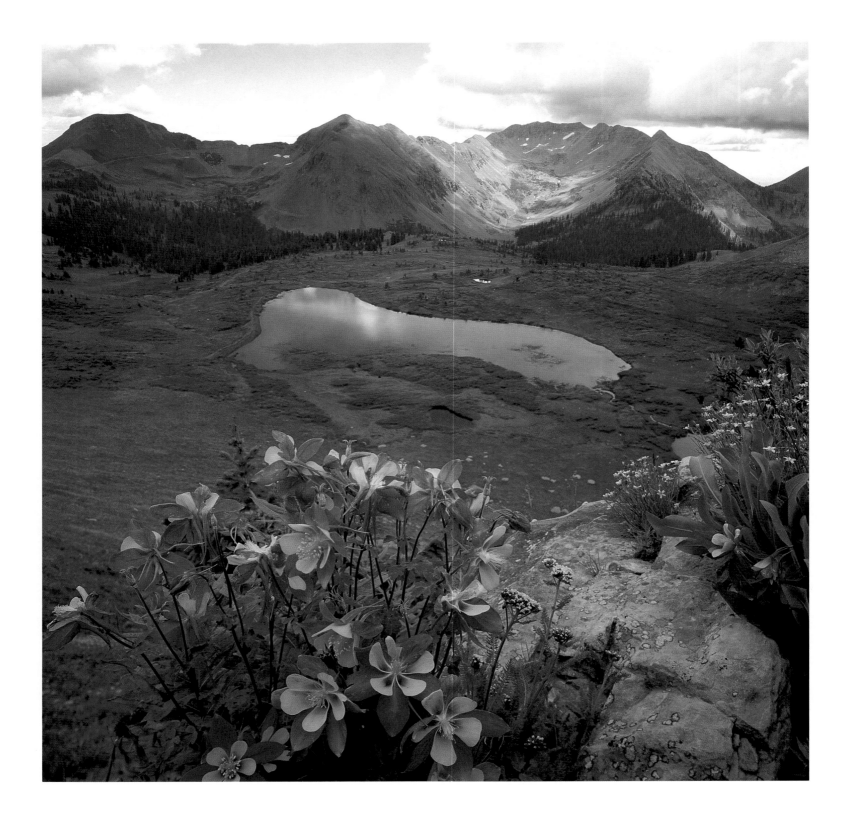

Columbine and alpine lake on Indian Trail Ridge. La Plata Mountains. *August*

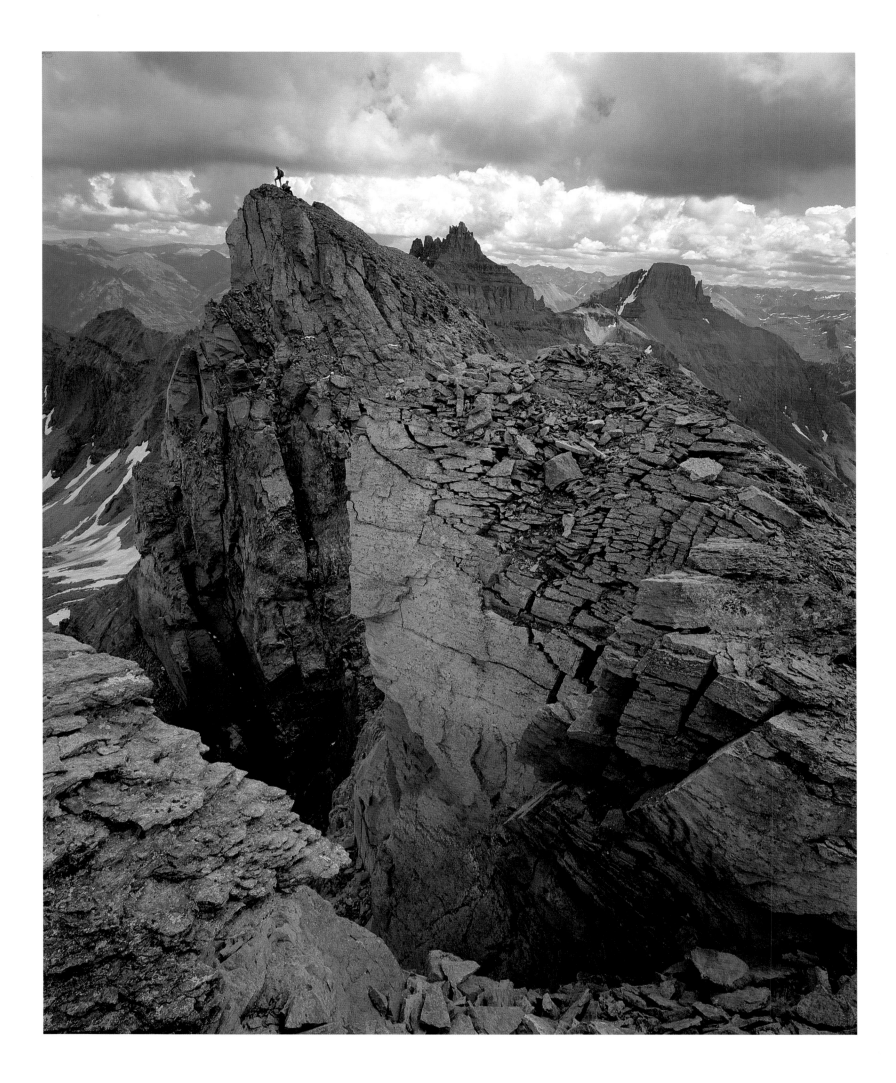

Ledges of Cirque Peak, with Teakettle and Potosi peaks. Sneffels Wilderness. *August*

HIGH PLAINS AND GRASSLANDS

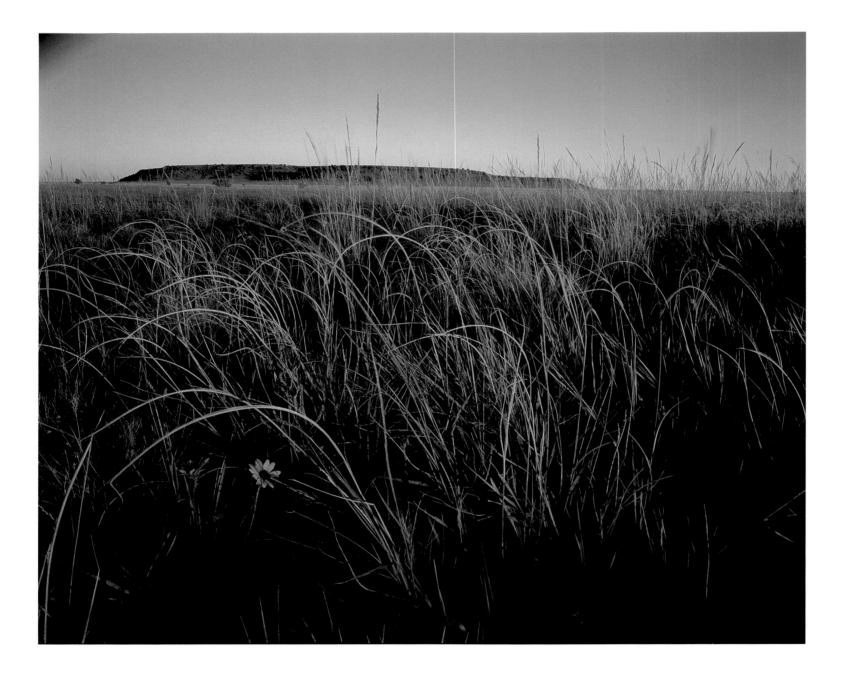

Expanse of grass below Mesa de Maya. Commanche National Grasslands. *September*

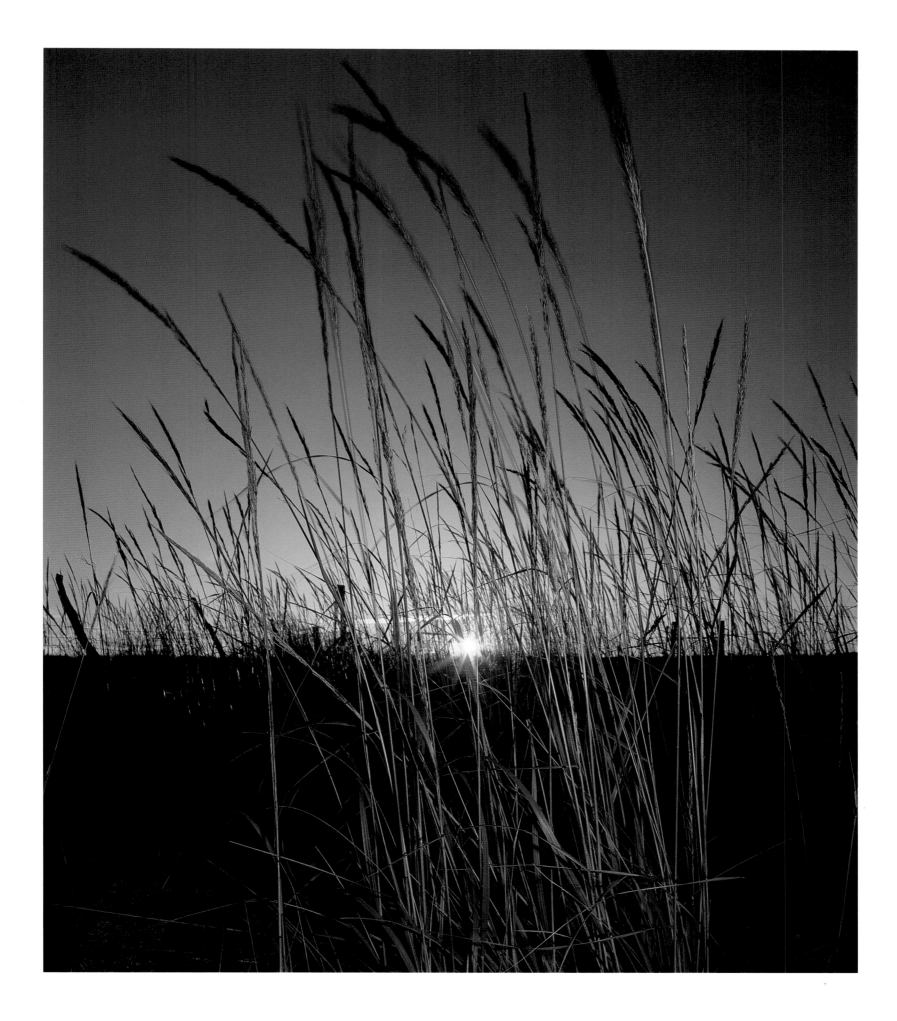

Sunrise glimpsed through sandreed grass. Commanche National Grasslands. *September*

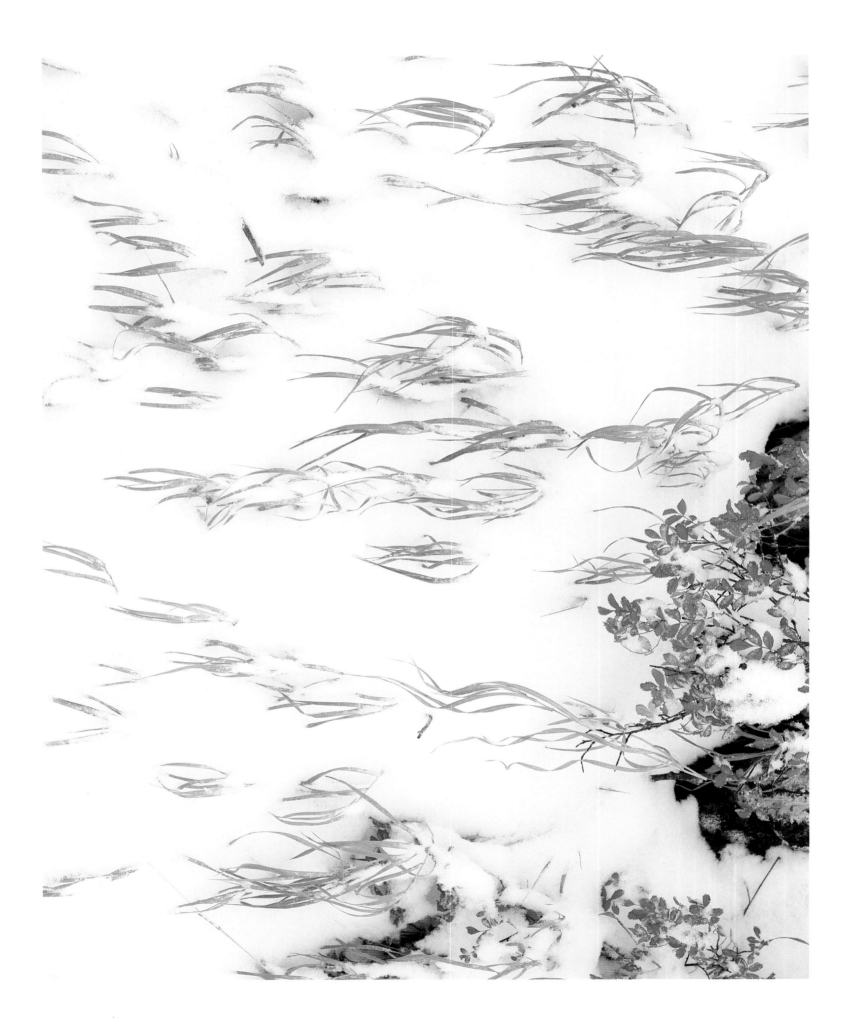

Grass, wild roses, and rose hips in Glacier Basin. Rocky Mountain National Park. *November*

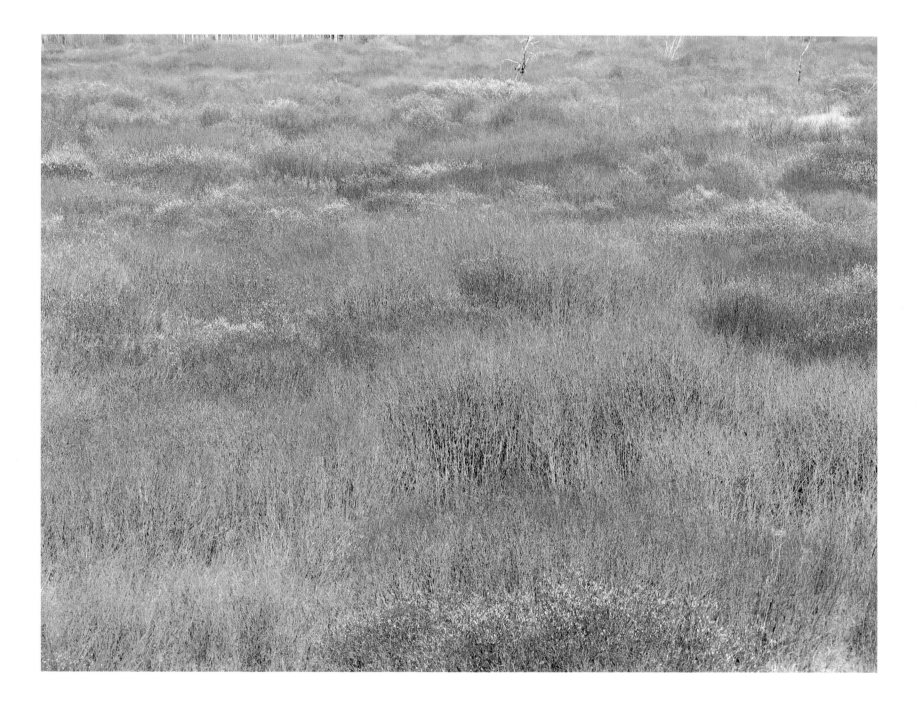

Willow marsh along Michigan River. North Park. *November*

Grasses and snow in wild meadow. Sneffels Wilderness. *November*

Rain mists held in delicate grasses near Mancos. *October*

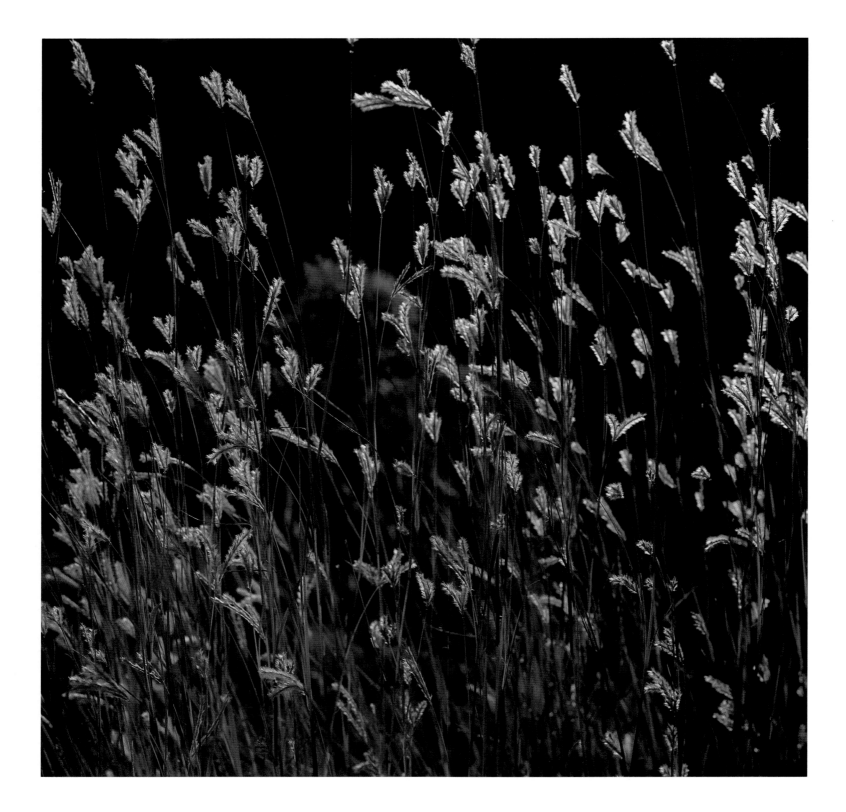

Big bluestem in Pawnee National Grasslands. *October*

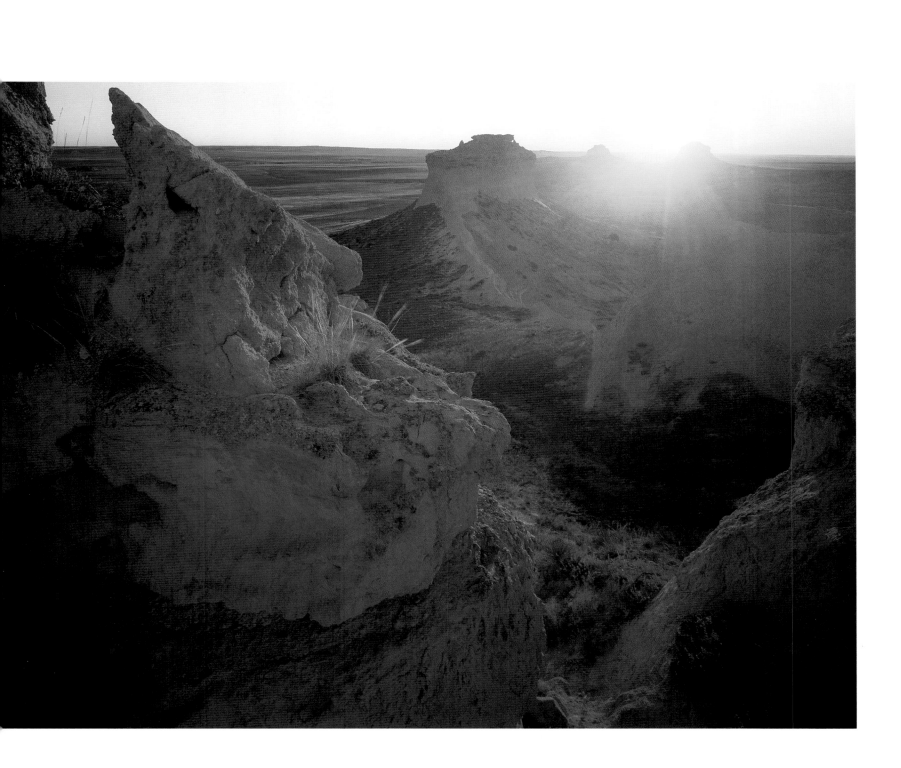

Pawnee Buttes and siltstone ledge. Pawnee Buttes National Grasslands. *October*

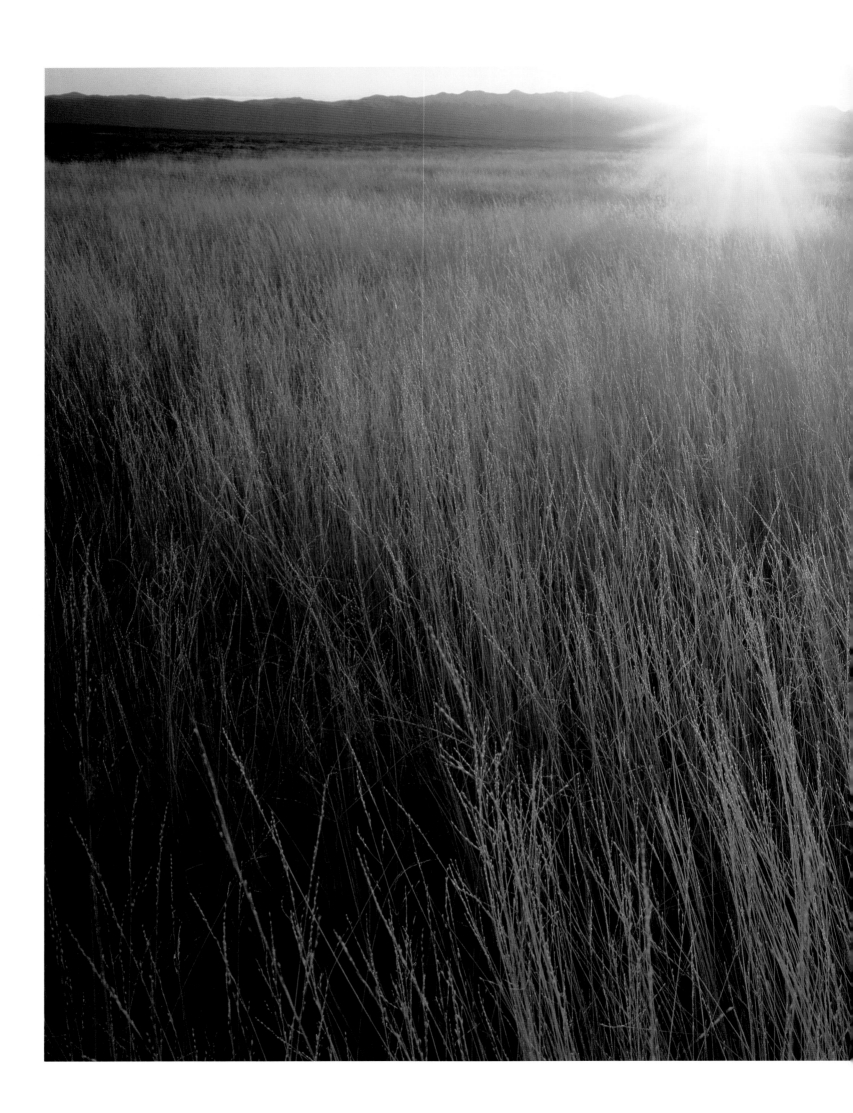

Grasses and Medicine Bow Range. North Park. *November*

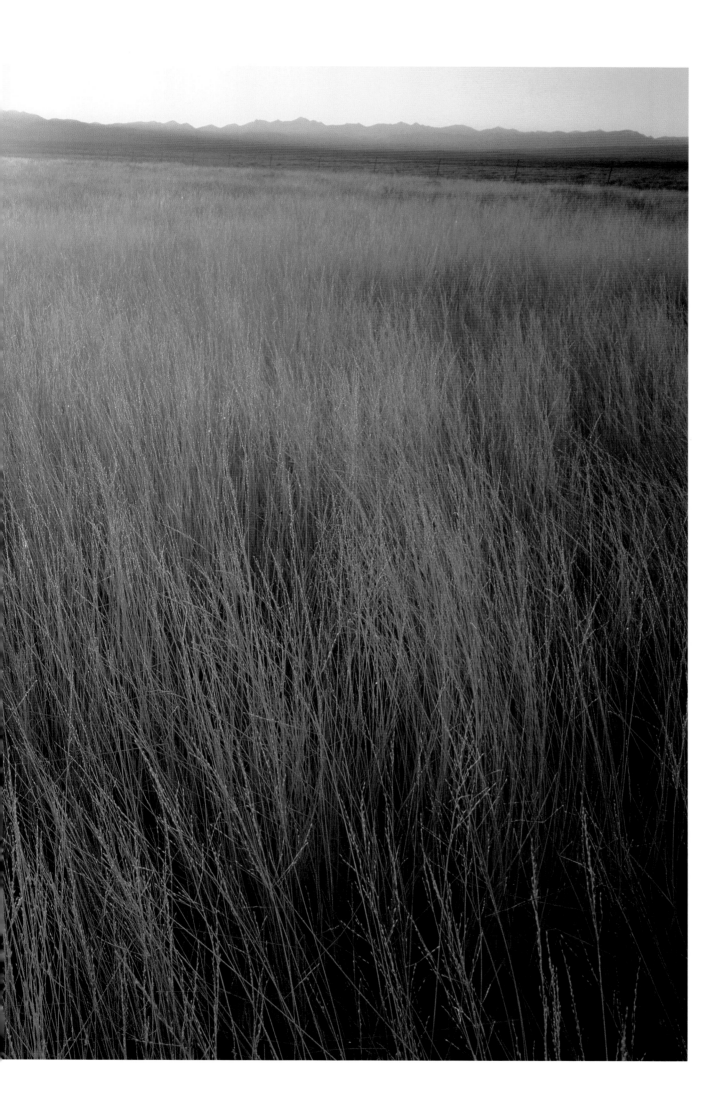

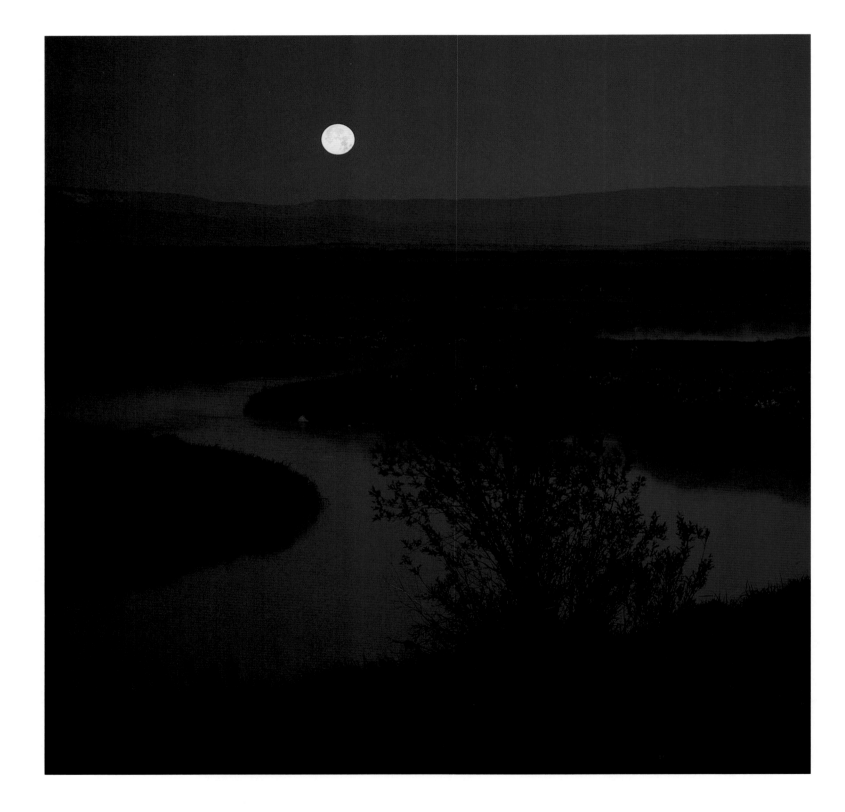

Moonset and meandering North Platte River. North Park. *June*

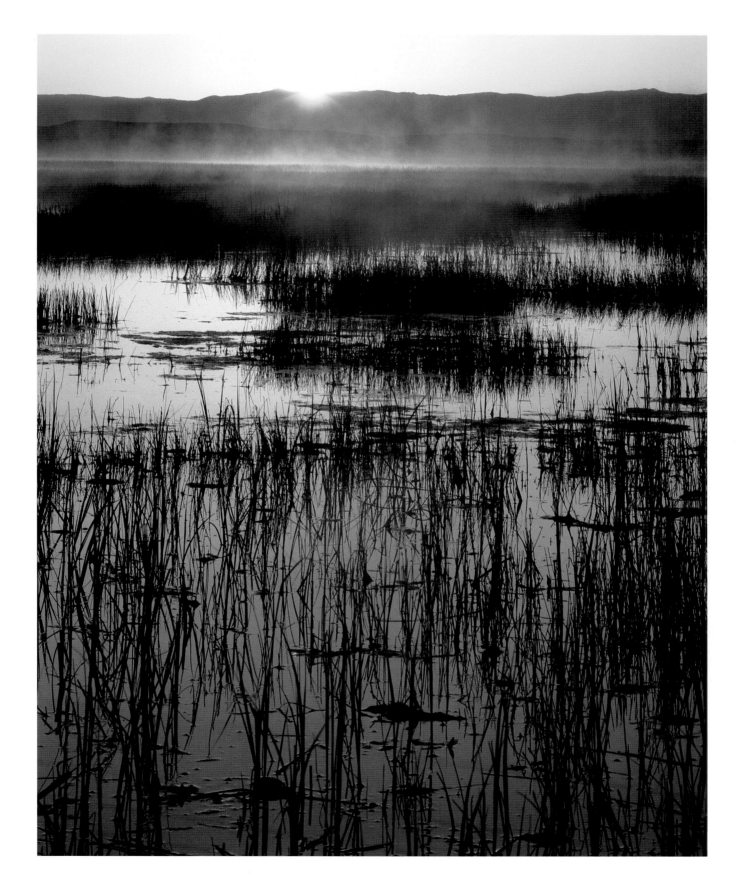

Marsh grasses and Medicine Bow Range. Arapahoe National Wildlife Refuge. *June*

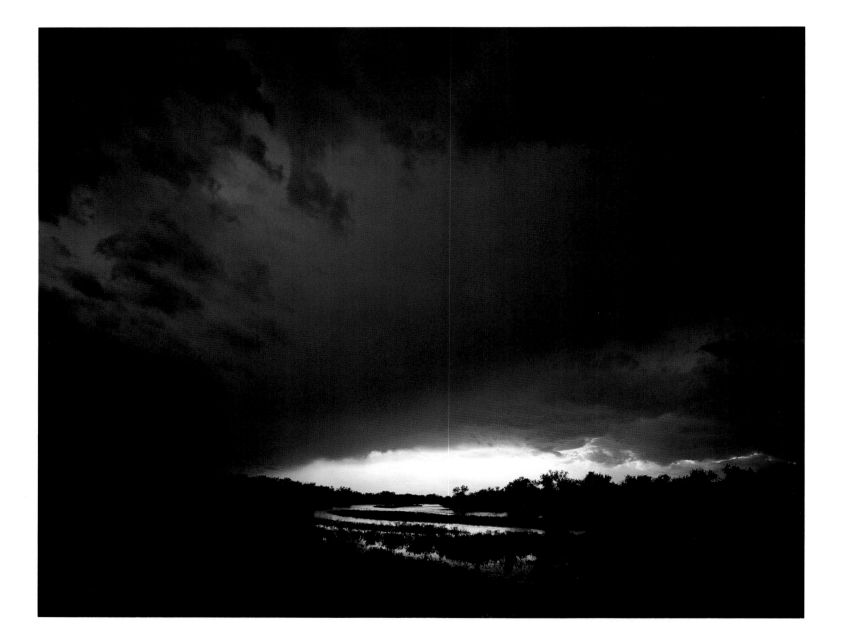

Passing storm and afterglow along South Platte River. *August*

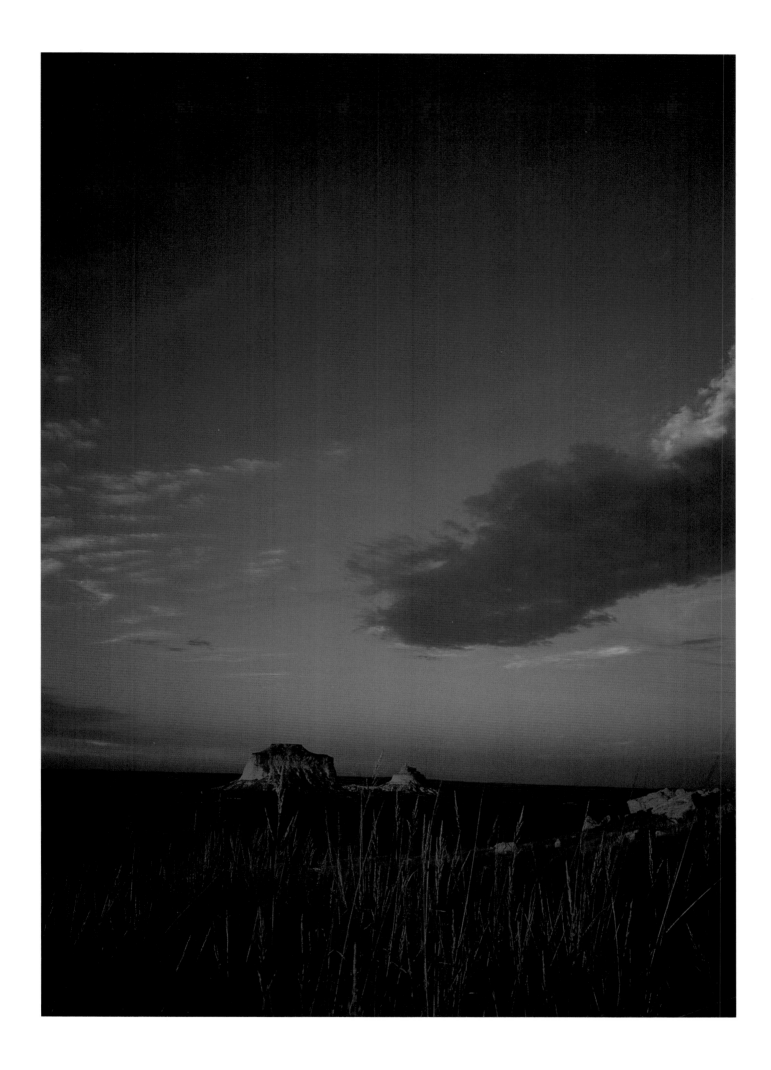

Pawnee Buttes in evening sky. Pawnee Buttes National Grasslands. *July*

SPRING

In the Colorado short-grass prairie, the year begins in March. Horned larks swirl off every fence post, white breasts flashing in unison as they wheel. Some swing high and dive low in a mating flight that acknowledges lengthening days, warming suns. The golden sunlight fires half a dozen mountain bluebirds to a brilliant blue. And meadowlarks carol in the early dawn, breasts of pure, saturated yellow so intense they incandesce, intensified by the dried grays and tans of the landscape. Colorado in the springtime always has a meadowlark, and today the air blossoms with their bountiful song.

My guess is that when people visualize Colorado they see rugged ranges of snow-covered mountains. Actually, mountains take up only about a third of the state, while grasslands cover three-sevenths of Colorado, the whole eastern section, border to border, north to south, a harmonious undulating land.

The short grasses furze and soften the demarcation between earth and sky, a horizon that defines the finite. When I scan the grasslands horizon, I feel what extends beyond peripheral vision, what I cannot see until I pivot—the same untrammeled, wind-swept, firm horizon line for 360 degrees: a full turn of the head, a full turn of the mind. Out in the grasslands, there are no mountains. You don't need them.

In the vast, grassland openness toward the Kansas border, my perception of Colorado is not of mountains but of sky, stretched taut from horizon to horizon, no slack left to luff in the wind. An enameled sky of crisp hard blueness. Unmitigated sky.

This morning the blue is speckled with clouds, rugged individuals all. Each floats isolated and on its own, dropping a slate-blue cloud shadow on the ground—so many clouds that the ground is leopard-spotted. Sometimes a shadow falls on the ridgeline, darkening the horizon, brightening the sky.

The wind sweeps all the clouds into the eastern quadrant. The wind is impatient out here, and there is no place to hide from its tirades. It rattles shingles, creaks windmills, quivers fences, buffets grasses, and piles tumbleweeds up against the fences.

Wind has its negative qualities but it does keep the sky clean, and for that I can forgive it almost everything.

The only way to place oneself out here is by section, range, and township numbers. Roads have no names, towns are on the other side of the horizon. I prowl a low-banked and open sandy draw in R 51 W. T 14 S, Section 6. Within it, another narrower, finer-grained channel has inscribed smaller meanders. Coyote and jack-rabbit tracks, small mice and three-pronged bird tracks filigree every open spot of sand.

I step up the two-foot bank to what, farther east, would be called a meadow. Here it is semi-desert scrub, getting along on fourteen inches of rain, over-grazed, and not likely to recover its original lushness in my lifetime. Witnesses to the aridity, cacti are legion. Hung with yellow fruit, dozens of big cholla bristle with spines that gleam evilly in the sunshine. Low prickly pears writhe across the ground. Colors are tans and beiges and grays, varied with the dull greens of cacti and the evergreen tufts of yucca, which bear last year's sturdy flowering stocks. Grama grass catches the low morning sunlight in its fringed heads. The grass cover is like a scruffy, worn rug, eaten through with large holes that show the bare soil beneath.

Even with snow still on the ground, brave little green sprigs poke up, unfold, begin to dance. Evening stars shoot up two inches; mullein rosettes lose their grayness; clover clusters close to the ground with its little origami-folded leaves; spiny thistle leaves splay out in rosettes close to the earth, soaking up the meager warmth, growing underneath the wind. A busy wolf spider, dark brown with a dark gray stripe down its back, patrols a grass mat.

A wingless grasshopper nymph, slow and plodding, picks its way across a ring of muhly grass the size of a dinner plate. A fine-stemmed grass, muhly is one of the most common grasses in the short-grass prairie, dying in the center as it sends runners outward. Only if I pry the tight thatch apart can I see any green. Edna St. Vincent Millay would not recognize spring in Colorado. It does not come babbling down the hill but seeps up quietly out of the warming earth.

I nestle into a small ravine, protected from the wind, to have lunch. Undetermined miles from nowhere, the terrain is a mere squiggle of lines on a topo map that shows the nearest town twenty miles away. There is an anonymity in these grasslands, a sense of going on forever, as if the whole world were short-grass prairie and no matter how far I go, that's all there is, all there ever will be, and to think otherwise is folly. Big patches of snow still linger, pristine white lozenges on the shaded slopes, but the sun is warm, the day, brilliant. A picket of seed heads surrounds me—dried sunflowers and asters, evening stars and rabbit brush.

As I eat, I look through the palisade of dried stalks at eye level to big cottonwoods that cluster in the draw. Red-winged blackbirds chirr and chortle that melodious announcement of spring and warmth on the wing. I loved hearing them in my childhood and I love hearing them here today, binding together yesterdays and today with such melody.

I do what I always do at these times. I take notes. This noon, sitting still, they are neater than usual. Just as often I write on the back of an envelope or a wrinkled piece of paper found in a ski jacket pocket or on the edge of an old grocery list, the necessity to record and preserve stronger than the urge to be orderly because even a few cryptic words distill a spring hour, bring back the taste of sunshine after a snowy winter, the sound of a spring breeze rousing up the valley. But words only work if they are written now, when red-winged blackbirds sing of spring on my birthday.

Some miles after Kit Carson and some miles before Hugo and still sixty miles east of the first mountains, they appear, like cardboard cutouts pasted behind the rolling horizon, simplistic shapes in a child's drawing. White with snow, struck with blue shadows, only the peaks show, notching the sky. Their blue shadows are the color of the sky, so that it looks as if the sky shines through the rock,

shines through a lacy phalanx, unreal and fanciful. It will be miles to reality.

Those mountains are the backbone of Colorado, and the ribs of the state curve away to either side of it. The land in between, 3,000 to 14,000 feet, makes Colorado *Colorado*—all the variety that change in altitude brings: grasslands to forests to elfin timber to no trees; rolling flats to serrated peaks.

In this wealth of foothills and mountains, I learned wilderness. Wildness *and* wilderness. The root word "wild" goes back to the eighth century—a word that adds alertness to watching, keens up the sense of smell, sharpens hearing, intensifies going—a word that talks about an out there, a someplace beyond that holds unforeseens and perhaps and maybes, that presumes unexpected experiences and challenges. Wilderness is a word that is fearful or welcome, depending upon how you feel about a world in which nature, not man, is in control.

This concept of a vast, untrammeled wilderness, which many who live in the West hold, encompasses a present point of view that is political as well as ecological, economic as well as conservationist. Out here, wilderness is wilderness for its own sake. And even where the government has not designated a "wilderness," there is a great deal of emptiness just down the draw, just over the canyon rim, just behind the lodgepole forest, just above the line of trees.

I grew up in the soft hills, flat fields, and squared-off woodlands of Indiana, where wilderness was hardly a concept. I came to Colorado as an adult and found in the mountains questions for my answers. I learned how to walk and look and to sleep in tune with aspen leaves and night-bright skies that showered down cones of light. I found home.

That I came to understand wilderness as an adult colors how I perceive it. In Colorado, a wilderness is a wildness is a wilderness. Never mind the piety and wit, bring water and blankets.

I see a great deal of Colorado's wilderness on foot, but because I am married to a pilot I also see a lot of Colorado from the air, skirting mountain peaks in the Sangre de Cristos that look too steep to climb and slopes of the Mosquito Range too loose to traverse, tilting over a sedge-bronzed alpine meadow in the San Juan Mountains, flying toward the headwaters of the Rio Grande over a valley that changes from dry, dusty and wide to narrow and green with a tinsel stream quirking through sedge meadows. These big views of the way a mountain drops away and white water ruffles in a quickening river and sedge meadows bronze, helps me to understand how Colorado hinges together.

So often have I flown the same routes that now I have familiar landmarks and guides which are visible only from the air. I watch for the patriarch mountain profiles in the Uncompahgre Mountains, the swatches of small valleys of distinctive shapes and odd configurations tucked between the peaks of the Continental Divide. My delight never diminishes when, flying west, we come over the Wet Mountains and see, not just the San Luis Valley, but the magnificent rolling mounds of the Great Sand Dunes.

In the northwestern corner of Colorado, I wait for the distinctive gray-green mesas formed of fine layers of oil shale and dotted with scrub, which from the air reveal both shape and color in all their subtlety. The flat tops, as if sliced off by a knife, are bolstered by gutted slopes striped in jade and ivory, verdigris and bronze.

From 10,000 feet, I visualize this landscape under water, the glitter of waves spiced with white-caps—surely the wind was

obstreperous in those epochs as it is now. All that reflected light is gone now, absorbed in the land as the water is absorbed in the shale. Past and present join, the past compressed to layers, the present stalked with sagebrush, and over them both, the skies that have seen it all.

Spring stirs up the grasslands but drags its feet in the Front Range Mountains that stretch all the way from Wyoming to near Canon City, Colorado. At the 8,300-foot level, where I spend a great deal of my life at a place called Constant Friendship, the snow is still almost two feet deep, crusted enough on top to hold my weight. The drifts are corpulent. The sun shone brightly yesterday and shines today, glazing the snow surface with a fine sheen, so that it looks like molten milk glass poured over the hollows, smooth and slick. Out of it stick brown angelica seed heads, inked in sepia with a croquil pen on brilliant white paper. I break through the snow's crust and stand knee-deep in stillness, letting the cold seep up my legs, my torso, my arms, into my head, suspended in time and cold, waiting to hear those first faint tickings of spring in the melting drops coming off the ponderosa branches.

I wait. All is silence.

The next day it rains snow in the aspen grove at Constant Friendship. The aspen are an unfamiliar color when wet, as if bandaged in strips of brown wrapping paper, and they blend in with the shadowed Douglas fir and blue spruce on the hillside. Their twigs and branches shine russet. The bud covers on the willows have already opened and their catkins emerge, furry gray against the chrome yellow branch.

The rain gnaws away at the edge of the ice skin on the pond—little bite marks all around the edge, the way a child eats a cookie.

The open water surface is almost as white as the ice with the pricking of the rain. Every pine needle is glass-tipped, the drops rounding, falling, instantly replaced. Thomas Hardy wrote about raindrops hanging like pearls on the gate—he should have seen them on pine needles, miniature glass globes reflecting a mountain world.

The rain lessens, the sky brightens, the aspen boles turn the color of pea soup.

The next week a fine, steady snow sifts down, clings to the pine needles, and leaves a knife edge of white an inch high on everything. The landscape has the clarity of a sharply focused black-and-white photograph. Even a color photograph would be black-and-white. Spring is postponed indefinitely.

The snow is so fine that, without wind, it floats, more suspended than descending. It smoothes the ground and the trees disappear in a scrim of white. Close by, the lion's tail tufts of ponderosa needles hold it in handfuls, but the first flakes melt. The needles must have had some residual heat in them. Then the flakes begin to hold, each balancing on those beneath, a grand acrobatic exhibition—half an inch high, then an inch, then two, needles sticking out every which way, like the pins in a kabuki hairdo.

Today I despair of spring.

I would have thought that the ultramarine blue of the Steller's jays would stick out like a sore thumb, an unnatural color. Instead their blue is a blue that matches the shadows, only their shape and movement give them away. The elusive Lark Bunting may be Colorado's state bird, but I vote for these cocky, skittish jays.

There's always a jay around in the mountains—the jumpy Steller's, the energetic gray, the aggressive Clark's nutcracker, the

busy Mexican, all permanent residents, cadging a seed here, beaking up an insect there, omnivorous and possessed of voices only another jay could love.

I watch the Steller's flashing blue and remember something David Muench once said when I asked him if he envisioned an audience for whom he photographed. "The coyote, eagle, raven maybe . . . or maybe the God within us."

The Steller's jay would understand that.

Semi-cloudy, semi-warm, semi-spring. In the mountains, mountain candytuft, like leftover snow flakes, is in full bloom, along with the first pasqueflowers. I catch the first pasqueflower half an inch above the ground, check it by the week, welcome the first snow-bitten blossom, watch the stem extend, the frowsy seed head develop, then empty, and the leaves unfurl to gather and store sunshine for next spring's reemergence.

Pasqueflowers belong to a mountain spring, sending flowers up to the cool spring sunshine, expending little effort on stem and leaf at the cool end of the season. They cower close to the meager warmth of the ground and close up when the day is cloudy—why risk a pollen-wetting when no pollinator in its right mind would be out? Plentiful as they are, on this cloudy day, all are closed.

In the distance, the woodpecker drums. The mountain chickadee fusses. A foraging chipmunk scampers into a hole in the bank, rattling a pine cone down the hill. A yellow-bellied sapsucker works a little ponderosa. The sapsucker braces its tail against the trunk and works patiently, as it has for several days. It stabs at a trunk, now so riddled it looks like ladders in a nylon stocking. The sapsucker has made several rows, up and down the trunk, to get at the sap and cambium layer. The resinous sap oozes

out in amber globules. The wind charges like a freight train down the meadow. Winter is still. Spring is noisy.

On a camping trip into the Collegiate Mountains, I awake from a nap when a gust of wind shakes the tent. No one slept last night—it must have been the subalpine altitude—and we have taken this day to catch up. Outside, rain and thunder, sound effects from the golden days of radio, a sheet of metal shaken, a bass drum struck. The rain sheets in from the east at almost a 45 degree angle. At a burst of wind, it rataplans on the granite. In the midst of all this pelting, a junco feeds. Thunder resonates off the peaks, sounding like boxcars banging into each other. The wind calms, the rain falls straight down, heavy and gray as lead shot, shredding the leaves. Now the hail comes, hurtling down, cavorting off the rocks, clattering a terrible racket. Another junco unconcernedly hops around amidst the popcorn hail.

It has been hailing for ten minutes now. The soil has whitened, but under the trees the ground remains dark like shadows, linked with jigsaw pieces of snow and wet hail. Thunder still ripples through the sky. Snow, so gentle and quiet, is prim and ladylike. This rain and hail are boisterous, loud-mouthed, tearing up the neighborhood, moving fast and loud, revving up their cycles, blowing off the sky.

The air chills beyond comfort. The tent leaks. I blot up the puddle, rearrange the tent floor, close the outer tent fly, and wrap up in my sleeping bag, shivering.

Once there must have been a monstrous snowstorm in this short, steep valley of the Collegiate Range. Most of the small aspen trees in this streamside grove are still bent over, likewise river birches and willows. Patches of snow still hold on the ground,

pock-marked from the dribbles and drops off the trees. Deer, coyote, mice, and rabbit tracks are legion, exclamation-point patterns crissing and crossing. The air is full of wingflash and birdsong: robins, juncos, jays, chickadees. In the lower meadow, a pair of mountain bluebirds fly roundelays. The summer influx has begun. A pair of flickers pokes a patch of open ground for early ants. A chickadee hangs upside down on a tree trunk like a nuthatch. All the juncos now are gray-headed; the white-winged juncos—the real snowbirds—have gone.

At Constant Friendship, I walk endless hours with my German shepherd, Nana, marking seasons, measuring the world, witnessing beginnings. I carry a bag with a field notebook and a clipboard with a chart on which I record flowering times.

Twenty-five calypso orchids bloom along an old log in the woods at Constant Friendship, ranging from pale to deep pink. They open each year the first week in June, unvarying, and, also unvarying, I make a pilgrimage to see them. I wonder if their insistence on this precise date of bloom renders them vulnerable to the vagaries of weather, which affect their numbers and perhaps their color. Pragmatic pasqueflowers, willing to adjust their blooming time, manage a generous show lasting a whole springtime. The elitist orchids perform magnificently in some years, thinly in others.

The pouting lip, the sophisticated juxtapositions of color, the speckled and furred throat, make the calypsos difficult to draw. The other early flowers seem simple-minded by comparison: the open, five-petaled strawberries and buttercups, the simple bells of mertensia and kinnikinnick. As much as I love the orchids, when the days are warm enough to take sketchpad and pencil to record the wealth of flowering, I return to drawing the crisp clear buttercup and the precise strawberry with some relief. Squaw currant dangles pink flowers, and columbine buds nod like lavender lanterns ready to be hung on Midsummer Night's Eve.

Early June days smell like pine as resins released by heat twine through the air. But no dragonflies. It cannot be summer without dragonflies. One wildflower may not a summer make, but one dragonfly does.

The pond at Constant Friendship, the eye of the land, is one of hundreds that dot the Colorado mountains, little irregular blots of blue sprinkled on the topographical maps with a sparing hand. Compared to the lake-strewn, water-rich Midwest and East, the number of ponds in Colorado is meager. And the chance to know one well, observe it in all seasons, is more rare than common. Much of what I know about Colorado goes on in this pond—the pavane of the seasons, the signal flags of change, the visitors, the residents, the users, the watchers.

This morning, mallards feed on the pond, sometimes upending in unison, like those toys hung on the edge of a glass that dip as if drinking. When the mallards tail-up, their orange legs paddle, pushing backwards, apparently because their center of gravity is askew. In the shallows, they rotate until their legs are exposed, and look as if they are standing on their heads. In deeper water, with nothing solid beneath them, they push-paddle vigorously.

After the mallards retire to a willow thicket, I walk the shore of the pond with some puzzlement, looking for water striders and finding none. Surely they should be out by now. I find them in a quiet cove, spotting not so much the striders themselves as the cabochon shadows of the surface-film dimples their feet make, little ovals of light, flickering across the bottom silt.

FRONT RANGE

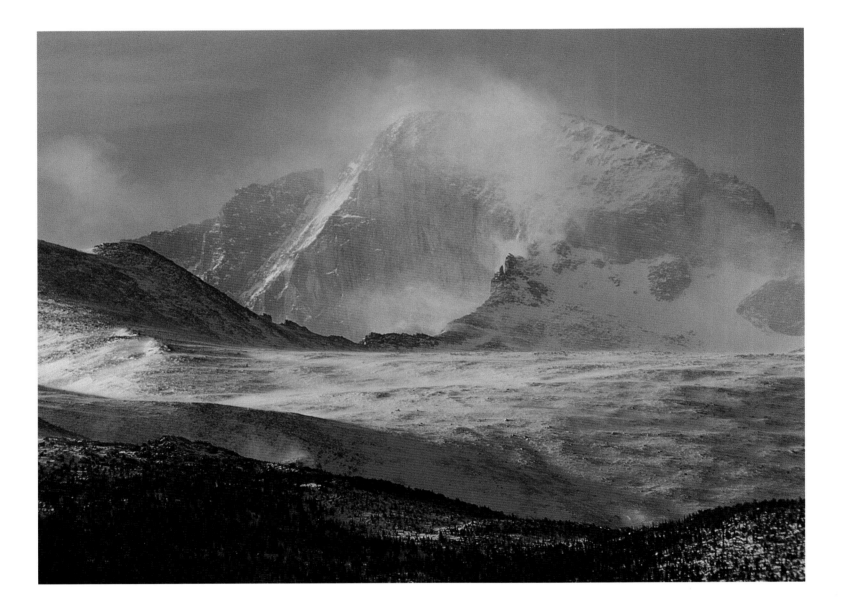

Monolith of Longs Peak in Rocky Mountain National Park. *November*

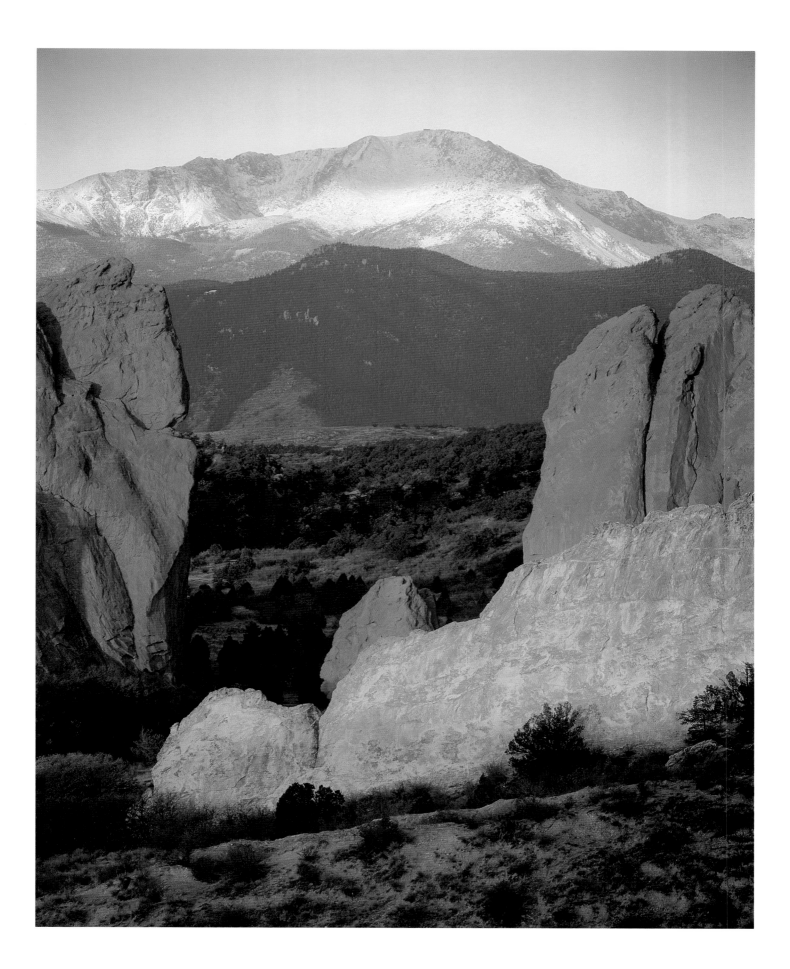

Rock of Pikes Peak and Garden of the Gods. *November*

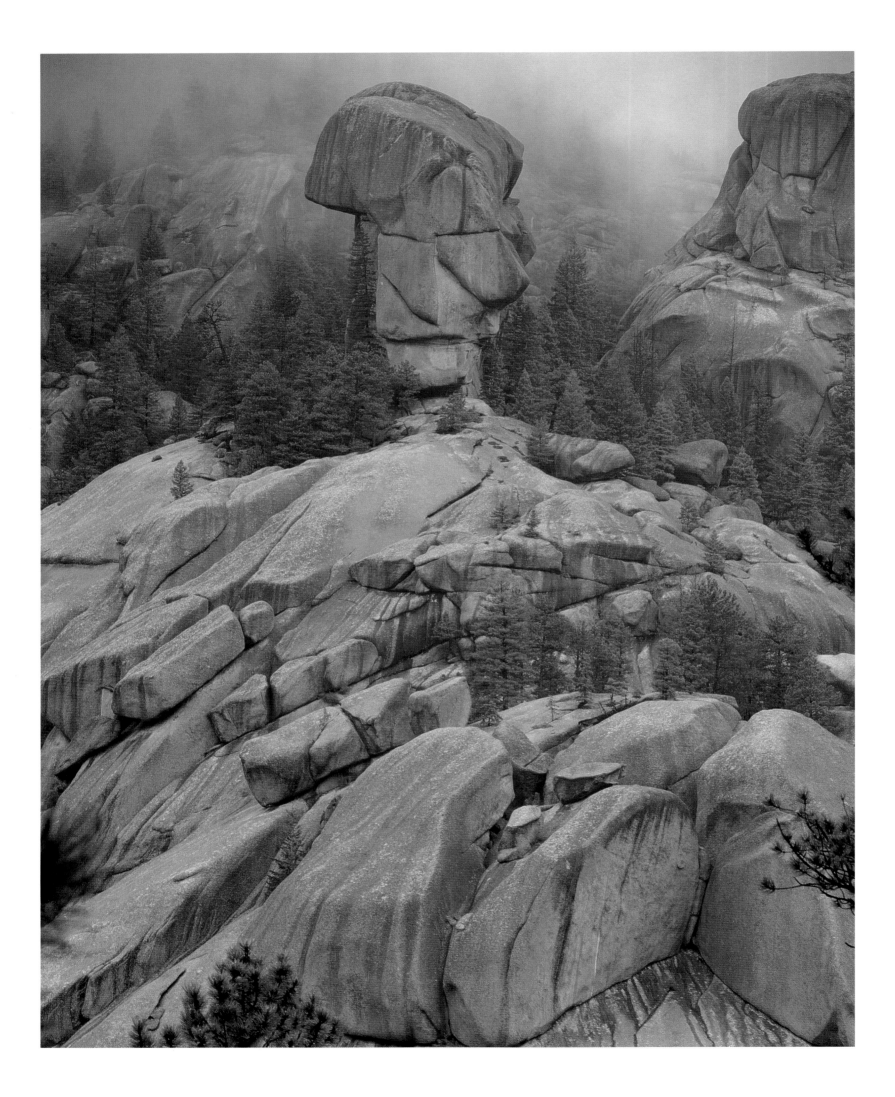

Ponderosa and spruce with eroded granites. Lost Creek Wilderness. *June*

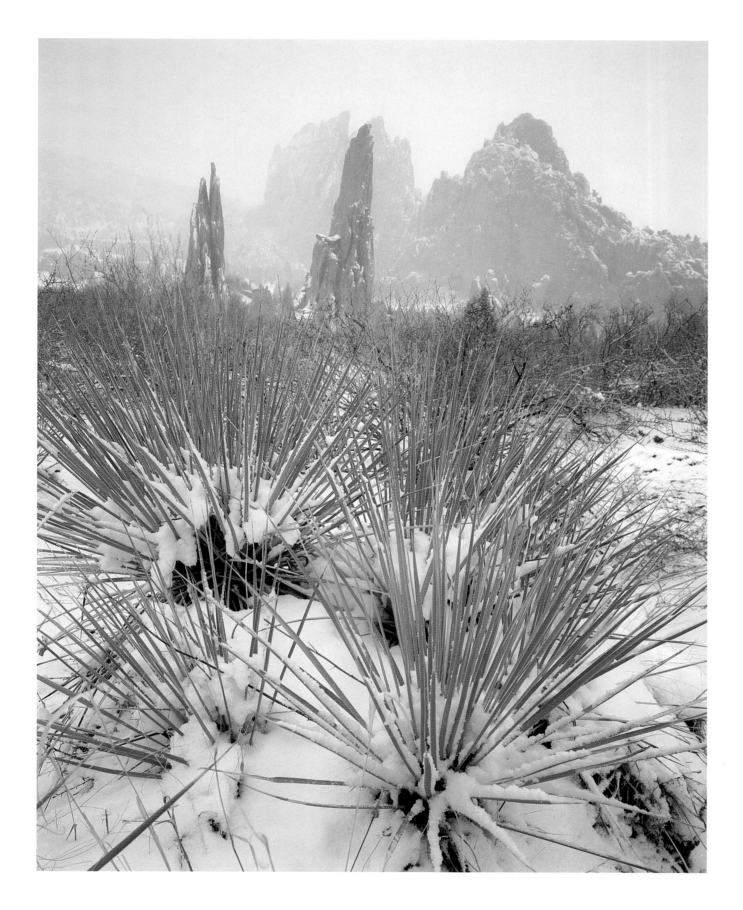

Yucca and rock in Garden of the Gods. *April*

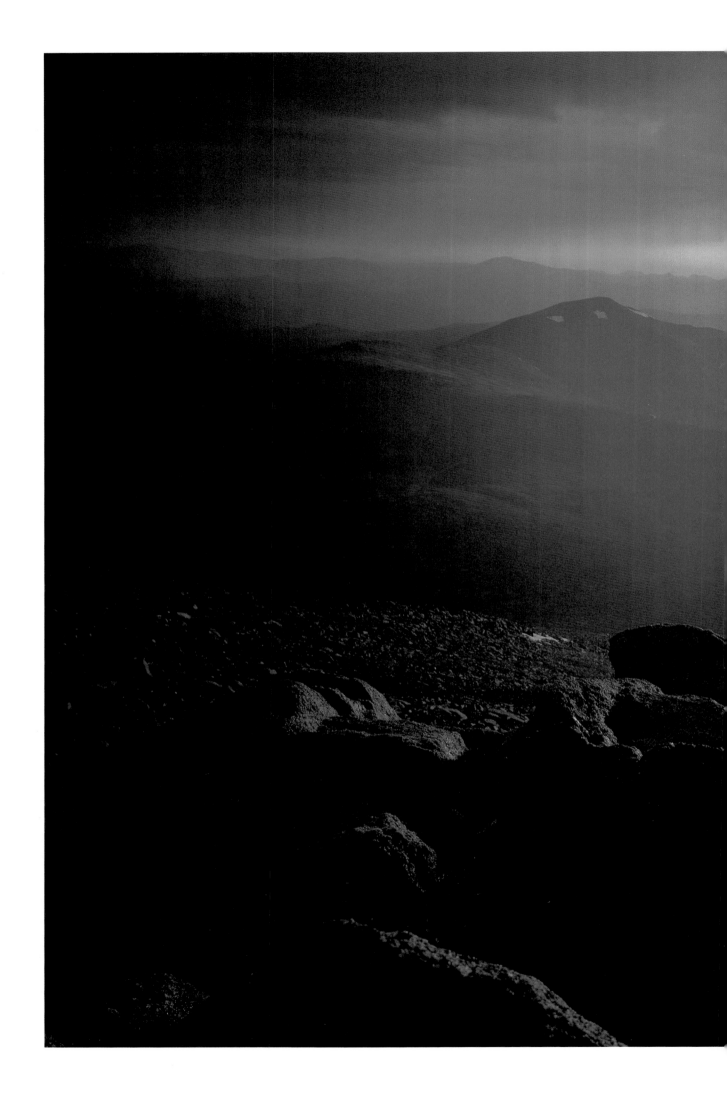

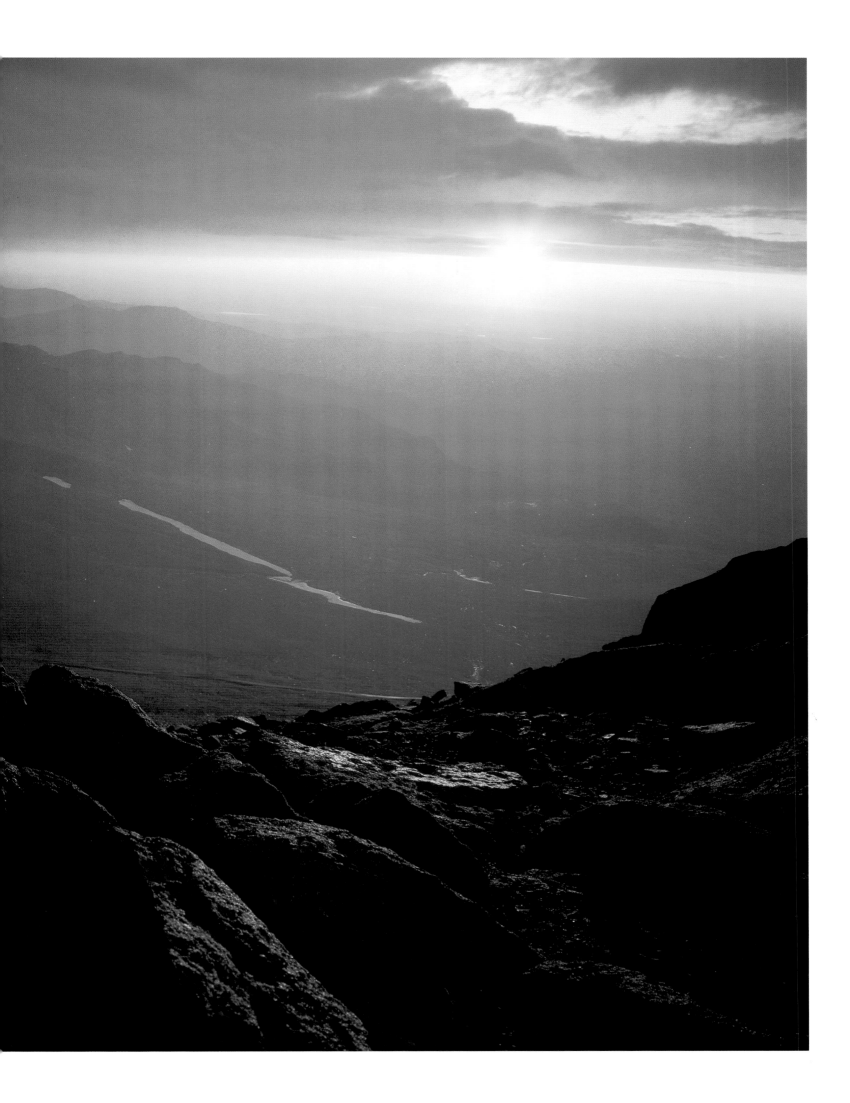

View east atop Mount Evans. Mount Evans Wilderness. *August*

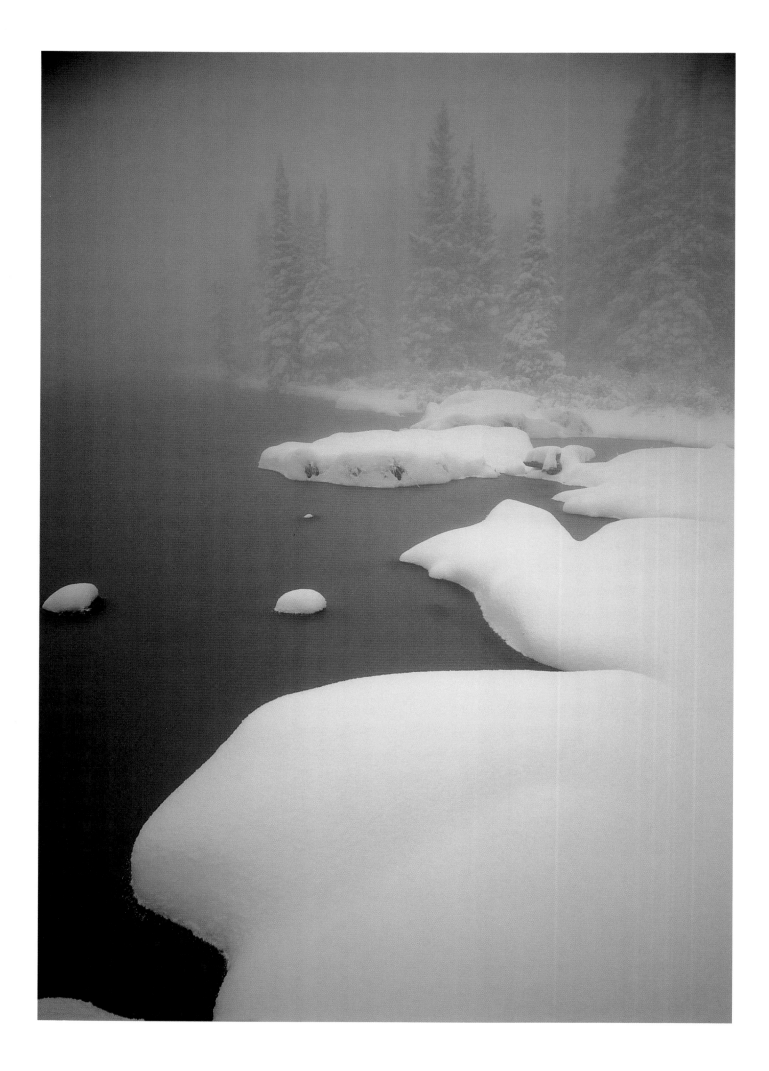

Snow pillows at edge of Long Lake. Indian Peaks Wilderness. *November*

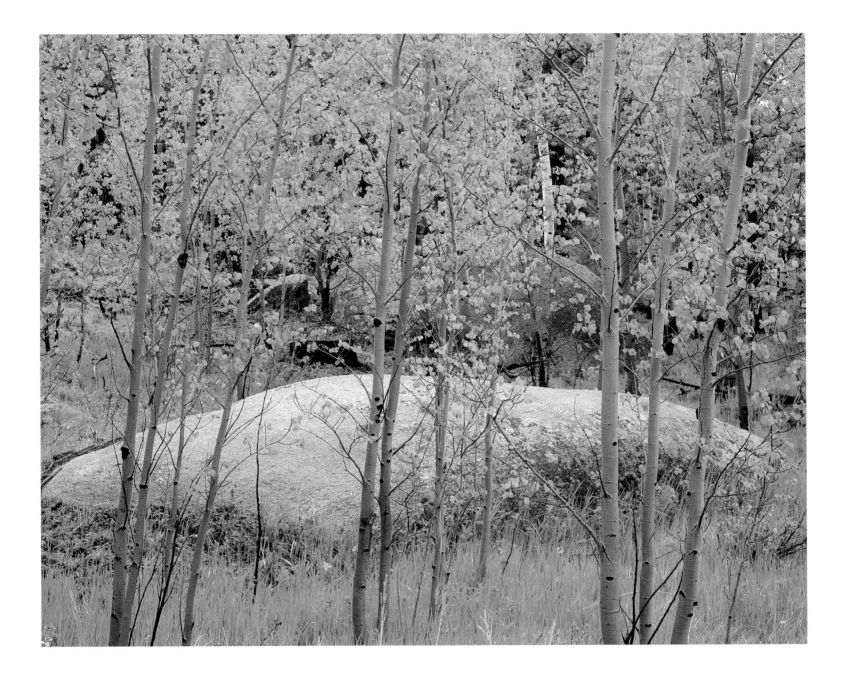

Aspen with granites. Lost Creek Wilderness. *May*

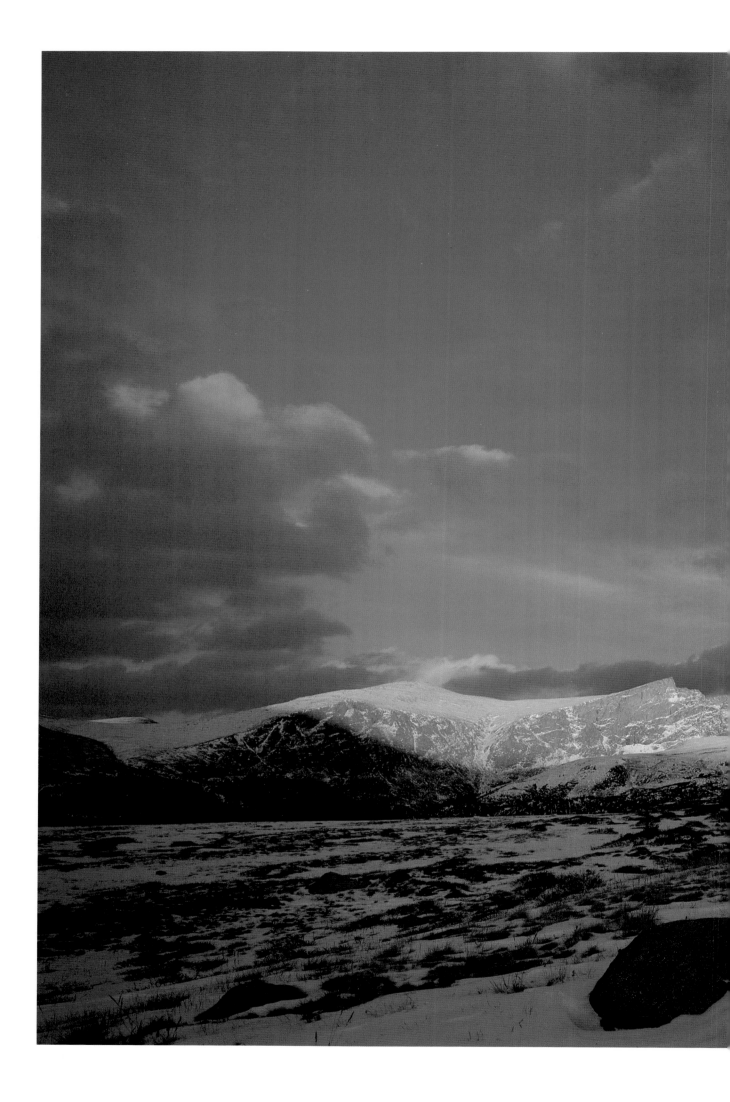

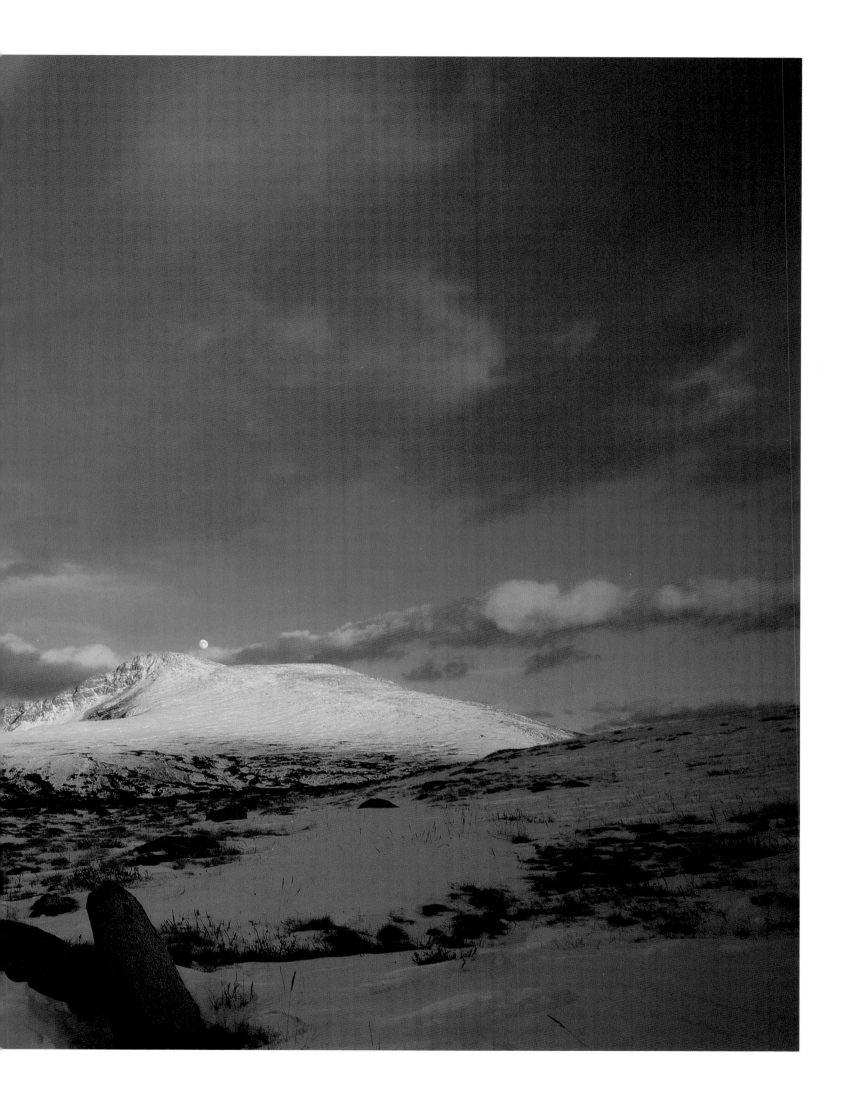

Evening moonrise and Mount Bierstadt. Mount Evans Wilderness. *November*

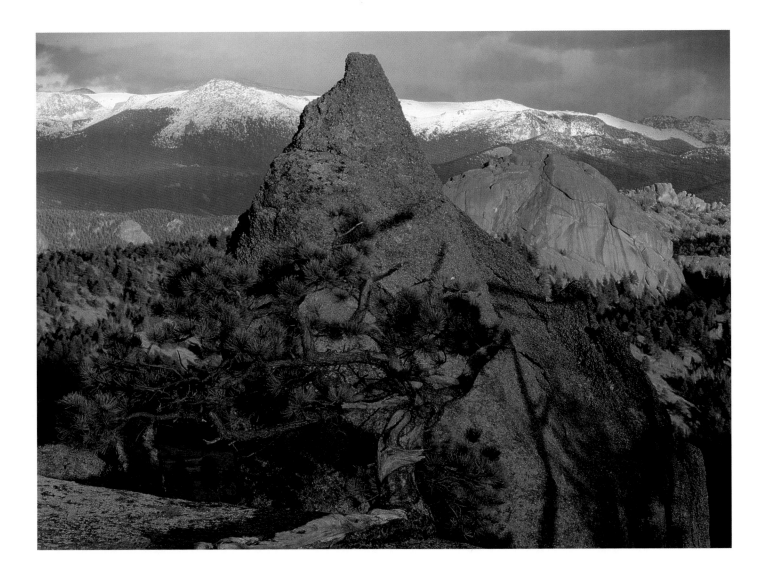

Domes of granite before Pikes Peak west side. *November*

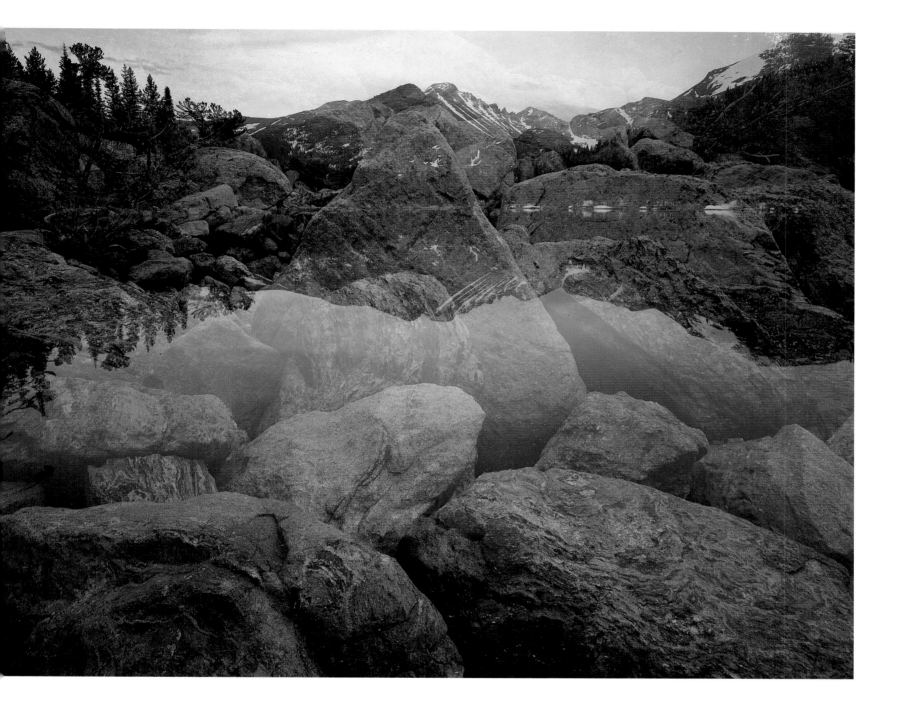

Granite reflections of Bear Lake and Longs Peak. Rocky Mountain National Park. *June*

SAWATCH RANGE

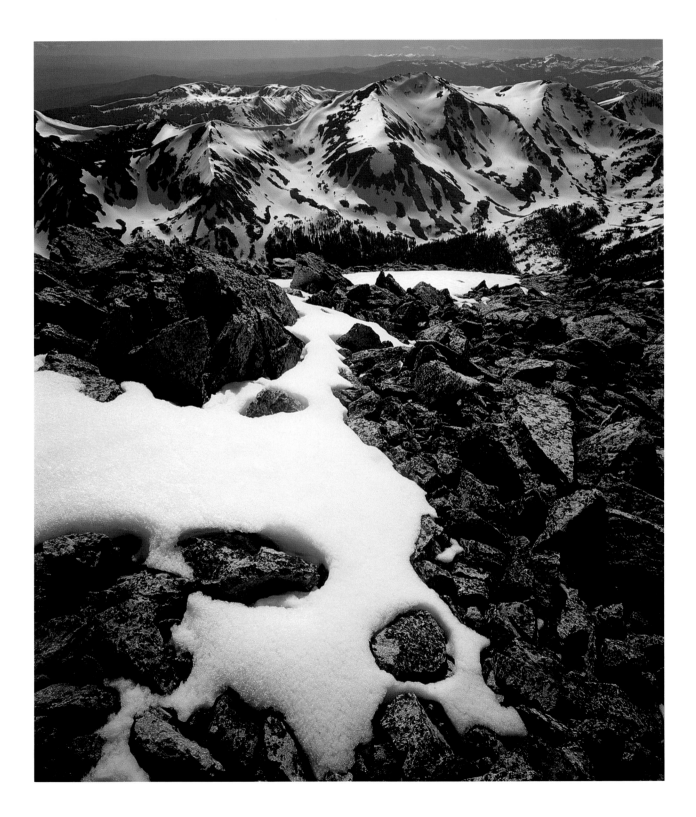

Remnant patch of spring snow on ridges of the Sawatch Range. Mount Aetna top. *June*

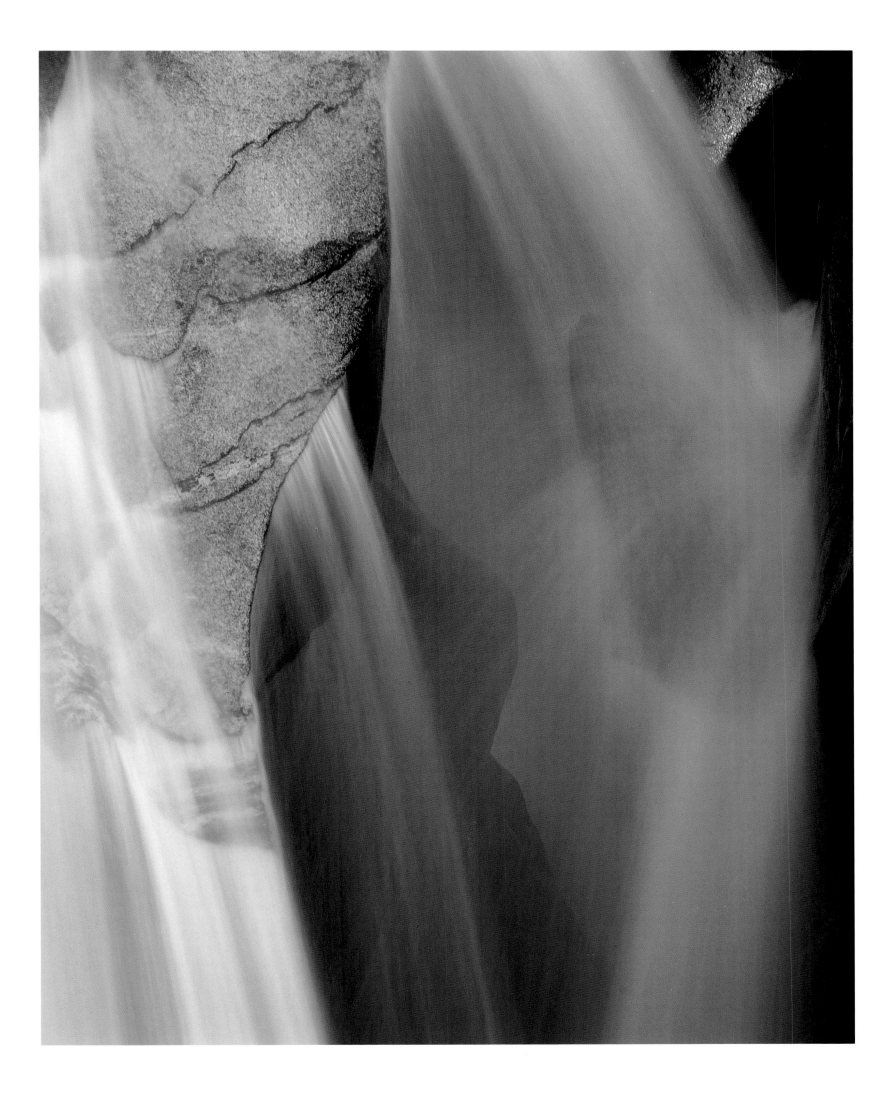

Granite walls and cascade. Upper Roaring Fork, Collegiate Peaks Wilderness. *August*

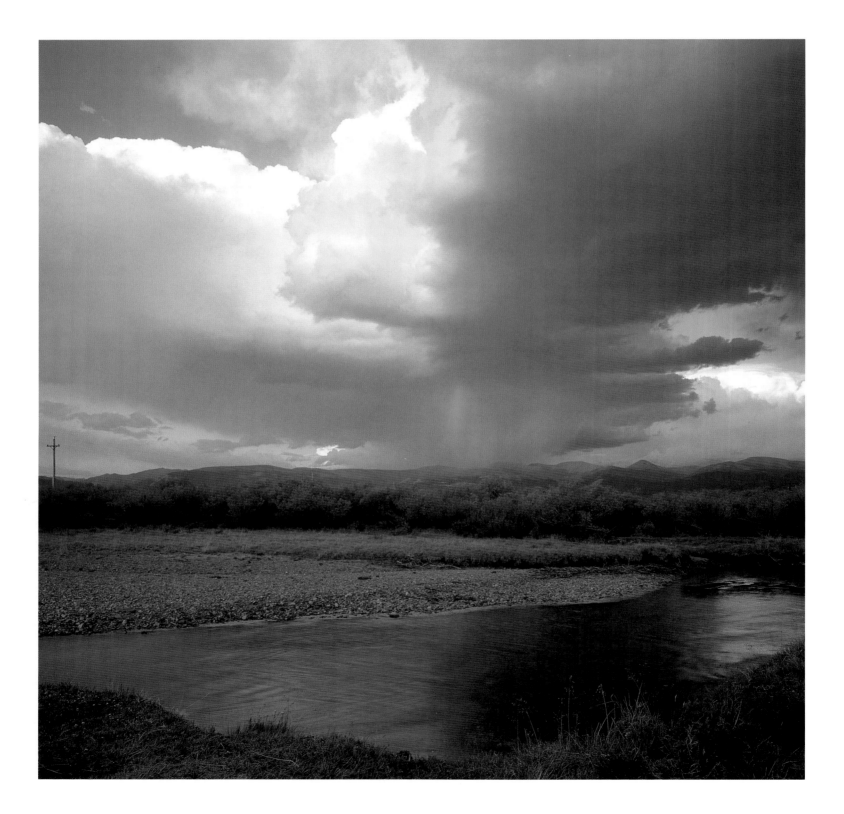

Evening above Arkansas River. *September*

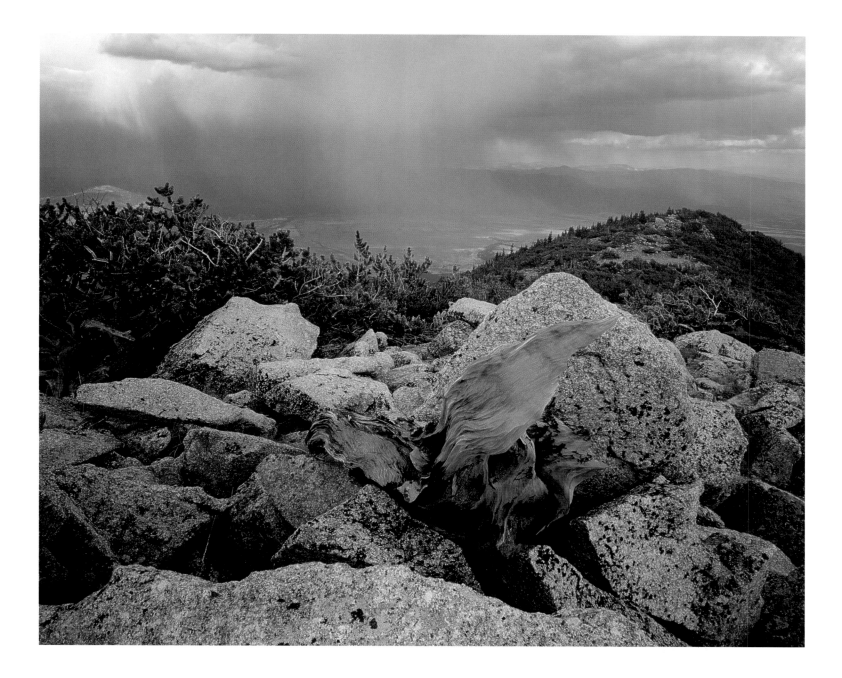

Passing storm in ancient bristlecone pine forest at timberline. *August*

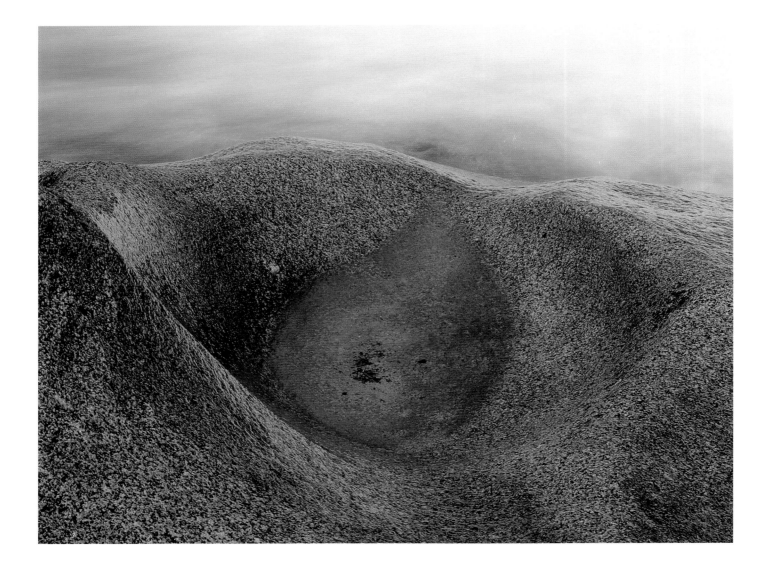

Water pocket at edge of Roaring Fork River. Collegiate Peaks Wilderness. *July*

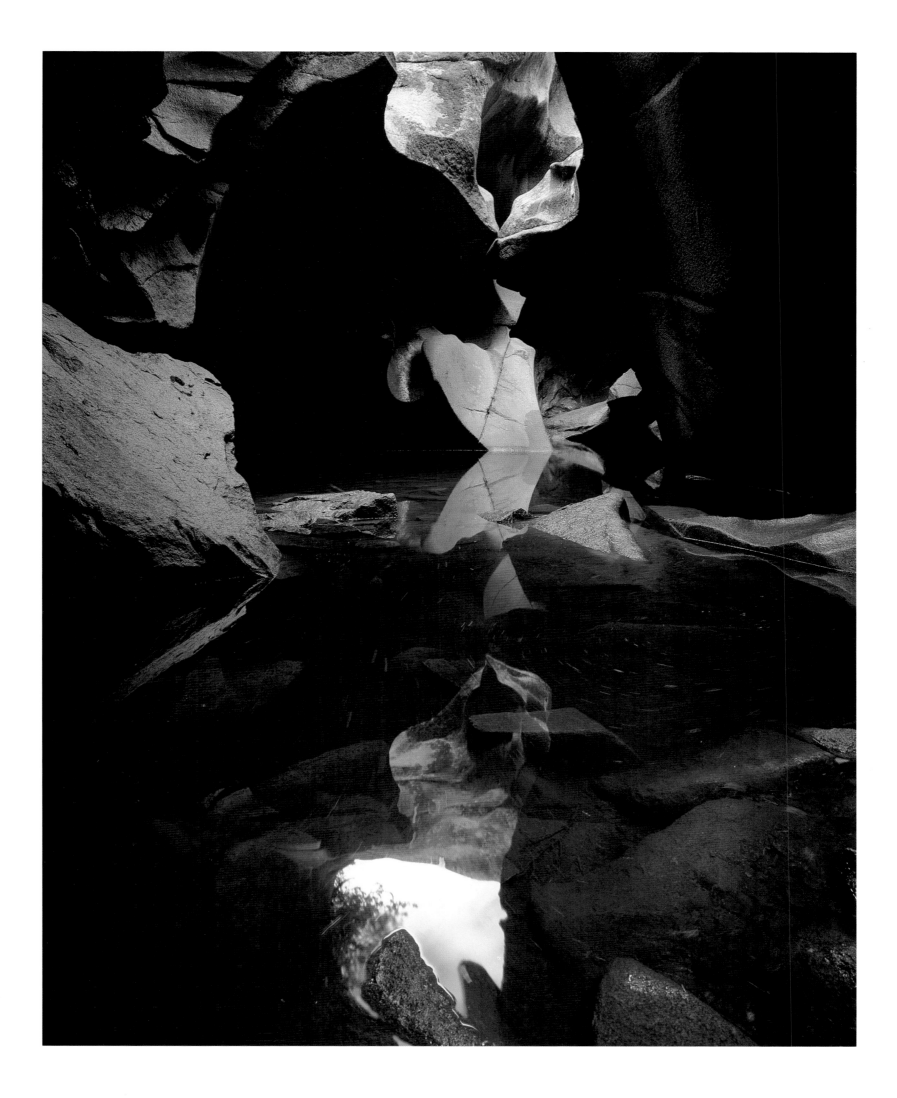

Shaded walls of old Roaring Fork streambed. The Grottos near Aspen. *July*

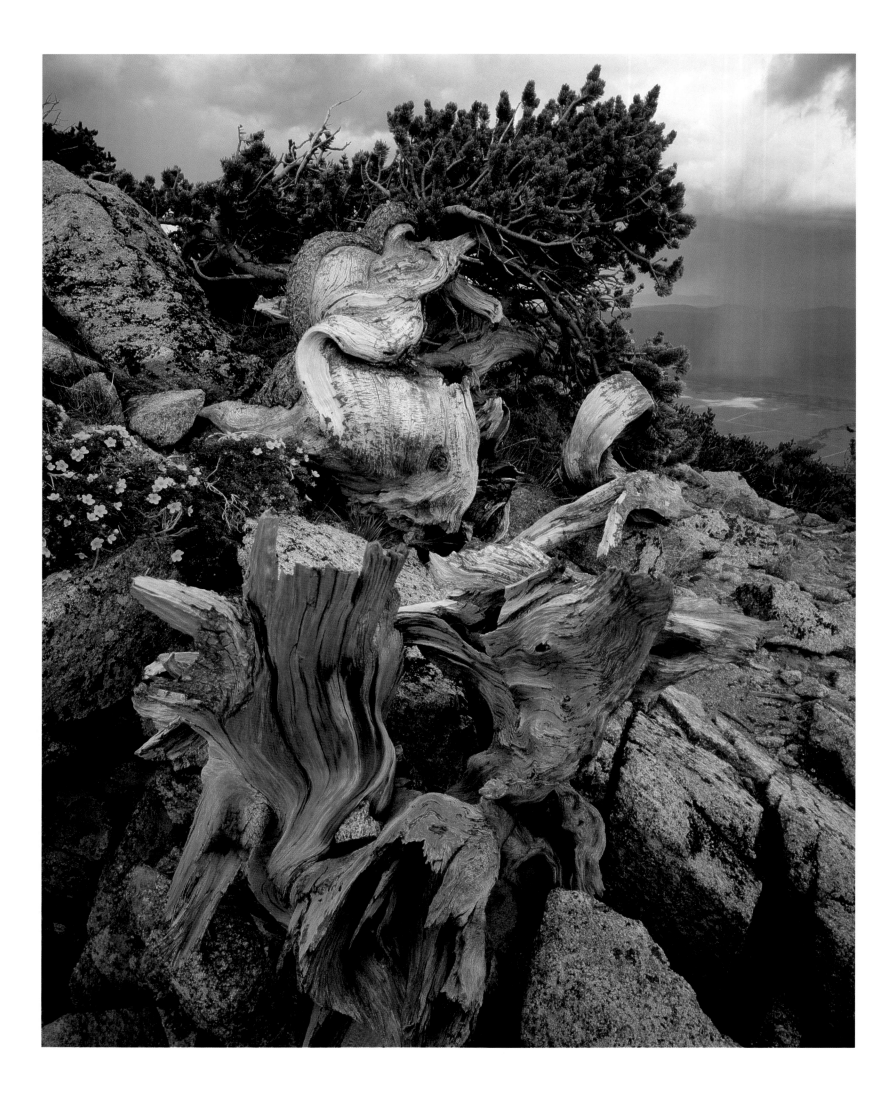

Wind and ice-eroded bristlecone pine. *August*

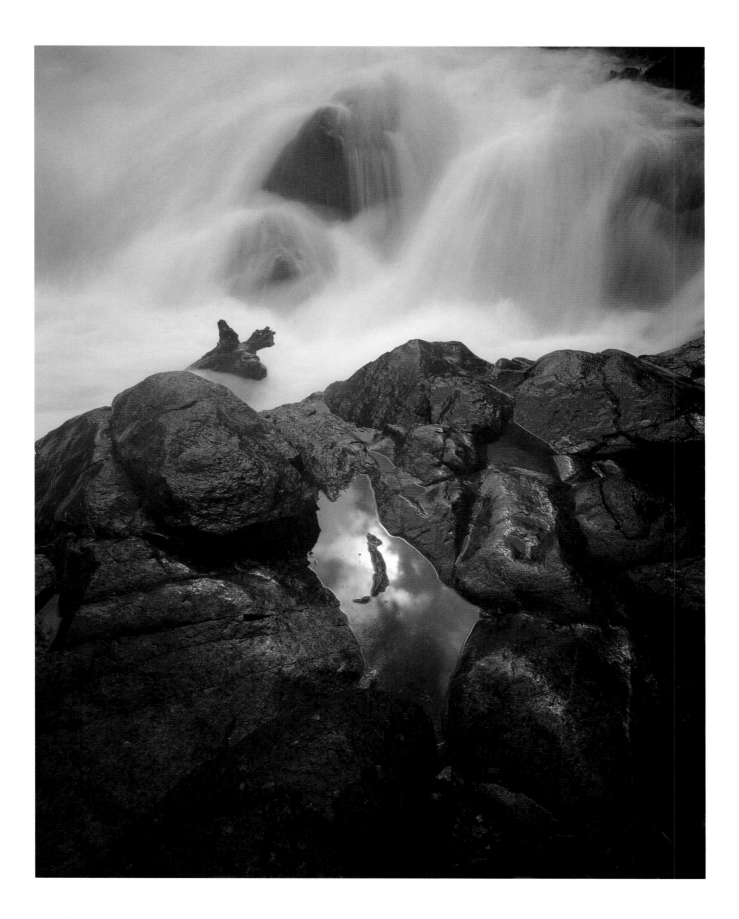

Flow of Lake Creek and tranquil rain pool. *May*

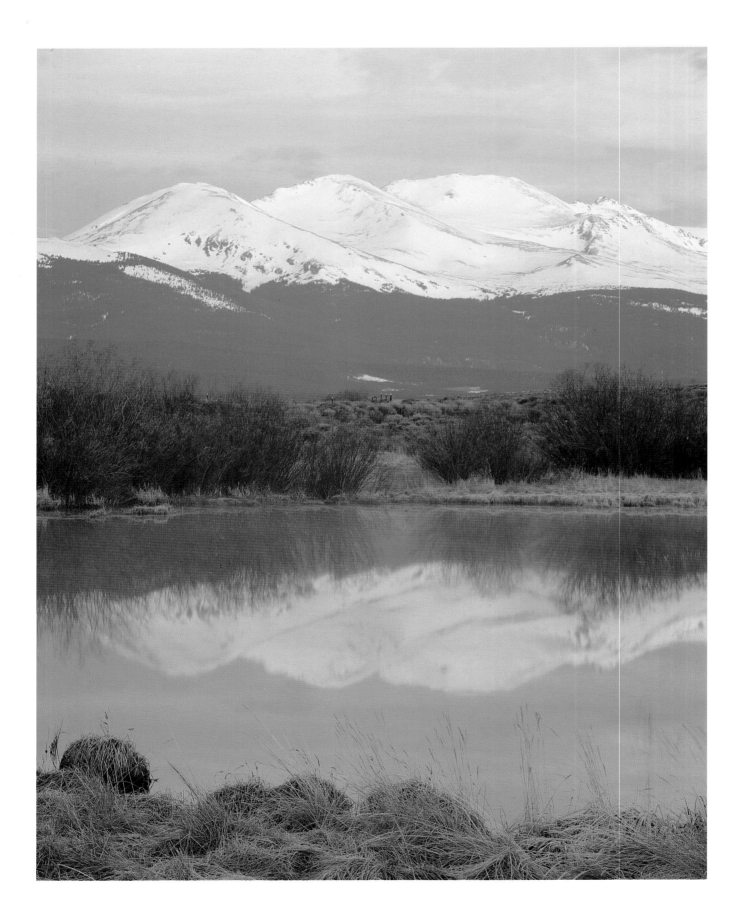

Morning pool and Mount Massive. Mount Massive Wilderness. *May*

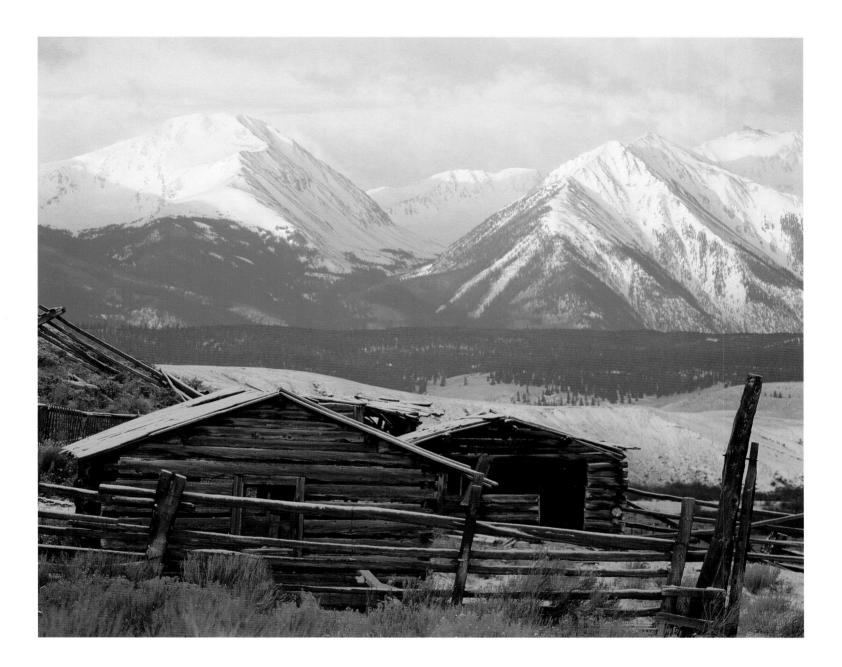

Mount Hope and Twin Peaks with dwarfed corral buildings. *April*

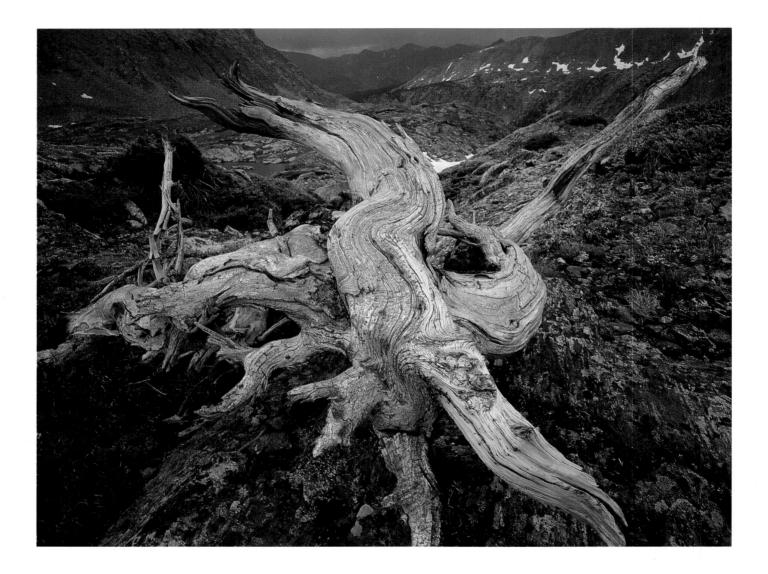

Ghostlike contortions of alpine fir. Seven Lakes, Holy Cross Wilderness. *August*

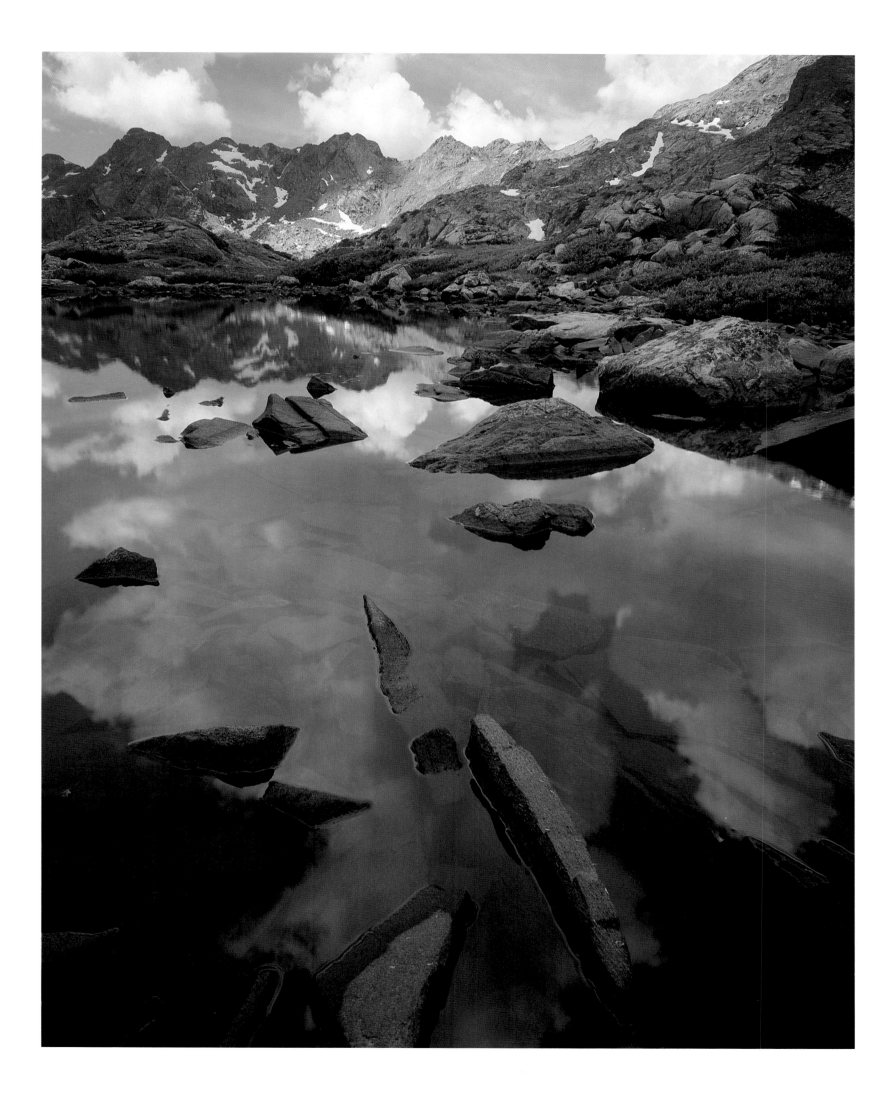

Alpine tarn reflections. Seven Lakes, Holy Cross Wilderness. *August*

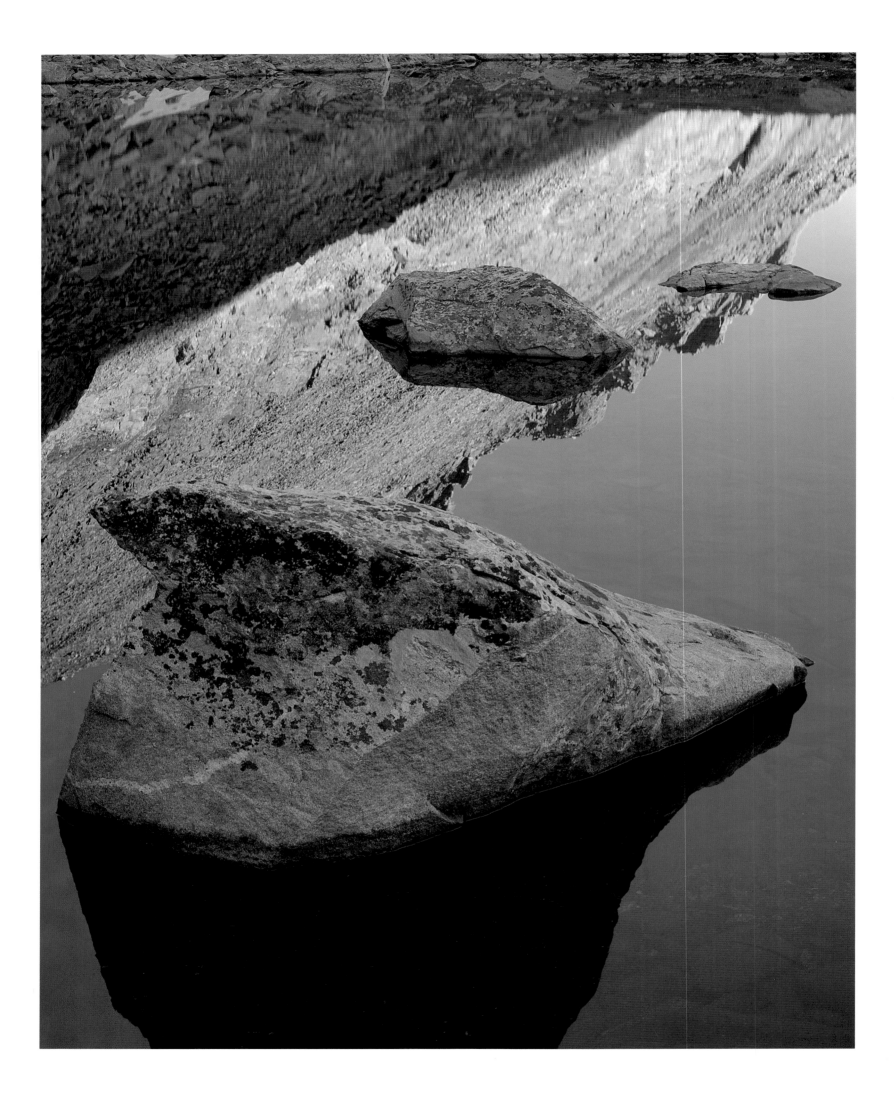

Granite and water in alpine tarn. Holy Cross Wilderness. *August*

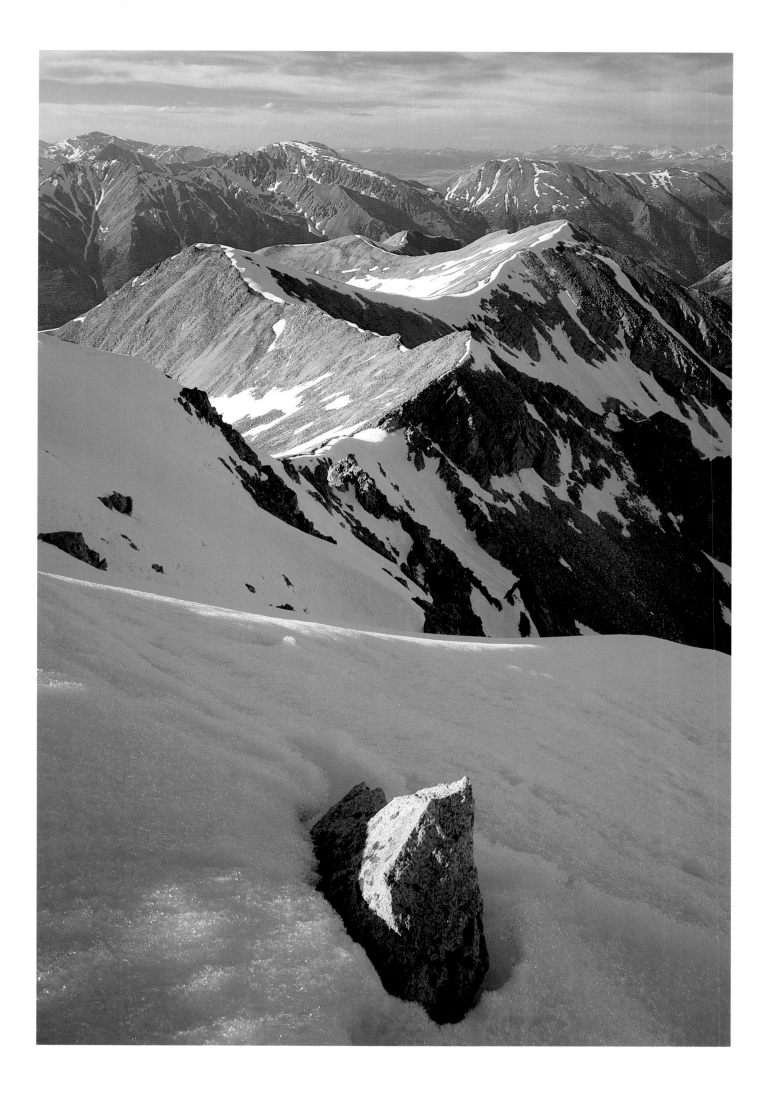

Curving ridges in view from Huron Peak. Collegiate Peaks Wilderness. *June*

MOSQUITO RANGE

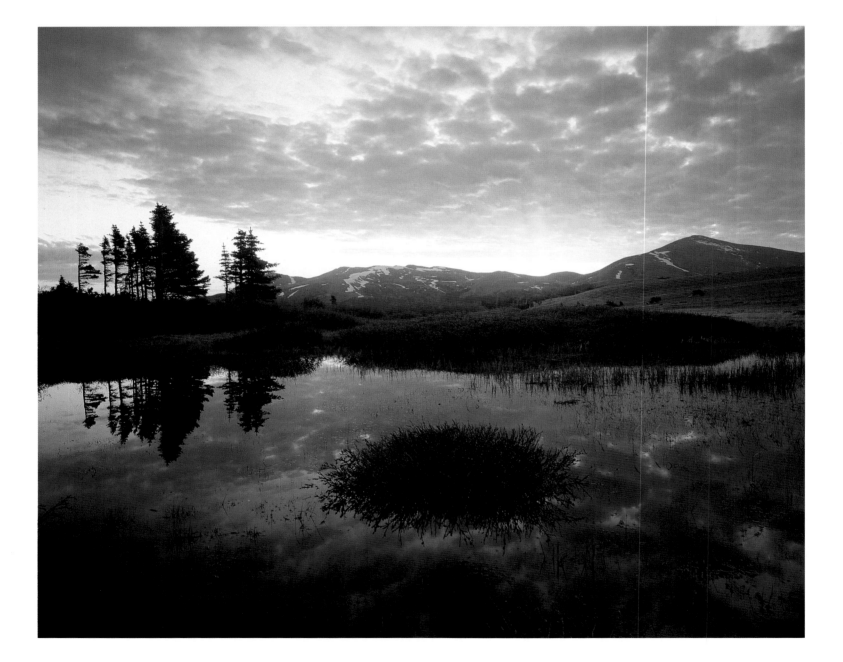

Pool on slopes of Mount Democrat. Mosquito Range. *June*

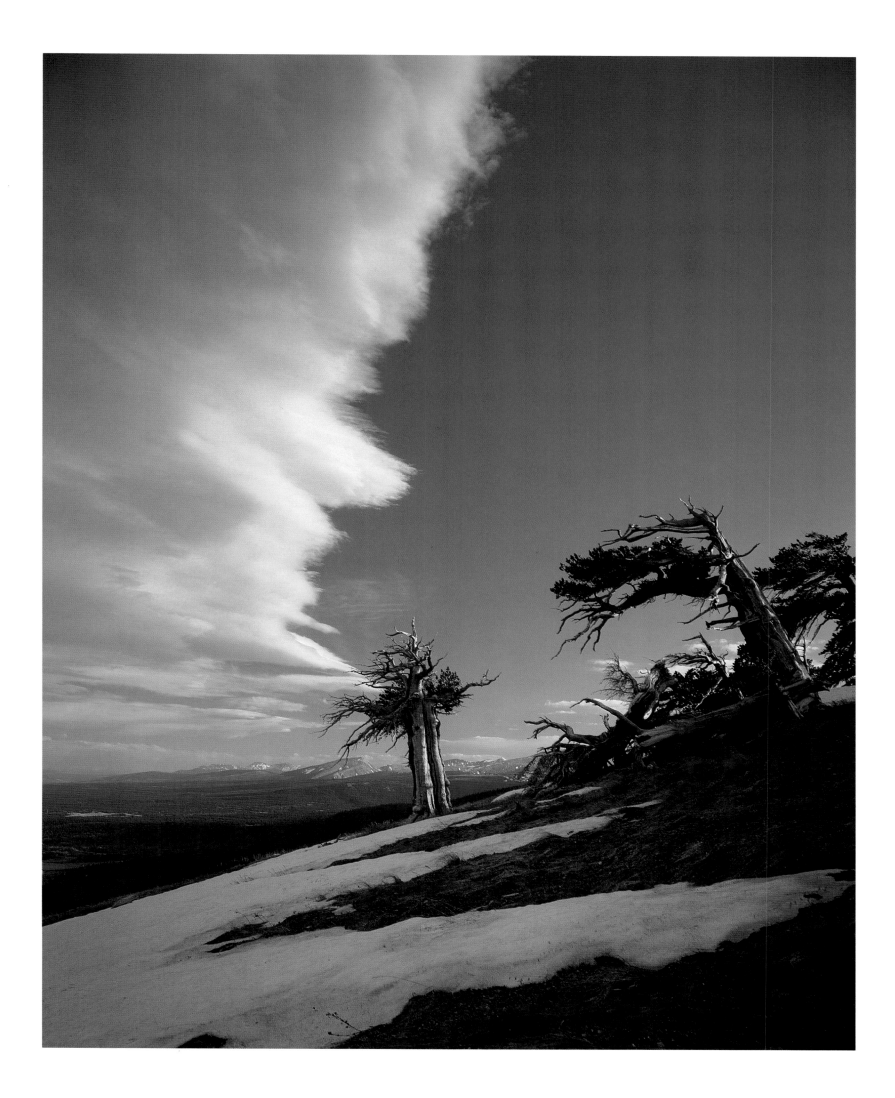

Ancient bristlecone pines and lenticular cloud. Mosquito Range. *May*

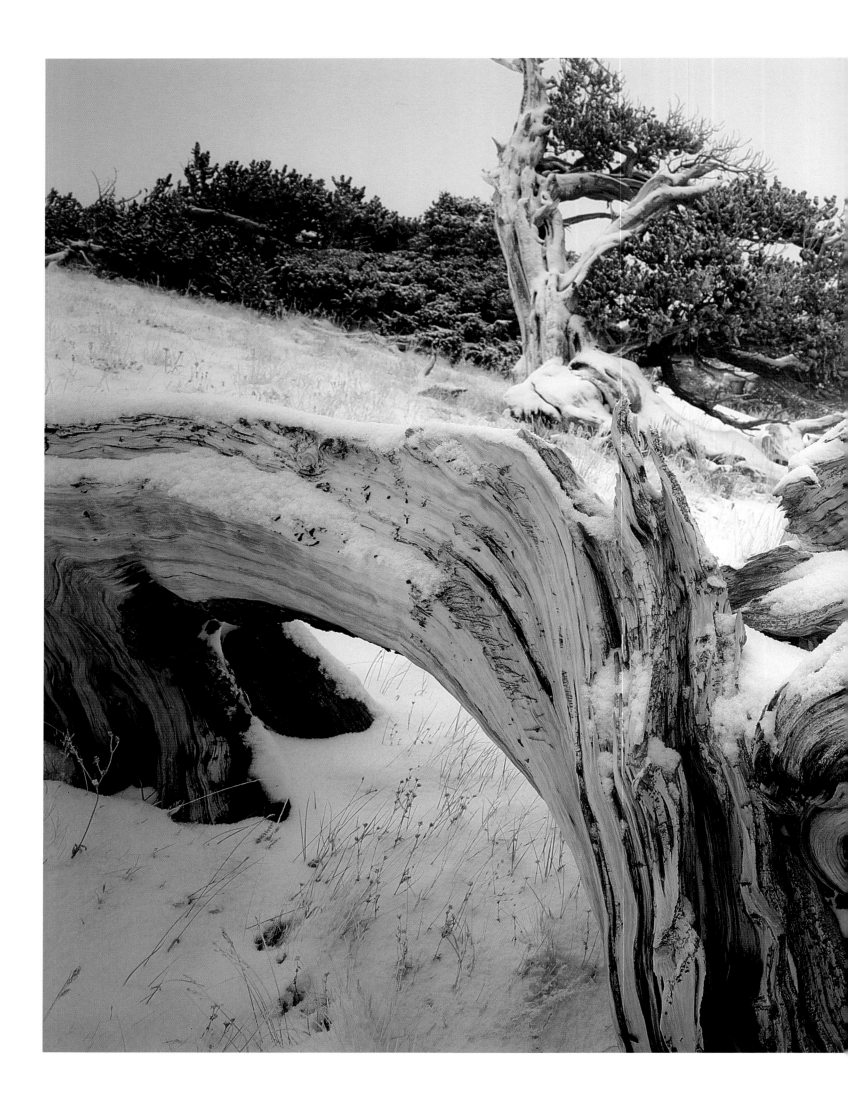

Light snow on bristlecone pines. Mosquito Range. *November*

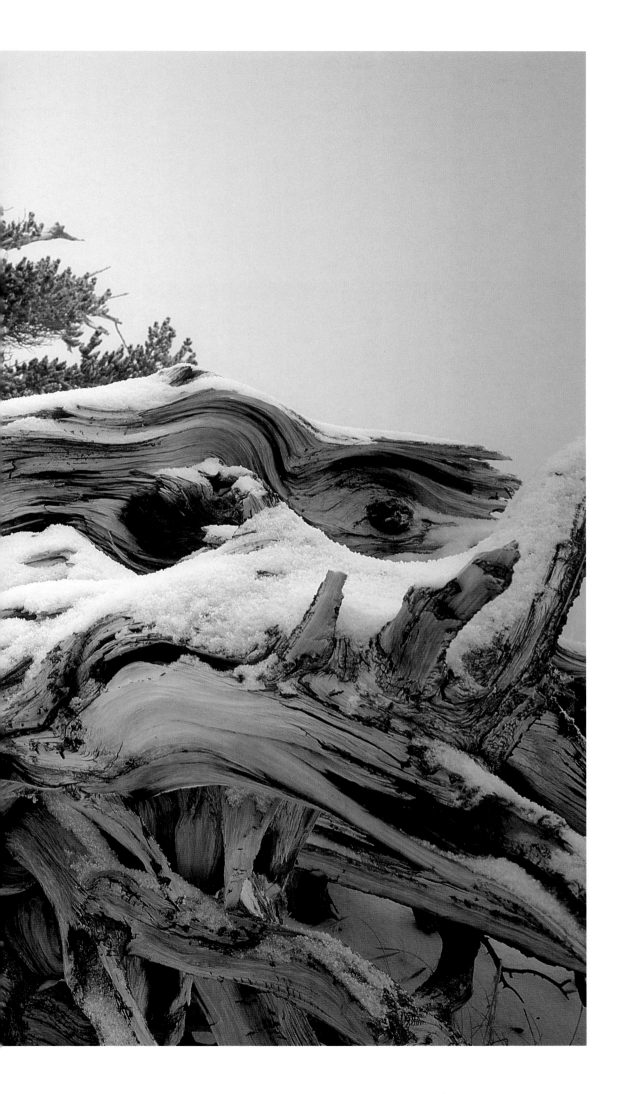

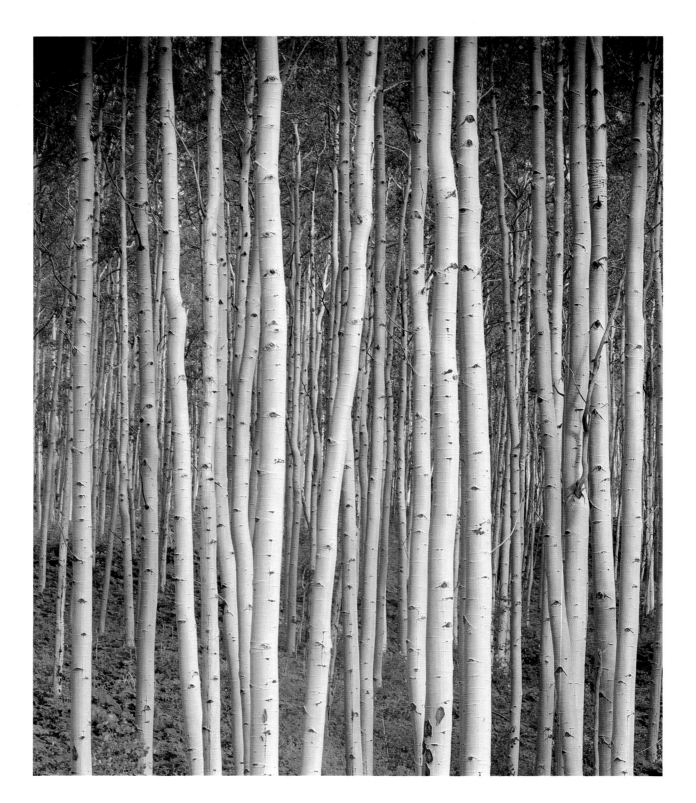

Young trunks in dense aspen grove. Upper Elk River, Mount Zirkel Wilderness. *June*

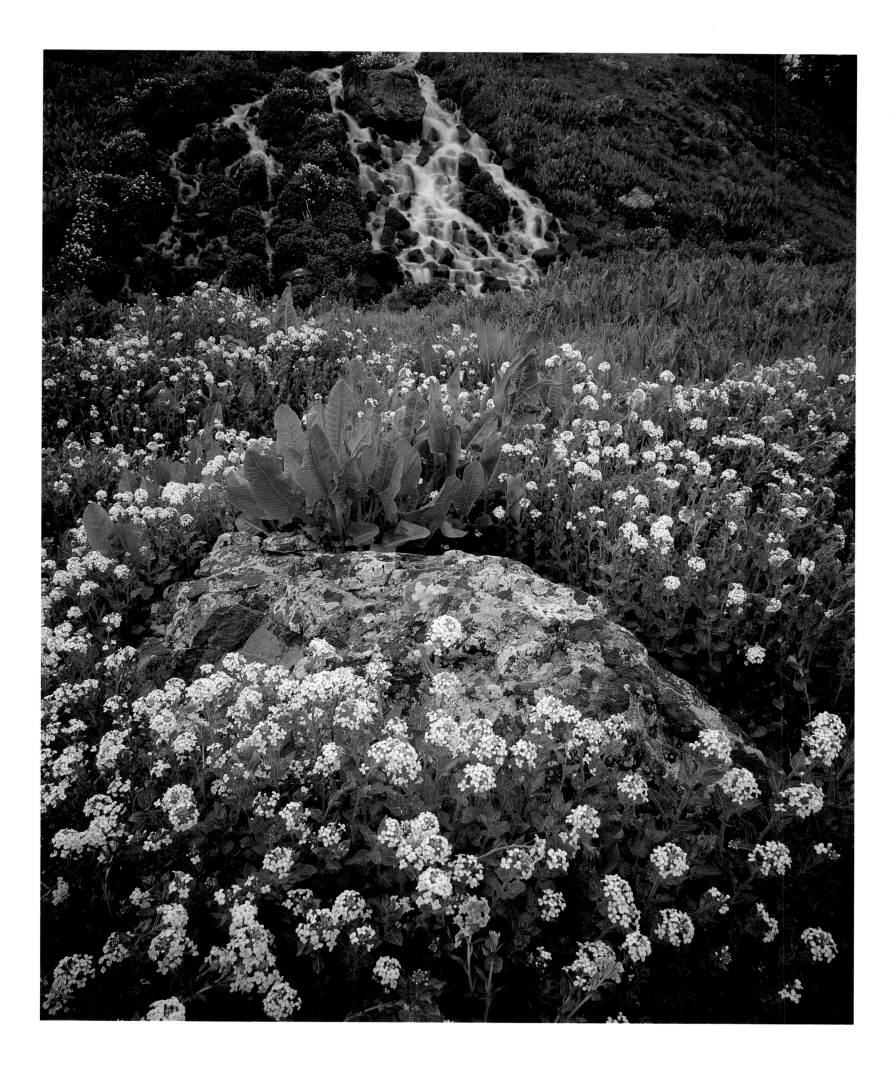

White mountain cress, rock, and cascade. Bear River Flattops. *June*

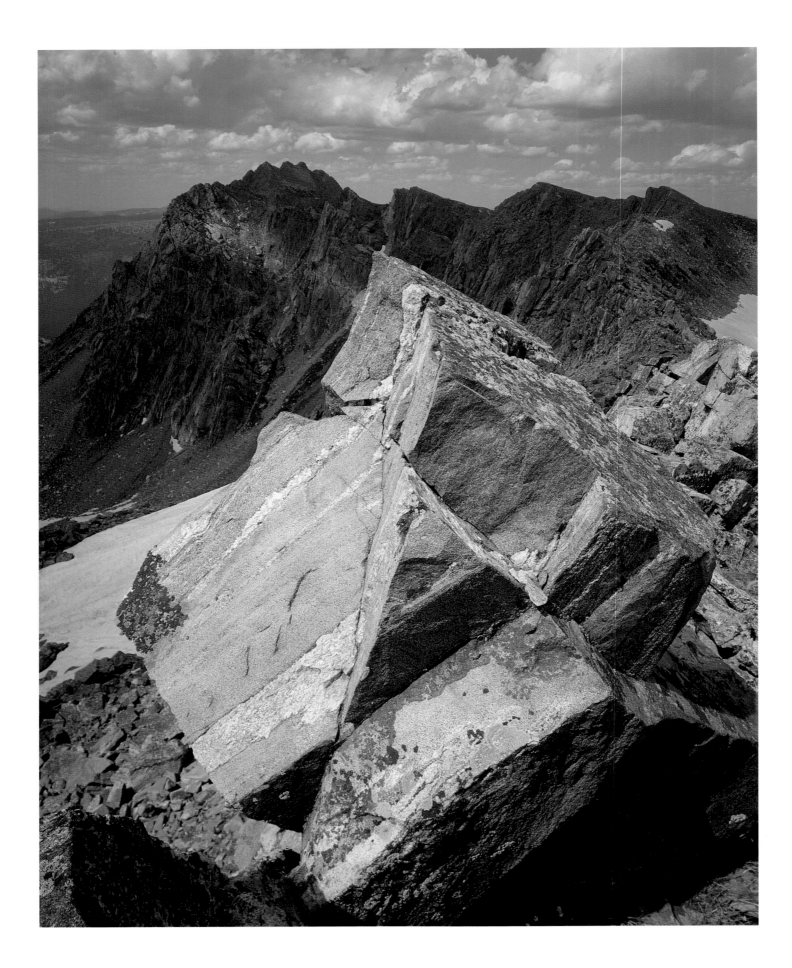

Time-fractured slab of ancient rock. Mount Zirkel Wilderness. *August*

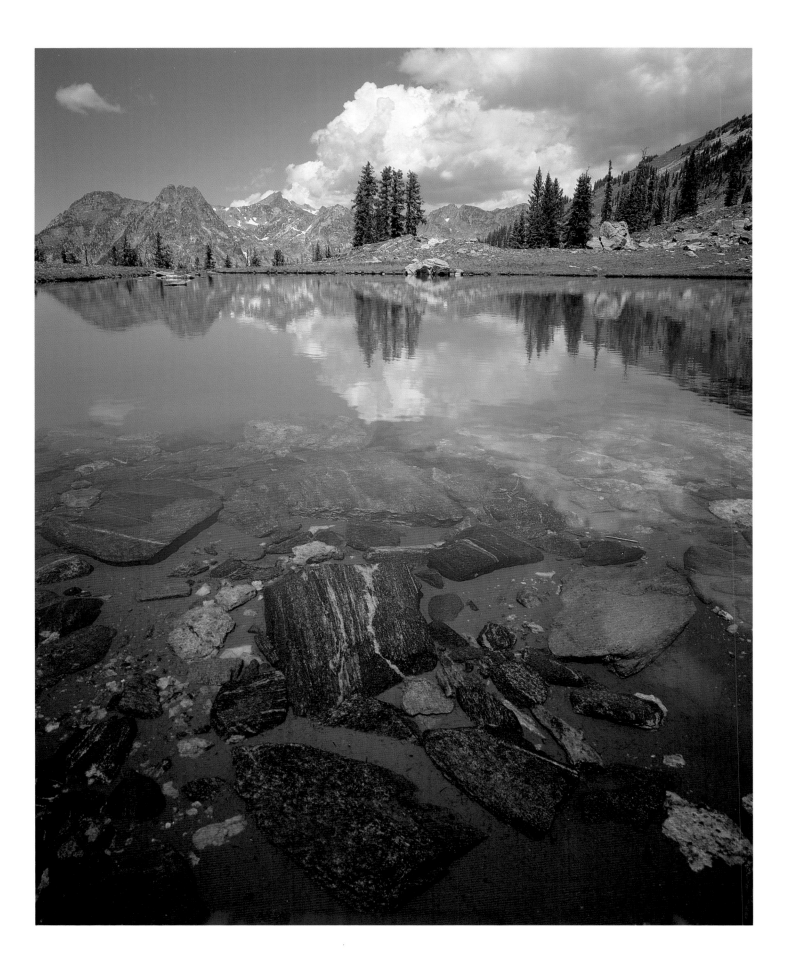

Alpine pool in the Park Range. Mount Zirkel Wilderness. *August*

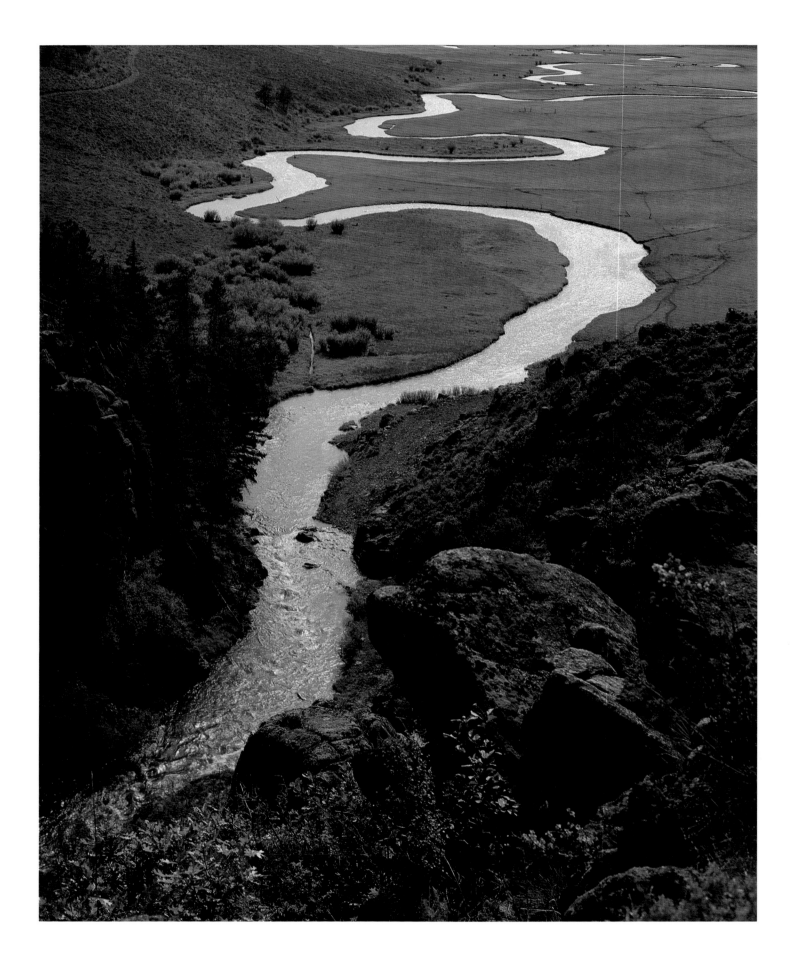

Spring-swollen meanders of Yampa River in the Flattops. *June*

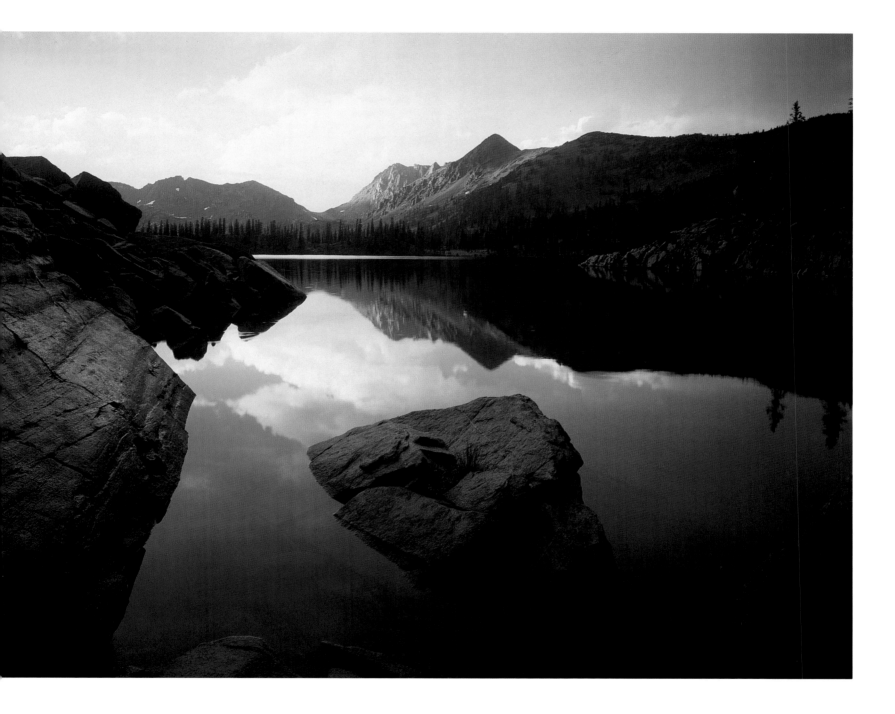

Waterscape left by passing storm. Gilpin Lake and Mount Zirkel. *August*

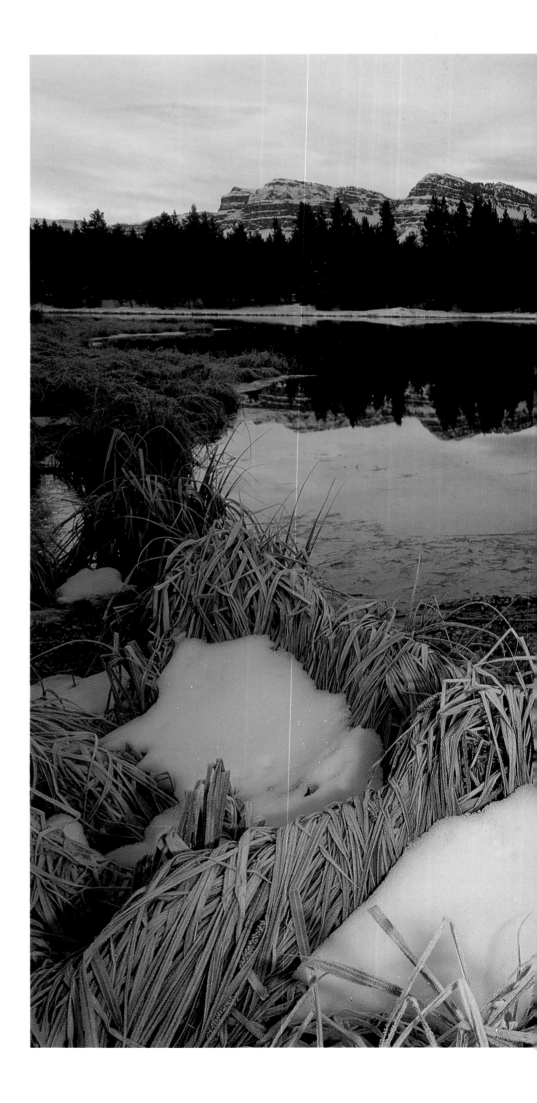

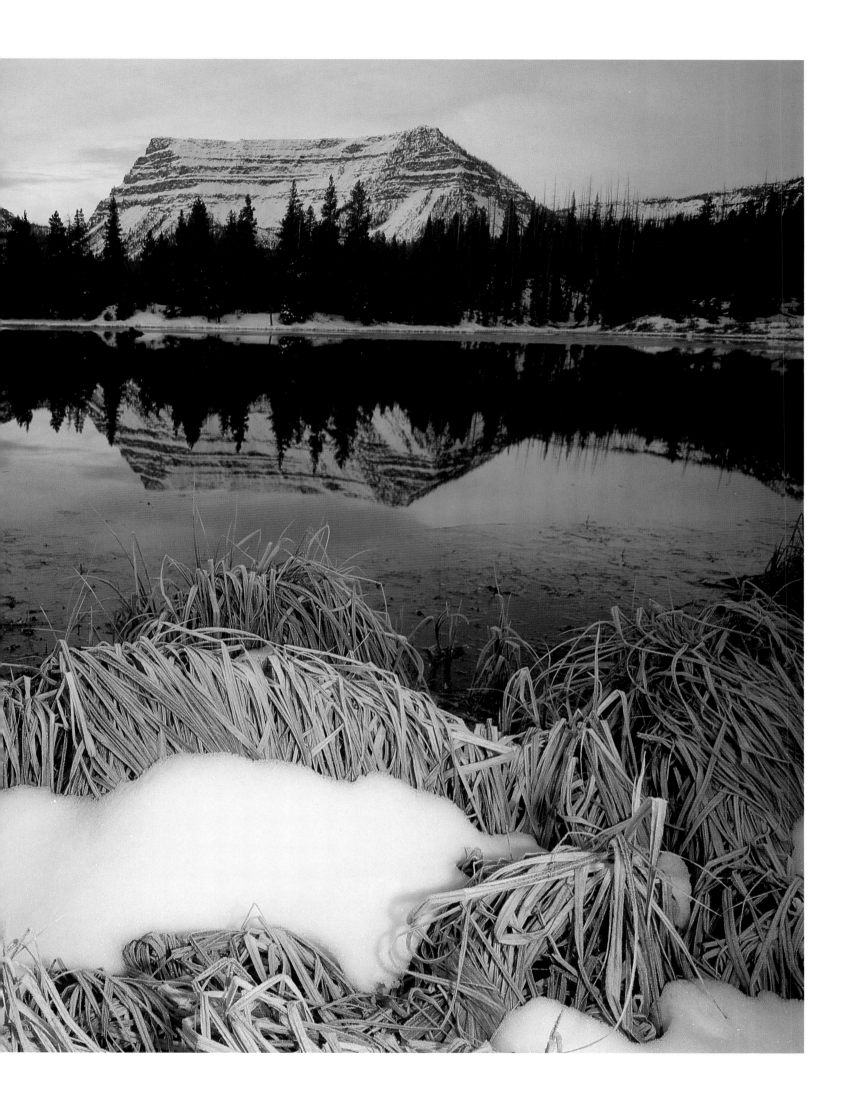

Trappers Lake. Flattops Wilderness. *November*

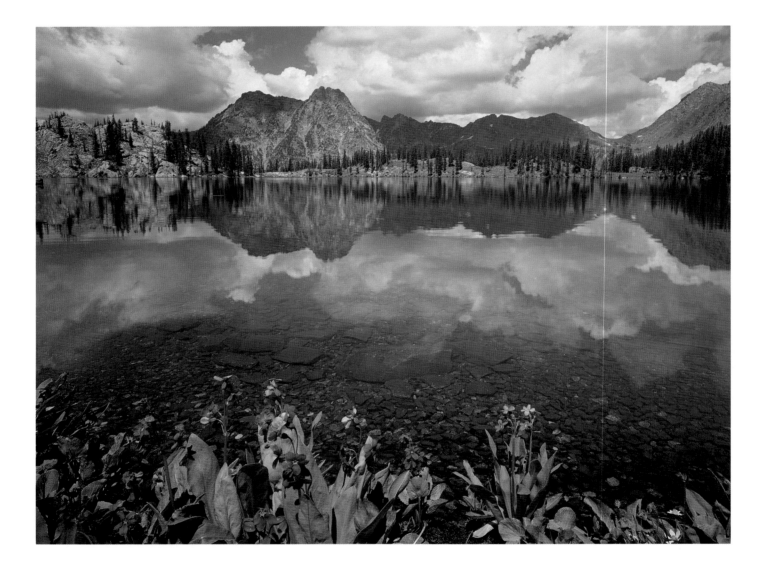

Parry primrose and Gilpin Lake. Mount Zirkel Wilderness. *August*

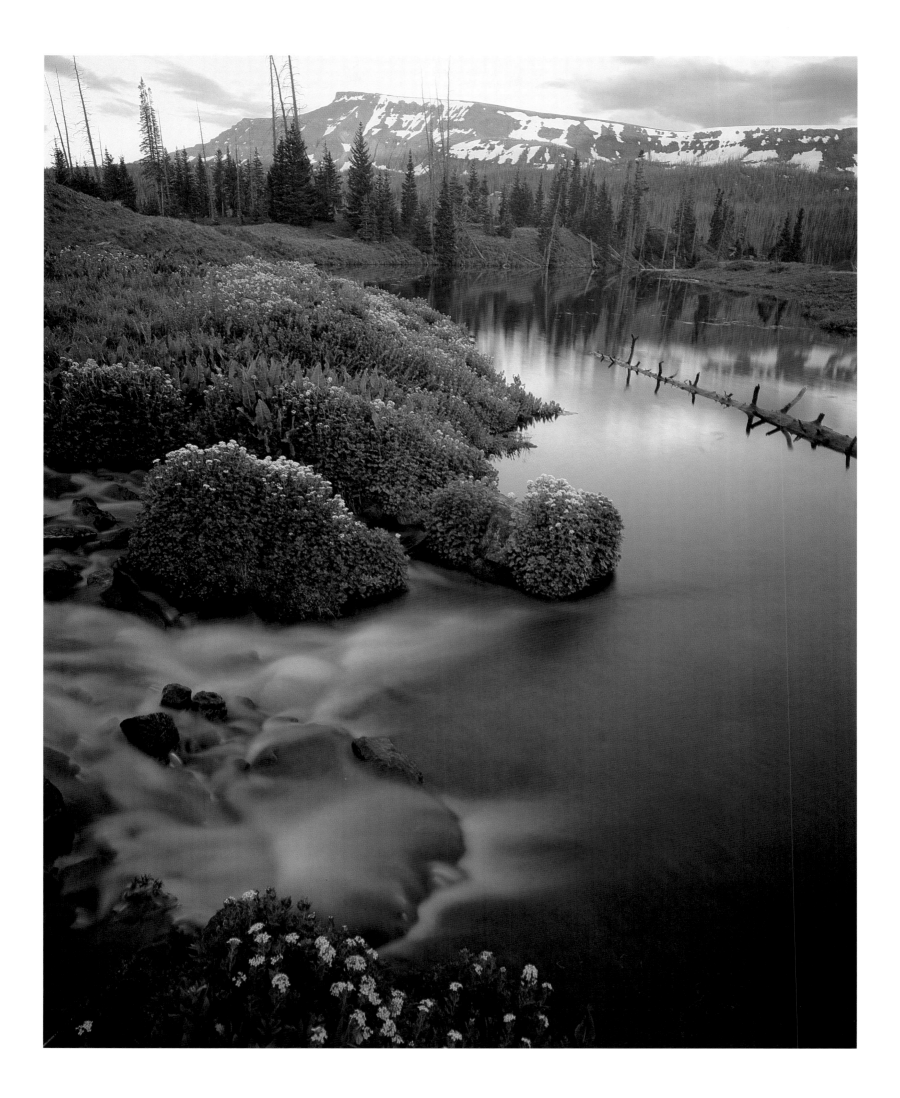

Snowmelt-formed alpine pool beginning Yampa River. Flattops Wilderness. *June*

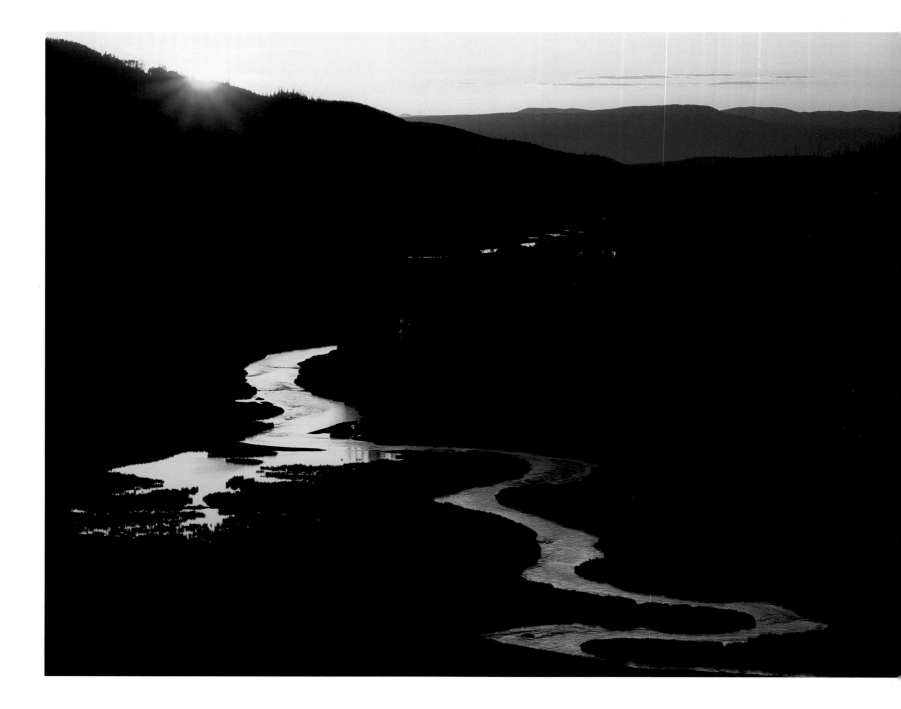

Meanders of spring-swollen Bear River from the Flattops. *June*

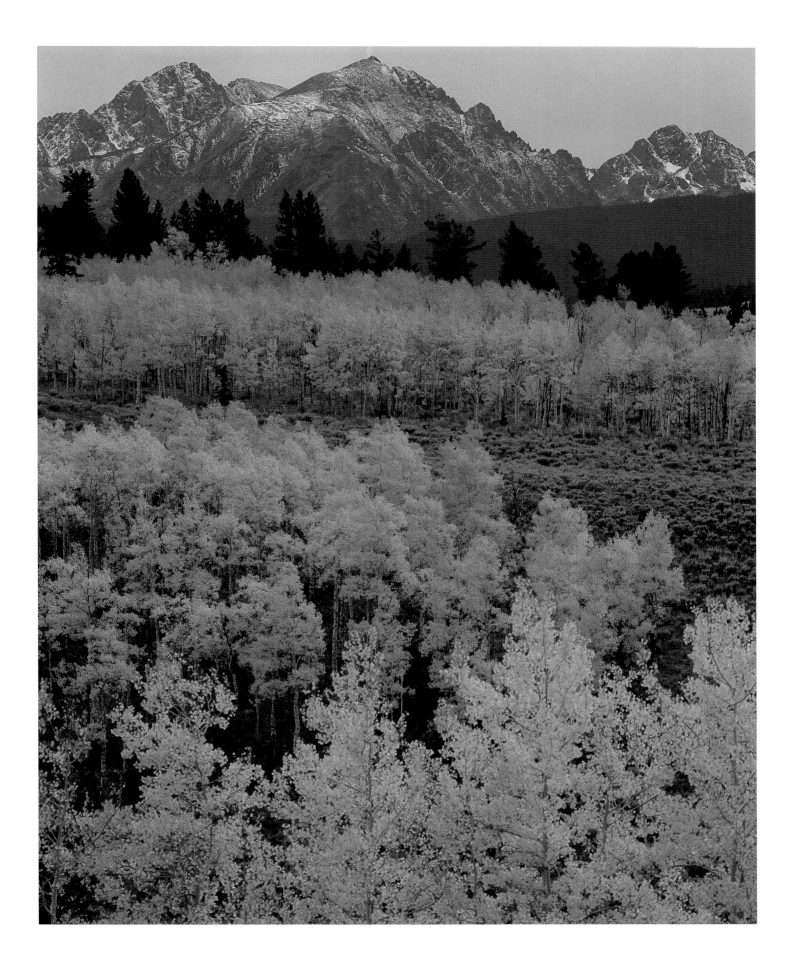

Banners of aspen in brilliant transition to winter. Gore Range. *October*

SUMMER

On this trip into the Collegiate Mountains, I finish an early cold supper, unpack my backpack, and take a pensive walk in the fading light. Magnificent thunderheads to the northeast glow as if illuminated from inside, like the clouds Michelangelo painted for the creation of Adam, great billowing clouds full of energy and life. Brome grass reaches to my waist, filled with fluttery creatures that rise and fall as I brush by. Settled in for the night, they are discommoded by my passage. I walk along with my hands behind my back, as I was taught to do in a florist's shop when I was a child. The whole-hearted wonder holds across the decades. I revel in such a luxuriant sunflower summer, so many flowers, so much blooming, so much wisdom in the air.

If Thoreau was the self-appointed watcher of snowstorms, I am the self-appointed watcher of alpine tarns thawing. This tarn in Rocky Mountain National Park is one-third open: water, scintillating, black and shiny as patent leather, bands the floating ice. The ice skim is dull, light-absorbent. When a breeze ruffles the water it comes alive, breathing in the summer, disturbing its reflection of the snowy banks.

I watched this tarn as it froze late last summer. It was as if a cruel presence suffocated it, inch by inch, creeping stealthily out from the shore by night, until one snapping cold night the pond thickened to syrup, congealed—and woosh! the water was gone.

Now as summer's warmth is exerting its power over the tarn once again, the remaining ice is a tenuous gray membrane, streaked with thin, spidery, white cracks, reluctant to yield its hold. Where there were footprints and the snow compacted, there are now indentations or even holes in the remaining skim.

The sky is clear, the sun like a heat lamp. While I am busy elsewhere, the sun etches away at the ice, and when I pass by, I make notations of ice size and time—11:13, four feet of clear water; 12:02, ice floe twelve feet across: 1:34, ice floe five feet, transparent edges. I like to think that if I don't document the ice's disappearance, it will slip back when I am not looking, snatch the pond back, reassert winter. One has to be careful about these things.

The last asterisk of ice doesn't disappear, it sublimates. The anima of the tarn casts off its widow's weeds and catches bouquets of sunsparks in its lap.

I sit on the damp bank of the pond at Constant Friendship, keying out a buttercup, turning the flower in my hand so that the petals glint. The water-repellent, shiny area on the petals' outer edge (the inner part of the petal is dull), may help in reproduction.

Bees and flies don't pollinate these simple open flowers very efficiently—they leave behind a lot of pollen which falls into the inner cup of the petals. When it rains, water fills the cupped petals to the top of the inner matte area but doesn't cling to the polished part of the petals' surface. The loose pollen, floating on the water at that level, reaches and clings to the stigma and adheres there as the water recedes. If insects don't pollinate the flower, self-pollination is assured.

The canoe rocks serenely. I honestly think I could sit here in the middle of this pond for the rest of my life, watching. The comforting, hypnotic sound of water warbles in the inlet stream. Intermittent hummingbird trills splice the air. There must now be enough scarlet gilia and Indian paintbrush to fuel its metabolism. Yellow jackets bump around the sunshine. A noisy fly drones close by and is gone before I can locate it. A mallard plies the pond in straight military lines. Overhead, taking insects, a violet-green swallow does Immelmanns and outside loops. Sunlight flicks off the wings of dragonflies patrolling the pond edge.

The hillside above looks as if someone flipped it with a brush full of yellow paint. The variations in yellow are legion and make it possible to identify a plant from a distance by its yellow alone. Dandelion yellow is a clear, sharp cadmium yellow; in bloom for almost two months, dandelions reach five and six inches. Buttercup yellow goes toward lemon. Golden banner and ragwort yellow are deep golden-yellow. Stonecrop yellow tends toward orange because of the vermilion dots on the petal. Woodrose is buttery cream. To each its own yellow. To each its own sunshine.

As I nose the bow in to shore, a cobweb hammock strung between two sedge stems glimmers, flashing magenta. A yellow swallowtail butterfly, in indolent flight, loops across the pond. In the far woods, three different birds are calling, syllables crossing over and blending as one song. Clouds of minute insects waft up from the grass and waver back again, silhouetted for a second against the smoky pond. The dragonflies dart fast and straight, purposeful and efficient.

Canadian reed grass blooms a lavender haze on the shoreline. I reach over the gunwale and slide my fingers down the smooth reed grass stem and find it warm. I feel the photosynthesis bubbling inside, cells expanding, stem elongating, summer flowing in its veins and in my vascular tissue. I think I'd make a good plant, and in the lethargy of this summer's day, why not stay here forever and find out?

This morning, a black and gold flower beetle lay curled asleep in a white thistle. And in the cooling air this evening there is another one curved so firmly around the stamens of a pink geranium that it would not shake loose. Sleeping in a pink wild geranium strikes me as elegant accommodations. Bed and breakfast. I recall a bee I once found in a cactus flower, cosseted inside, protected against the cool night. I wonder how many insects spend the night in floral bowers.

Walking swiftly, I nearly step on a male broadtailed hummingbird lying on the ground. Hard to believe, that vindictive, concentrated bundle of energy, that shot of contentiousness, is now so still and dead. "Dead" is such a blunt, final word. It falls with a thud. Another broadtail shoots by and perches on an empty ponderosa twig, as vivacious as this one is still.

This little corpse is scarcely three inches long. The tiny curled feet look fashioned of fine wire. The transparent, pink siphon

tongue extrudes. The needlelike bill is three-quarters of an inch long. As I turn him in my hand, some of the throat feathers catch the light and gleam ruby red, then phase back to dullness. His rusty back hides metallic glints of green; malachite capes his shoulders. He weighs almost nothing. Could I not see him, I would scarcely know I hold him.

I study him with no understanding, no answers, only questions. His eyes are as tight shut as mine are open, but in that still little brain was knowledge I will never have, horizons I will never see. His death tells me that I can be done-in just as easily by a swift misjudgment, a fractured flight.

I've held him long enough. Before I become maudlin, I hurl him into space, a long trajectory, and turn away so as not to see where he fell, where he will again become part of the earth. But the question will haunt: how did this tiny sheath of feathers, this incredibly complex little creature, rise out of those elements around me, animate the day early and late with his belligerent trilling and aerobatics? Where in the wilderness did all this life come from, and where in the wilderness did it all go?

Evening. Hiking in the San Juan Mountains, we have walked for hours. Now we rest, looking down into the valley from where we have come. Mists rise from the ground, drifting in from the east, leaning to the southeast, curling in from the west, a ballet line that swirls over the valley floor, splits, gathers again, and flounces center stage front. Every time the line splits again, it meets in upward helices. The diaphanous traces form, seethe, oppose, coalesce, in endless motion. As the evening darkens, mists settle, drift downward like motes of dust, wraiths of summer, losing definition in the dusk.

I lean back against my propped up backpack, food untouched on my lap. The clouds are so spectacular, so constantly changing that I can't be bothered to eat. They form a bank with sweeping upward lines, the top cream and apricot, crowned with one great dome, lit from within, a shape that reminds me of the Greek *omphalos* at Delphi, the navel of the world. One cloud levels off at the top into a great anvil. Along the rising column, wisps of moisture tat lacey edges.

As the daylight dims, the high mounds diffuse and soften, blush peach. Suddenly the color snuffs out. The clouds roll blue and gray against a brighter sky. A thin thread of lightning passes between turrets, one last communication, before all fades into everything.

A branch quivers and shakes in the willow thicket along the shore of the pond—I can just catch a glimpse of a beaver as it disappears. In among the leafed branches of the willow bushes are stubs, clean cut at a sharp slant, a miniature but formidable abatis. This evening the beaver swims back and forth, back and forth, tireless, purposeful. Finally it climbs up on a large flat rock in the shallows; the rock has a good-sized ledge underwater, and there the beaver stands, grooming itself sleek.

Ripples vee the pond's surface. Muskrat ripples. Across the pond, the sedges twitch. The little sleek body, busy feeding, moves economically, neither quickly nor slowly. The sedges fringe the shore beneath a willow that snows cottony seeds on the dark water. An intimate world, plant-green and water-dark, and the little muskrat moving neatly from clump to clump. Caddis flies rise, blurred, out of focus. Their movement is like a stillness. Reflections blur the hillside above, a world turned upside down, a varied reality, liquid greens, floating evening, willow, willow.

In the half light of dawn, I watch the pond awaken. A whirling disk of white in the middle of the water catches my eye: a moth caught on the surface. It is too far to reach it with a stick. The spinning continues for half an hour. It torments me. The muskrat swims close by. I am not interested. My attention is nailed to the white scrap gyrating on the water. Suddenly it stops and lies motionless on the surface. That sudden cessation of struggle is shocking, unbelievable, unacceptable. With all that effort, it should have survived, should have overcome. I stare at the smoothness with disbelief. It floats, wings outspread, in a kind of final supplication. The silence of the water is horrible.

I take my butterfly net and sally forth, out to pillage the countryside. I say this before someone else does. I am an amateur entomologist for two reasons. First, insects refuse to stay still long enough for me to find out who they are and whither they goest and when (and who's eating whom), and only when they are immobilized under a microscope can I sigh at the beauty of a fly's wing. And second, there is a peacefulness in the pursuit of the winged and the swift, the bumbling and the clumsy, that for me is the equivalent of fly-fishing's serenity. When you come right down to it, I don't mind if I don't catch a thing.

Quickly the eye learns patterns of flight and feeding: quick or indecisive, spiraling or straight. Just as quickly the ear learns buzz patterns. The big early bumblebee drones in a heavy, intermittent "look how busy I am," overly virtuous tone. Deerflies, with their delta wing configuration, whine like a buzz-saw. Big bee flies, full of bombast, rise to a crescendo of petulance. And bottle flies, pompous and insistent, tell the world of their travails. Only the lethal robber fly, hunched on a gooseberry branch, is silent.

I net a white butterfly with black and scarlet markings, *Parnassius smitheus*. Red wing spots on the males decrease with altitude and disappear in the alpine zone; with altitude, the wings of the females become progressively darker. *Parnassius* lays its eggs only on stonecrop and flies wherever stonecrop grows. I am inordinately fond of it. It is a handsome butterfly, a joy to watch, predictable as stonecrop, reassuring as summer. And easy to catch, so easy that I release most of them after I have a chance to peruse the patterns and colors of their wings.

Fritillaries, with their wings folded, look exactly like dead thistle blooms. I net a lot of dead thistle flowers. Last week, there were many fritillaries, this week, none. Lots of flies and loads of bees, making wanton passes at the butter-and-eggs. They frequent the late asters, the last daisies, the pendant bluebells. But I seldom see insects on the golden asters or on the yarrow.

By the end of summer, very little is a-wing. I prowl the meadows. Even the usually ostentatious robber flies, making low-flying raids, are missing. Then I see one on a thistle leaf, oddly still. It hangs in the clutches of a small green-and-red crab spider. Poetic justice.

Any small lake is best observed from an appropriate hillside above. One subalpine lake in Rocky Mountain National Park appeared when three of us crested a ridge at 10,500 feet. It was marked on the topo map a pale blue, which reads "water" but does not say "scintillating." In this precise combination of wind and light rain, the lake scintillates, shimmers like hammered steel. Were it set to music, it would be the quick, liquid sound of steel drums.

Yesterday morning, like some photographer's dream photograph, symmetrical and striking, a leaf in the woods had drops of

water at the end of every vein. Someone said, "Look how the water's collected after the rain!" "No," said the botanist, "the plant has too much water and is getting rid of some—it's called gutation." I look it up. It means the loss of water from an uninjured plant, an "exudation of moisture." It is not something I have seen before in dry Colorado.

As if in countermeasure, we find only a couple dozen raspberries, and they are watery, dull, and pale, their usually pleasing tartness an unpleasant sourness. They have not profited from the rain.

In the woods, not a spruce bough moves. Not a Douglas fir branch bends. Not an aspen leaf flutters. The stillness has a surreal quality. The landscape is a photograph, and I am caught, immobilized, within the scene. I hold my breath at the stillness. The spire on a Douglas fir moves slightly. It seems a kind of miracle.

The dogbane is lovely with its yellow leaves and rose red stems—wish I knew what to name that yellow (naming colors is not something photographers have to worry about): it is soft, bright, warm, no green in it at all which rules out *lemon* and *cadmium* and *brass*. *Butter* is too pale. *Butterscotch* is too brown although it has that bent. The dogbane turns long before anything else does, saying "autumn" like a Cassandra while other flowers bloom in happy summer obliviousness.

The color of dogbane stems? Undeniably alizarin.

I stand above the pond and look down at the wind's windrows, cast across at the gold-silk curtain of the aspen, note the pale seed head of the reed grass against the dark water, scan the yellowing willows, and feel not ready. The part of me that finds comfort in the stately pavane of seasons is not as strong today as the part that is reluctant to see this summer end. This summer, especially, when Nana and I have had so many walks, so many hours out-of-doors and loved it so much. I would go out and glue back every falling leaf, paint every yellowed one green, shatter the ice as it forms on the pond, blow my lungs out against the storm. Where is my faith in other summers? That this time will return? That the sun will track higher again, my favorite anemones will drift by the streamside?

I never knew it was so hard to let go of summer.

A big deep wind blows, coming from every quadrant, a wind with purpose, a restless, moving wind that takes off the corners, an autumn-nudging wind that frets grass and tree, low and high, all together, all at once. A scary wind with hidden intents. When I walk, there are no popping grasshoppers, no officious flies, no larking sulphur butterflies, just wind. I flush three juncos. They blow out the other end of a willow alley, white tail stripes flashing.

The season turns even as I watch. A meadow by the north stream, white with daisies, stuffed with lavender asters and black-eyed Susans, still holds summer. There are still buds to open among the drifts and ranks and ruffles of daisies. The shooting stars are only seedpods now, yes, but the daisies—they make it possible to still believe in summer.

When I turn my back on the meadow, I scan the slope of a dry hillside, close-packed grasses filled with yellow butter-and-eggs and lavender showy daisies. But the thick turf of grass has begun to bronze, and the horizon line of the hill is blurred by the blowing, bending fringe of grass stems, pushed into changing curves by an irrevocable wind. The sting of fall colors the slope.

The silhouette of a hillside tells so much. And this one tells all, the sad all.

SNOWMASS AND MAROON BELLS WILDERNESS

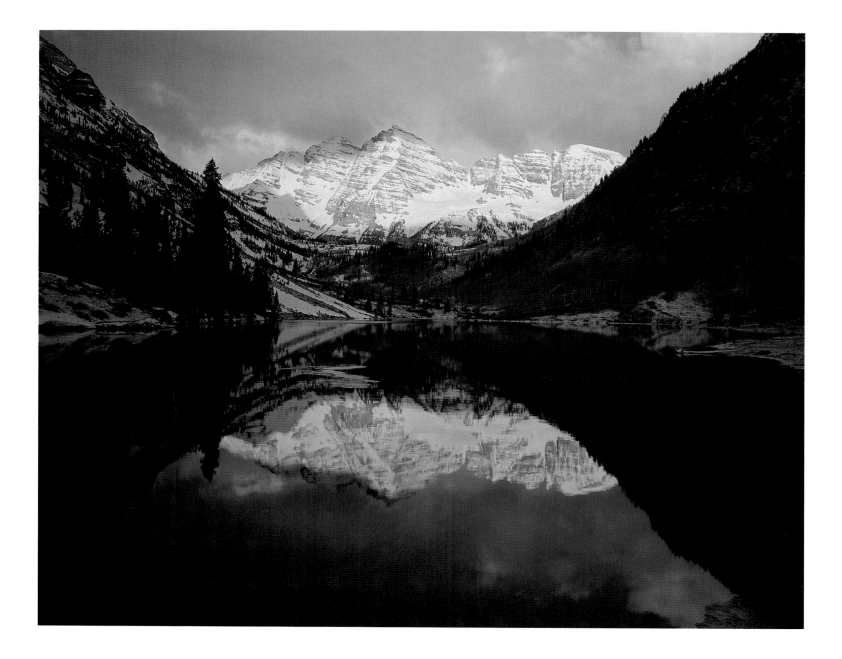

Maroon Lake. Maroon Bells/Snowmass Wilderness. *May*

95

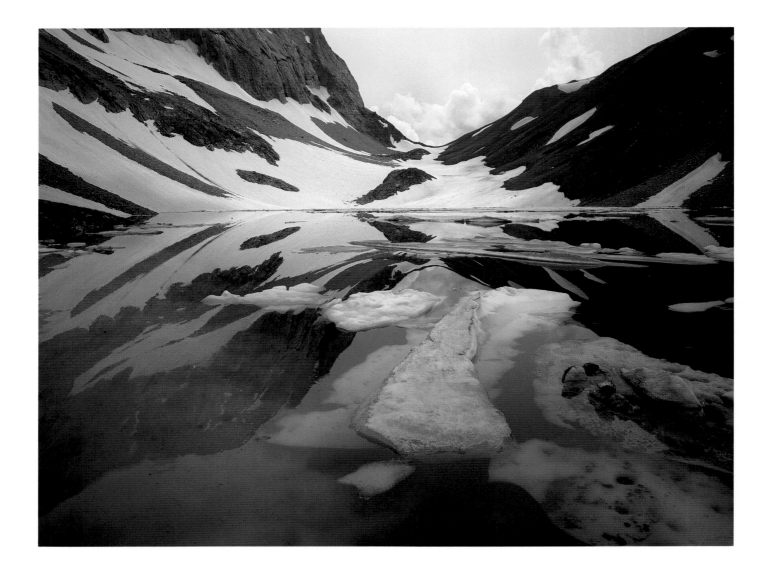

Ice flows below Capitol Peak. Capitol Creek, Maroon Bells/Snowmass Wilderness. *July*

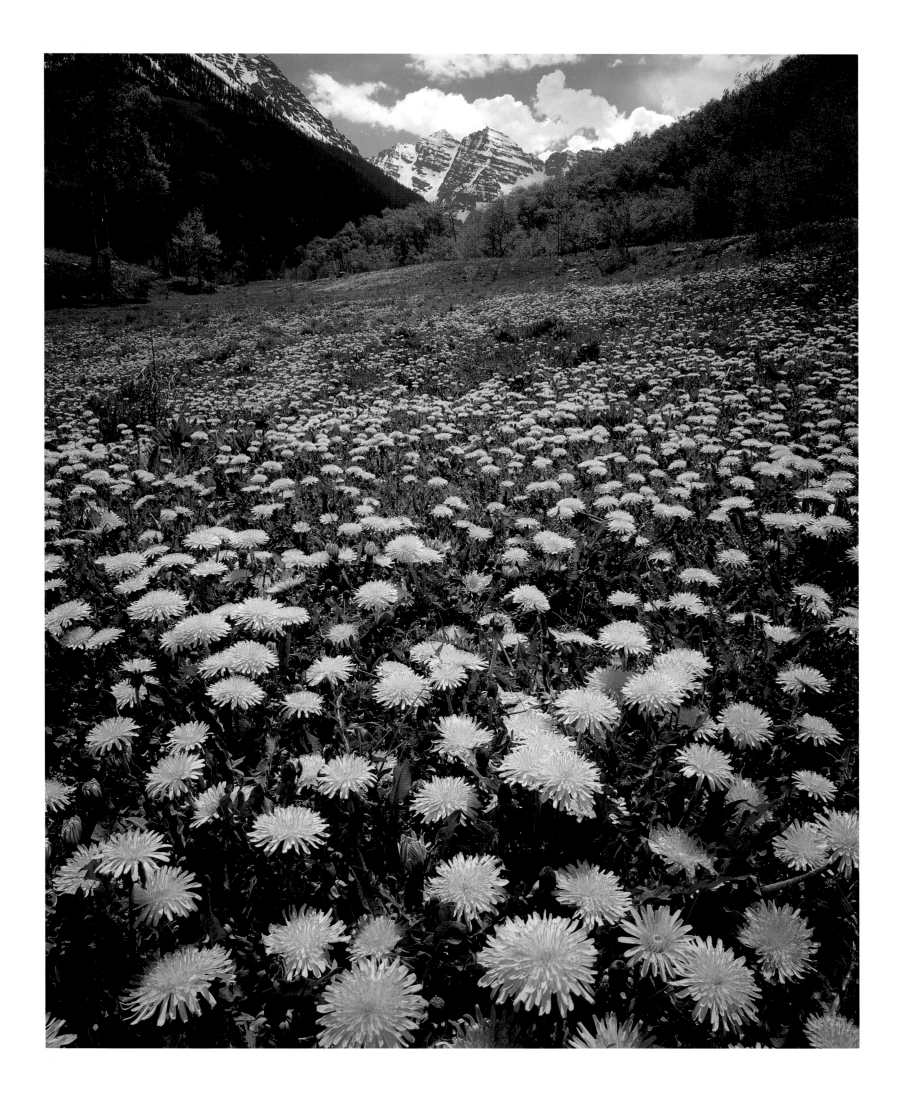

Dandelions in Maroon Canyon. Elk Mountains. *May*

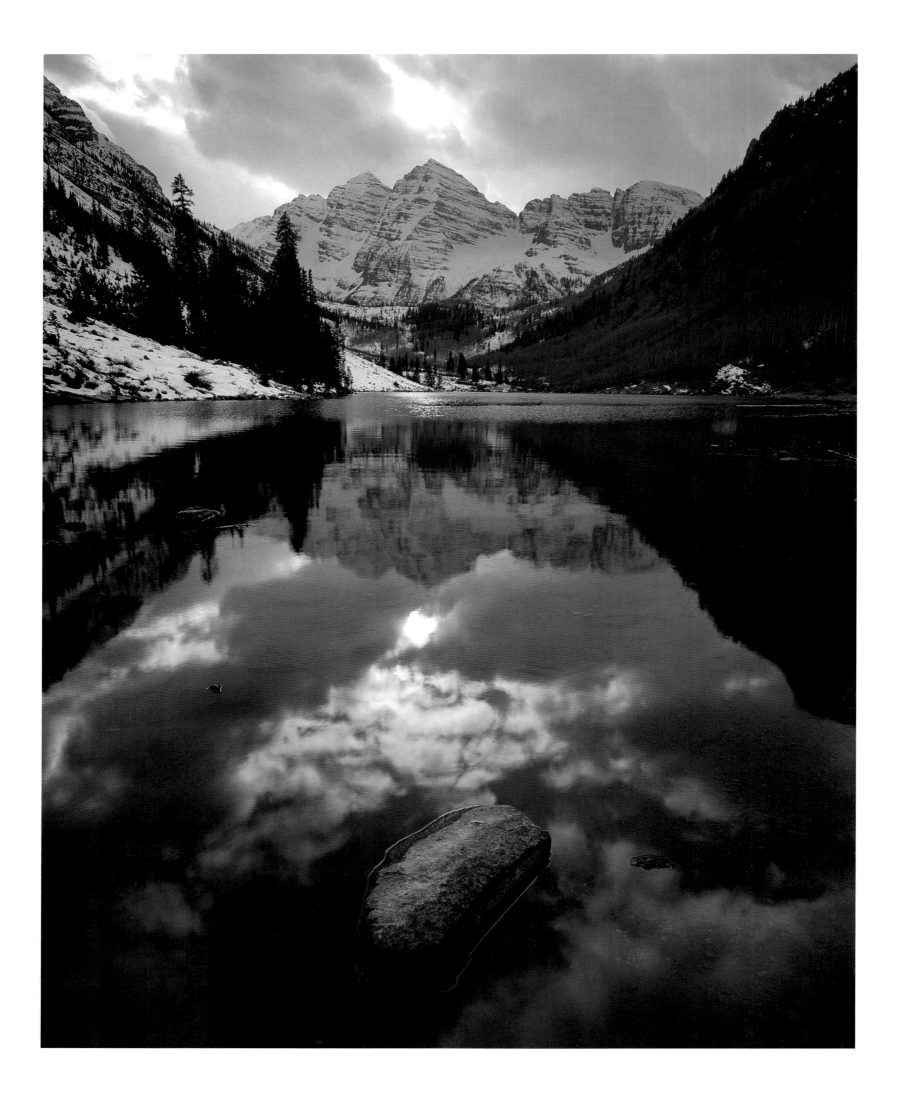

Maroon Bells reflection. Maroon Lake, Maroon Bells/Snowmass Wilderness. *November*

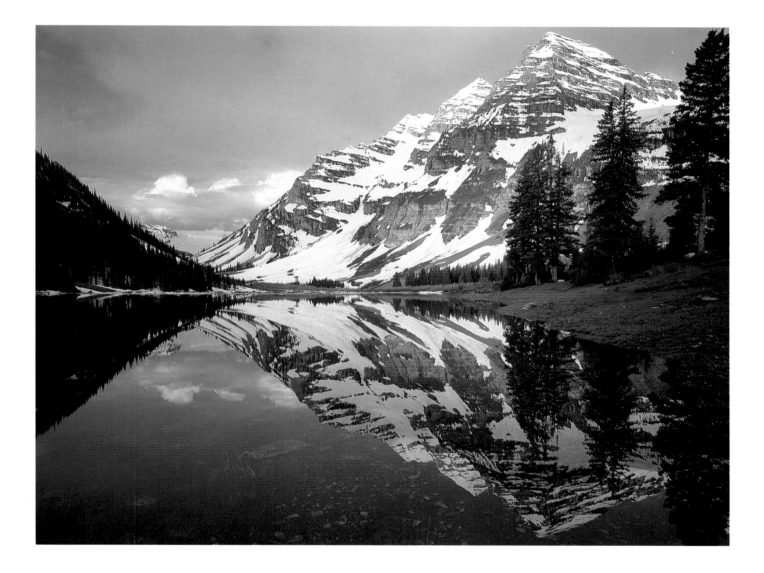

Maroon Bells mirrored in Crater Lake. Maroon Bells/Snowmass Wilderness. *June*

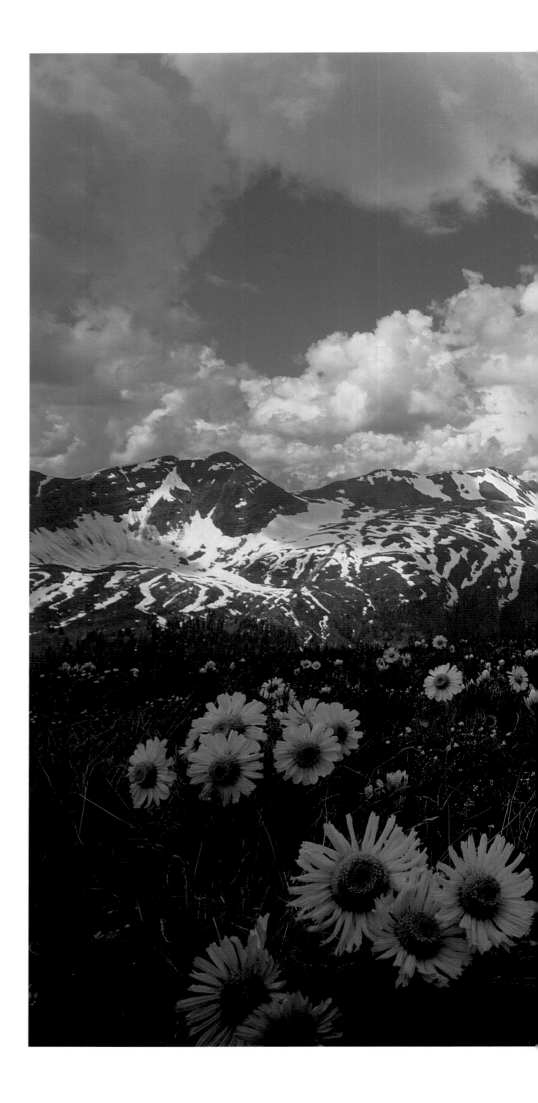

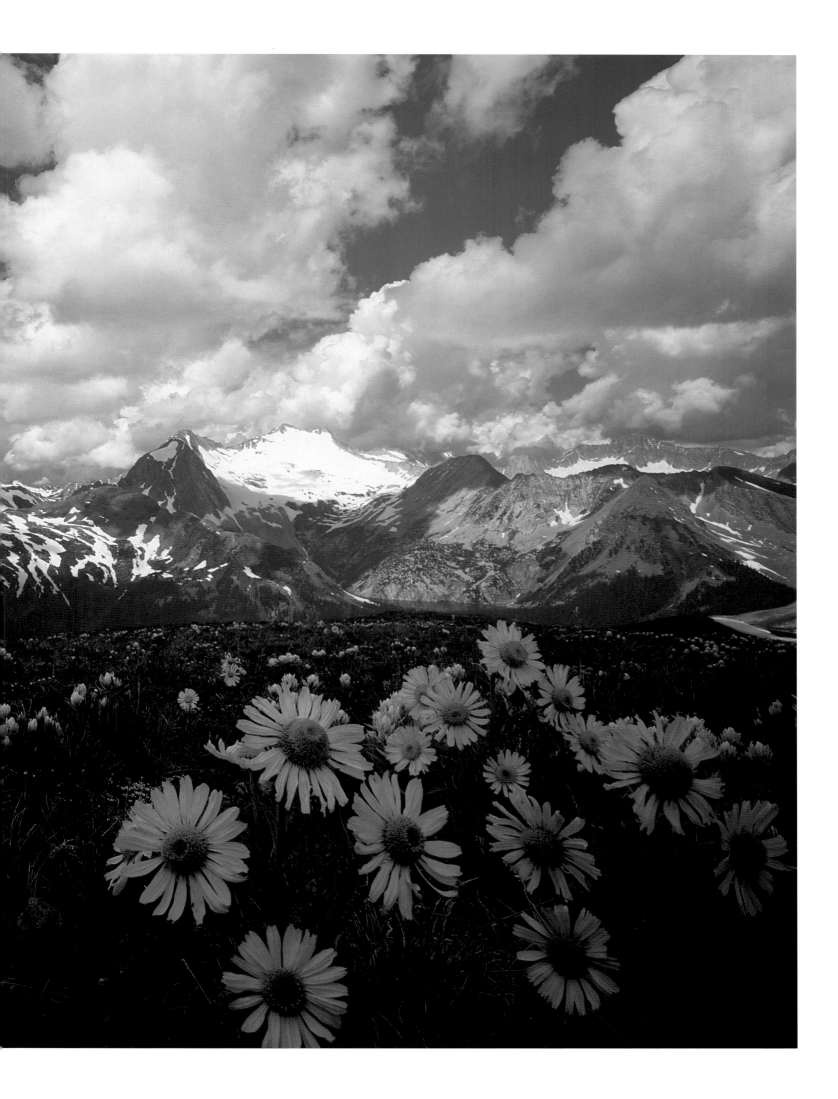

Yellow wheels of alpine sunflower. Maroon Bells/Snowmass Wilderness. *July*

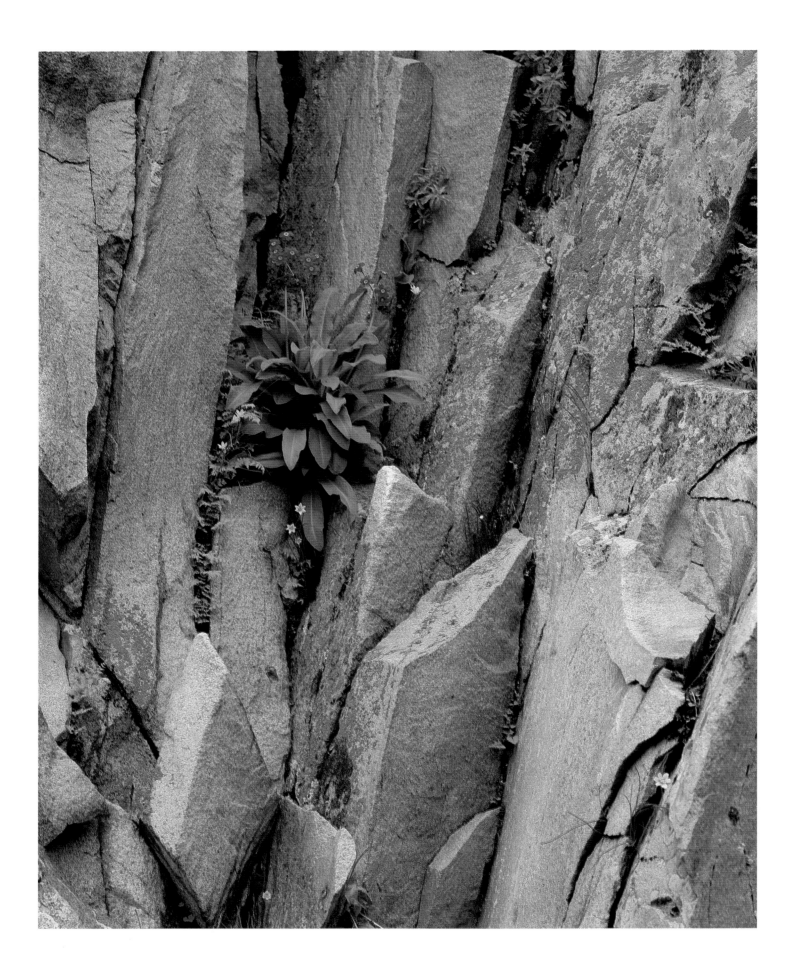

Parry primrose, ferns, orange lichen. Capitol Creek, Maroon Bells/Snowmass Wilderness. *July*

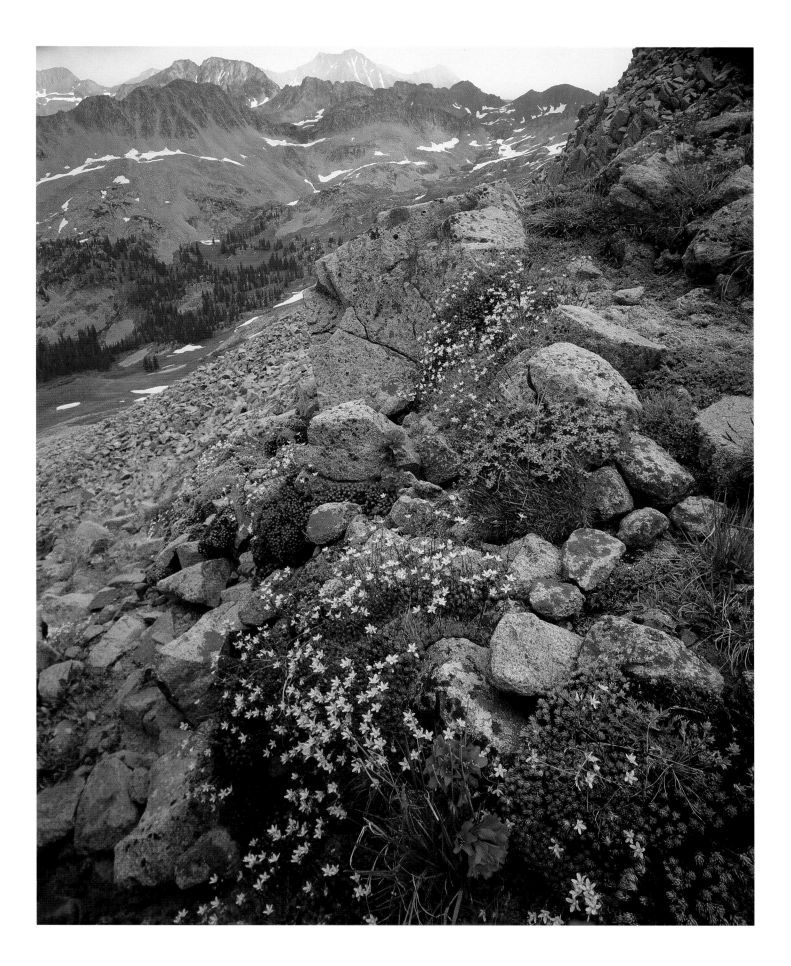

Moss campion, sky pilots, dotted saxifrage. Avalanche Pass, Snowmass Mountain to east. *August*

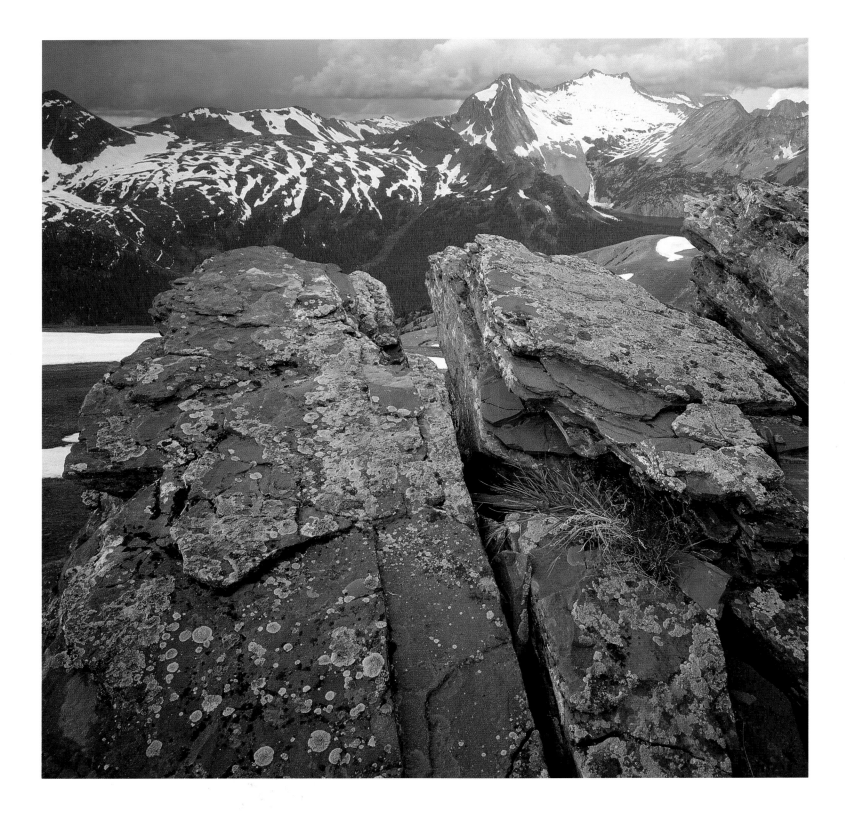

Red of Maroon formation with greys of granitic Snowmass Mountain. Elk Mountains. *July*

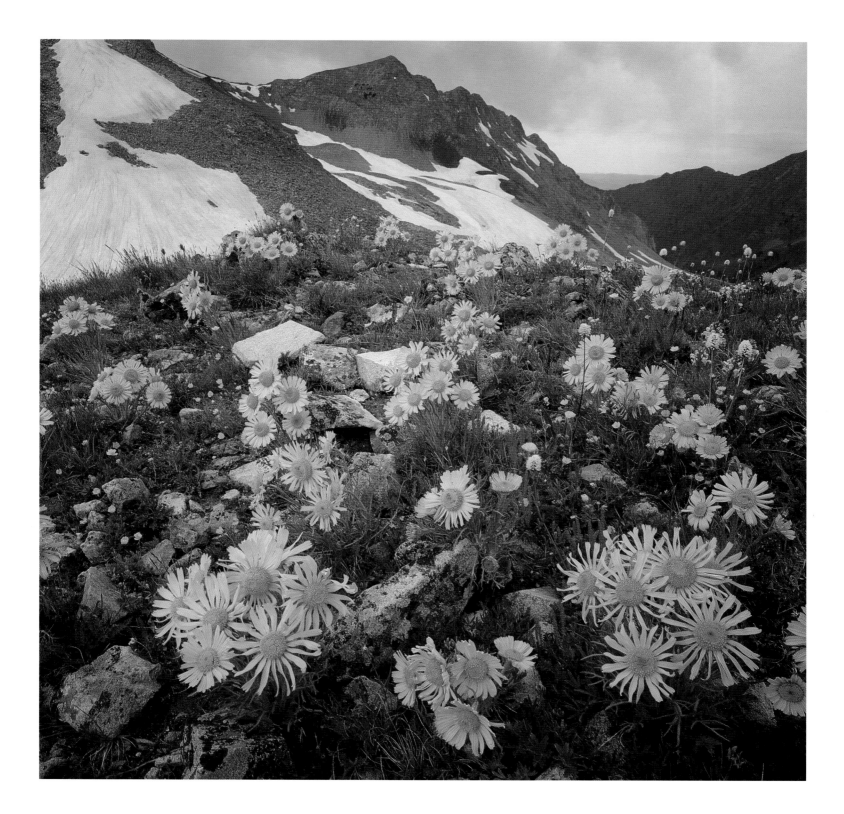

Sunflowers in Avalanche Pass. Maroon Bells/Snowmass Wilderness. *August*

SANGRE DE CRISTO

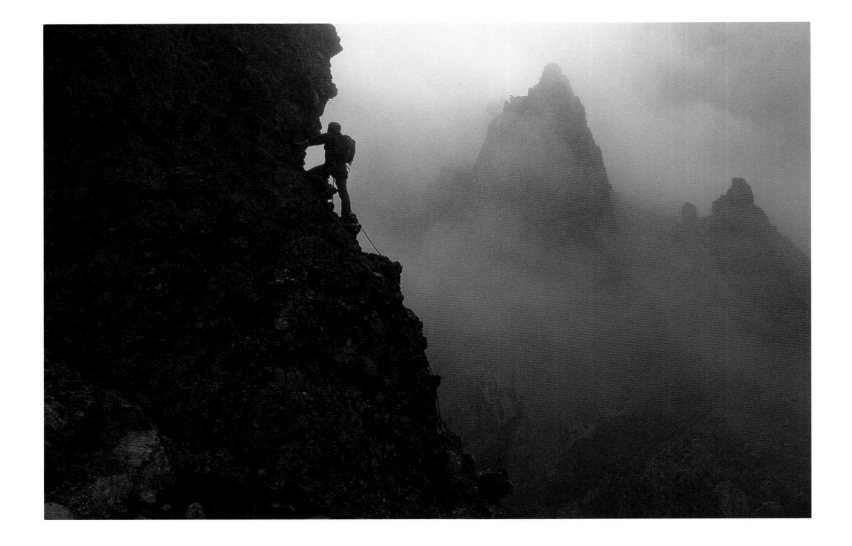

Crestone Needle shrouded in storm clouds. Sangre de Cristo Range. *July*

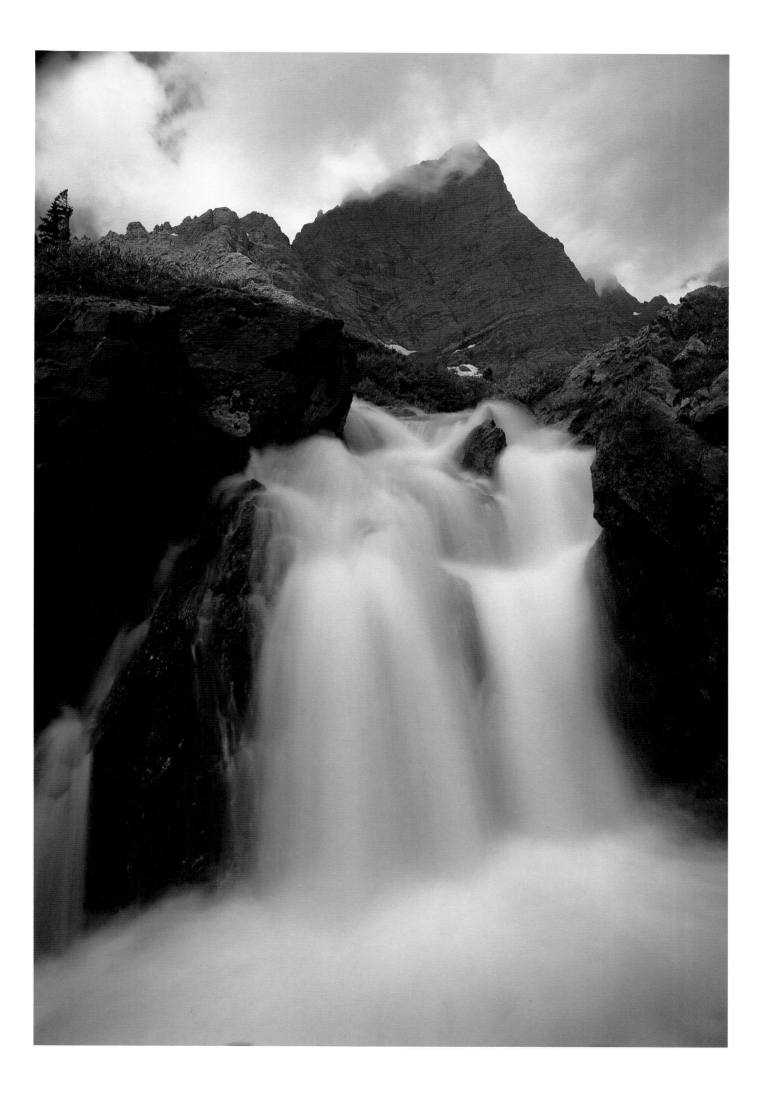

Cascade before east face of Crestone Needle. Sangre de Cristo Range. *July*

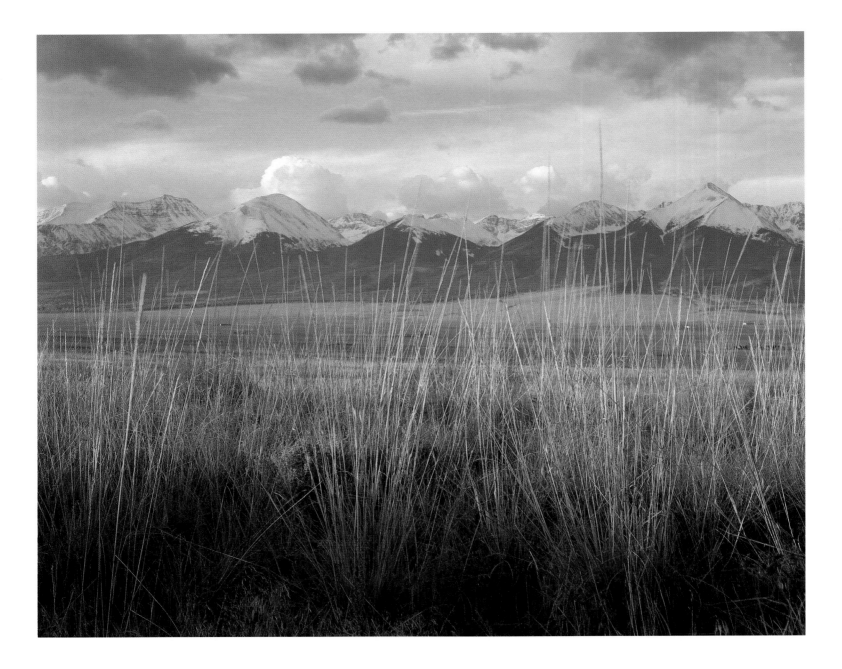

Grasses and east side Sangre de Cristo Range near Westcliffe. *November*

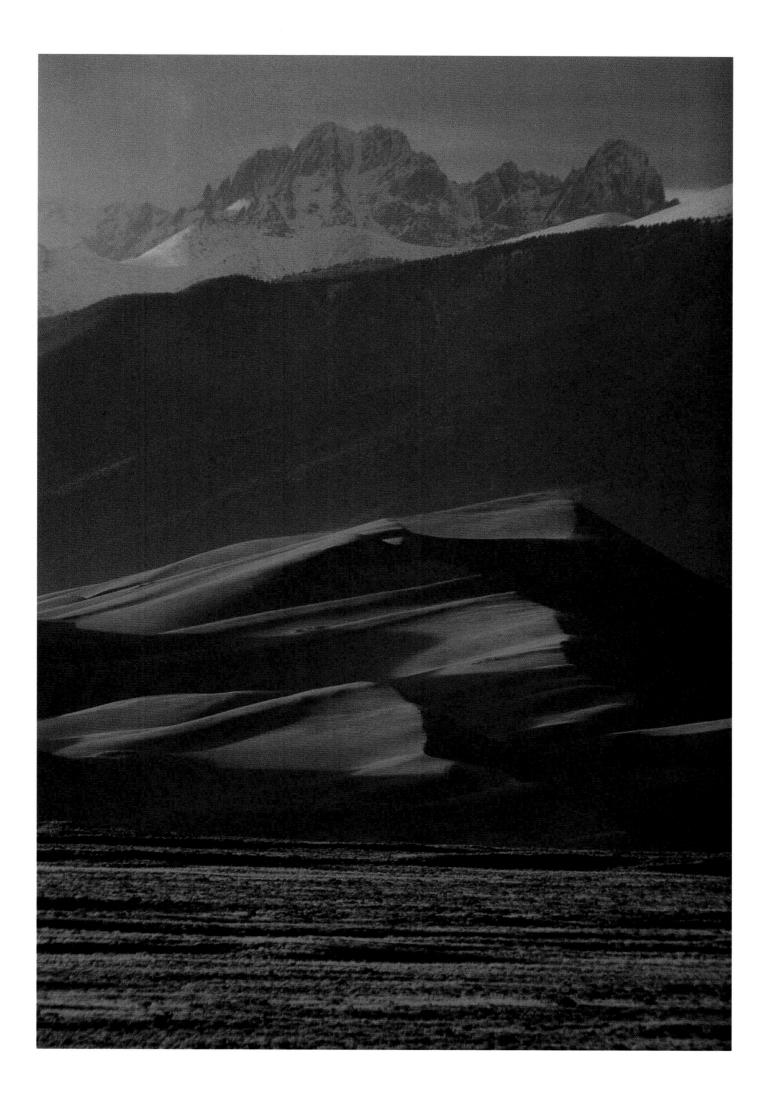

Windblown sands below Crestone Peaks. Great Sand Dunes National Monument. *May*

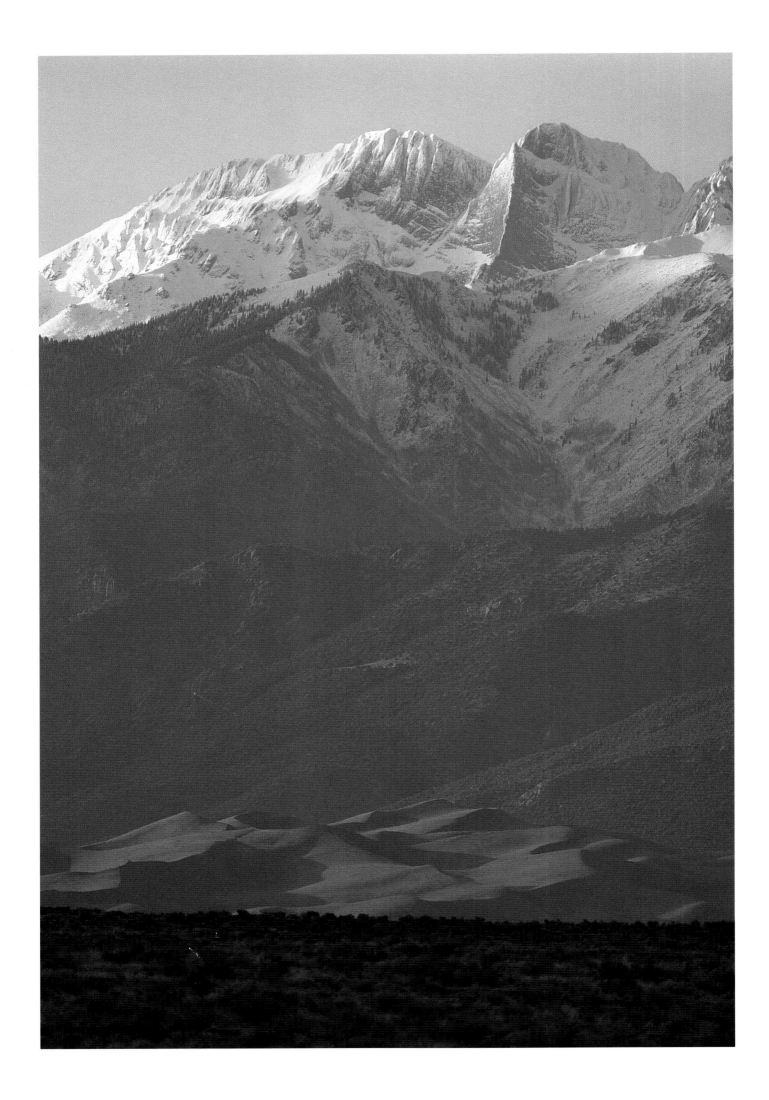

Kit Carson Peak under fresh dusting of snow. Great Sands. *May*

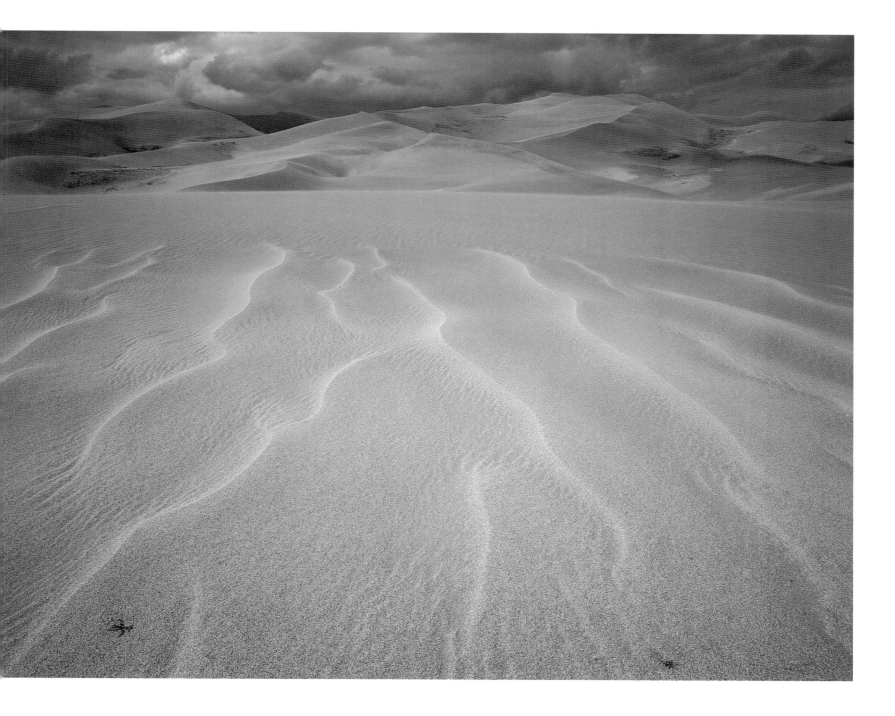

Delicate temporal surface etched by predominate westerlies. Great Sands. *May*

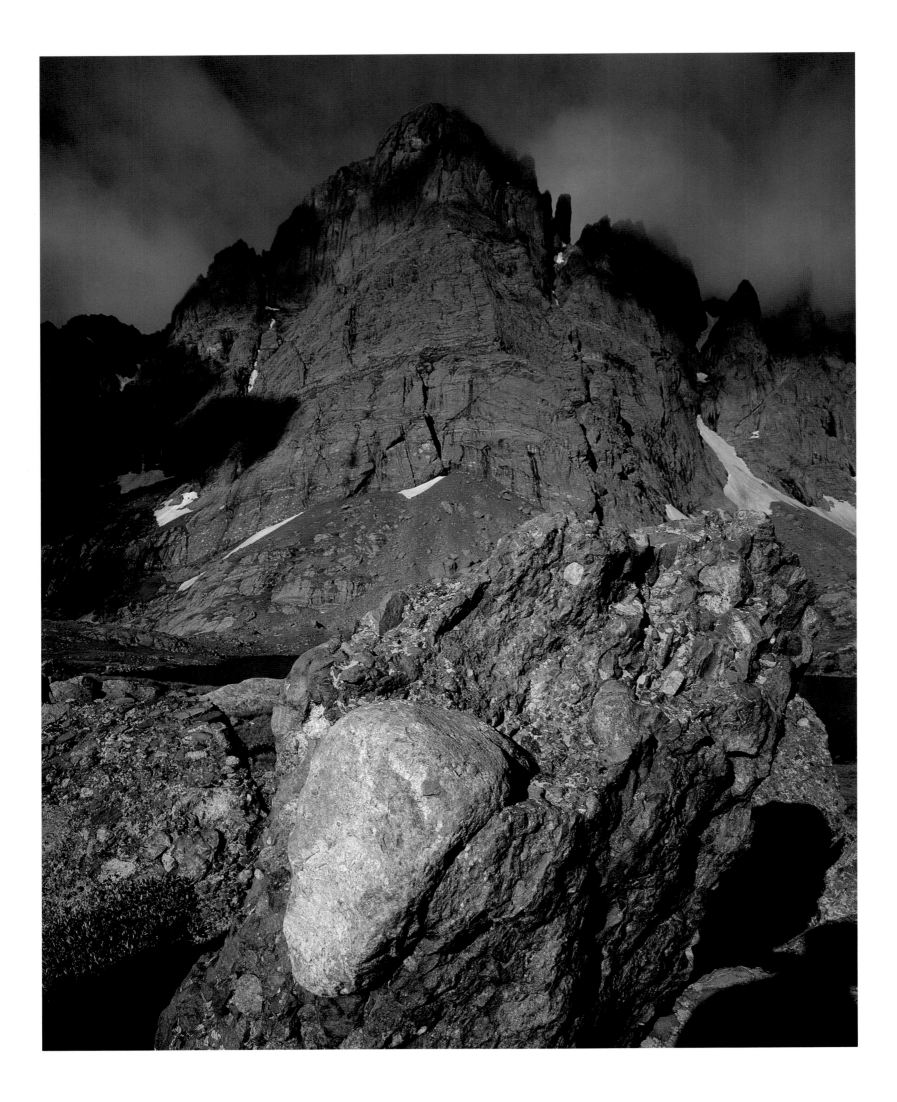

Conglomerate rock of Crestone Needle. Sangre de Cristo Range. *July*

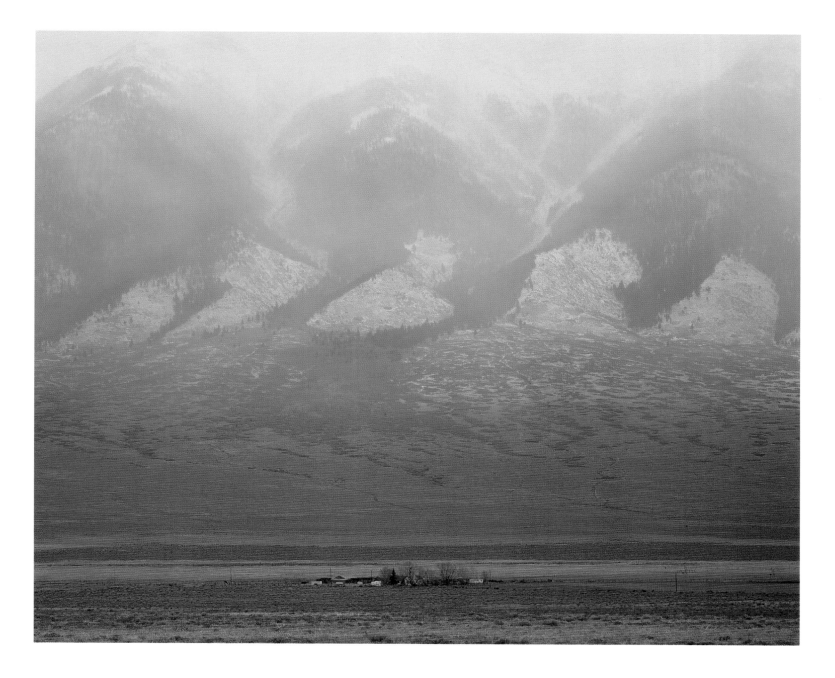

Homestead in San Luis Valley with Sangre de Cristo Range. *April*

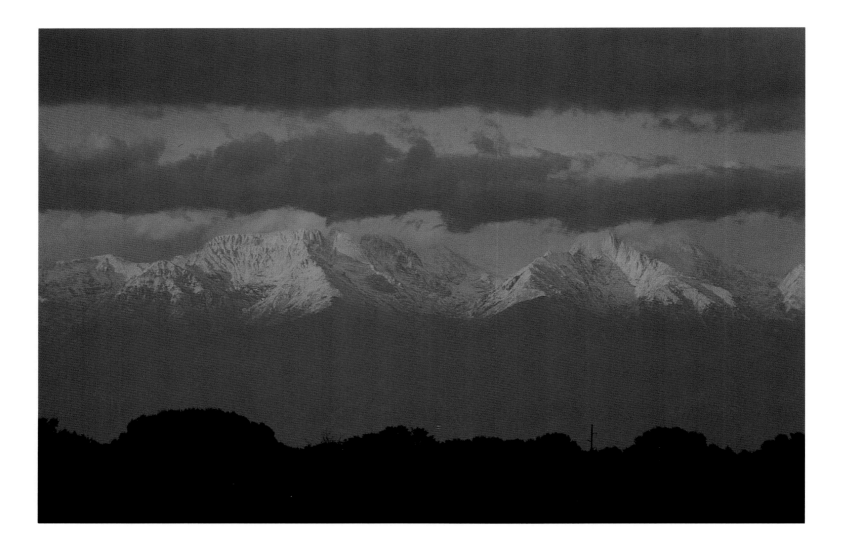

Crimson colors of clearing storm. Sangre de Cristo Range. *April*

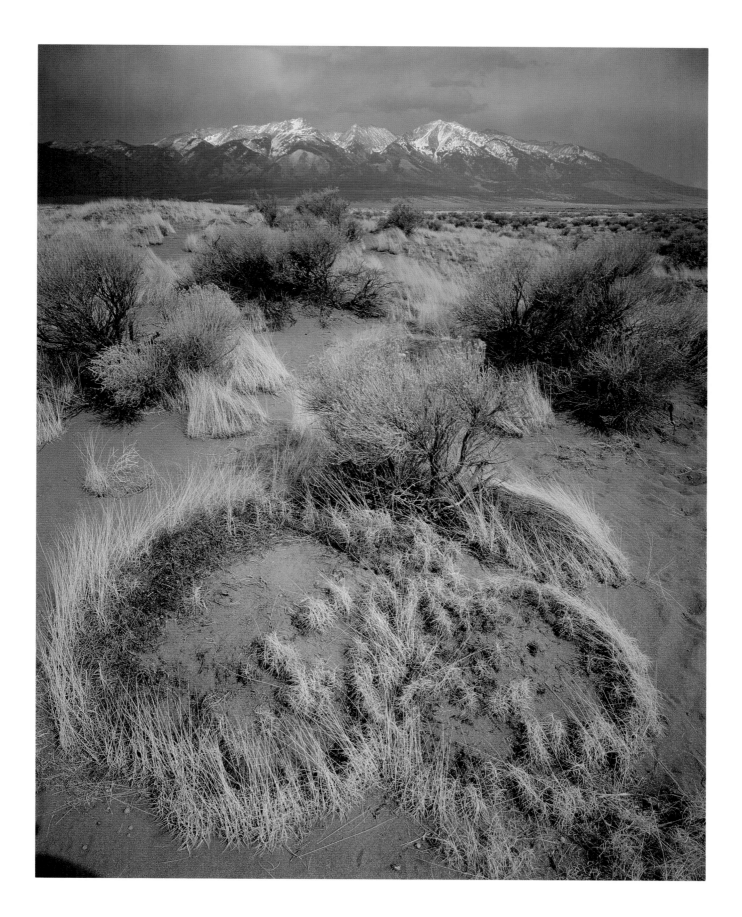

Ring grass and sage. Sierra Blanca. *April*

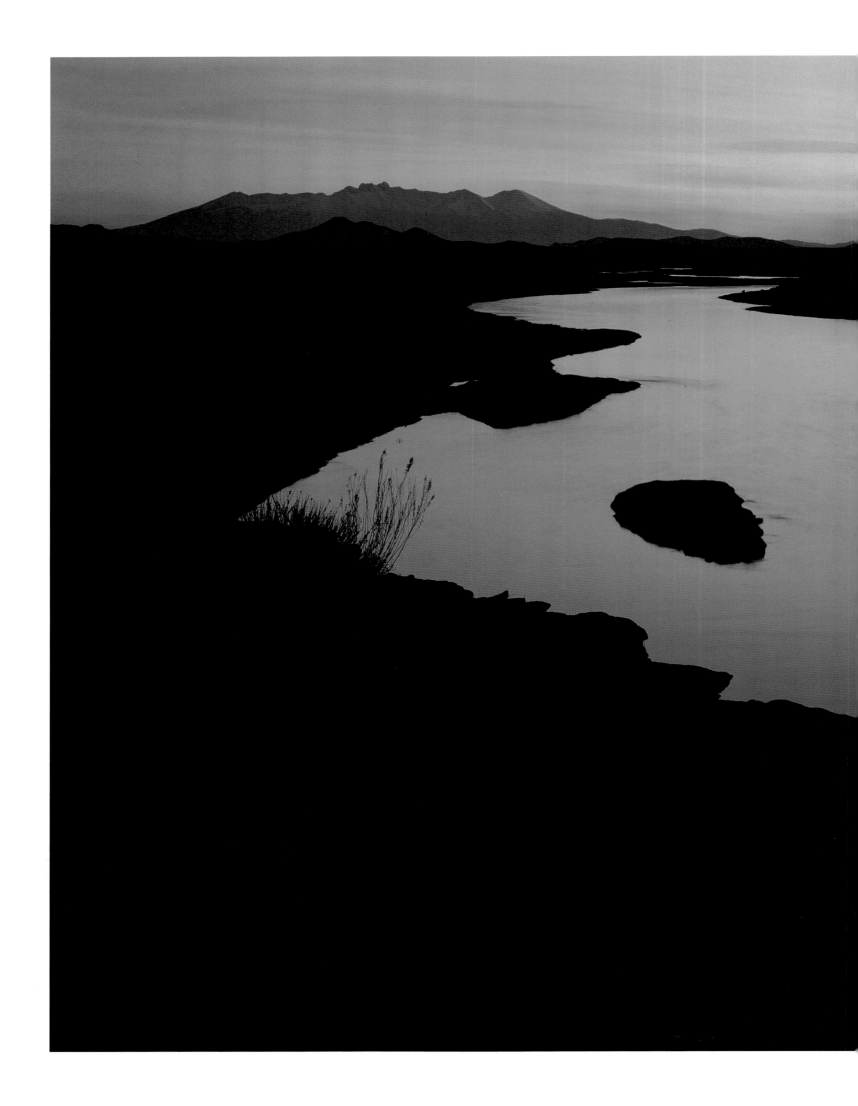

Flow of the Rio Grande below Sierra Blanca. *April*

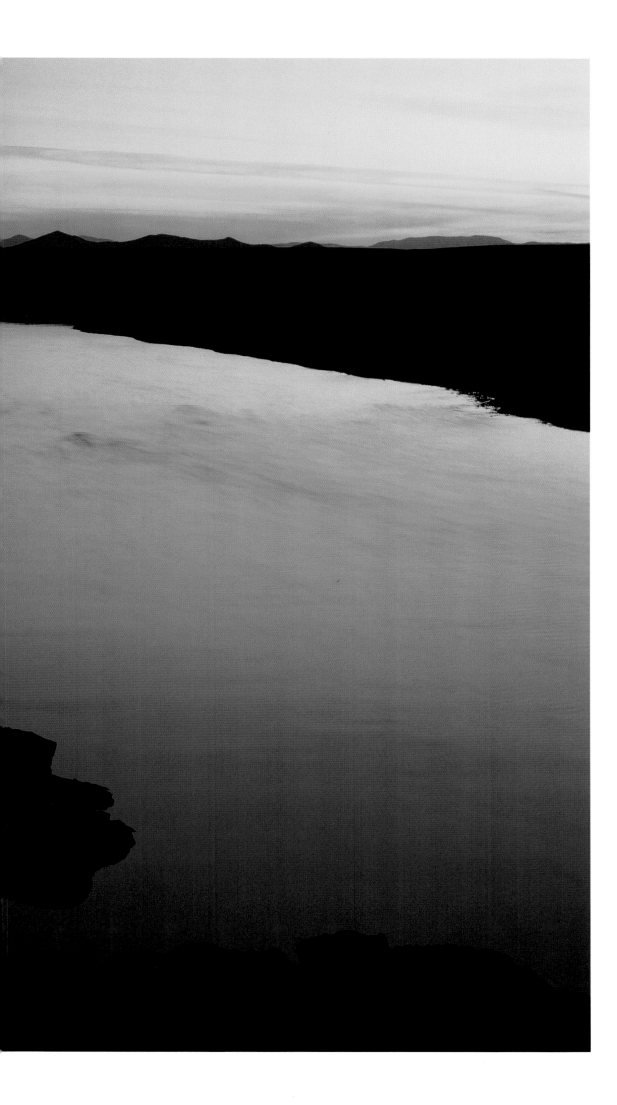

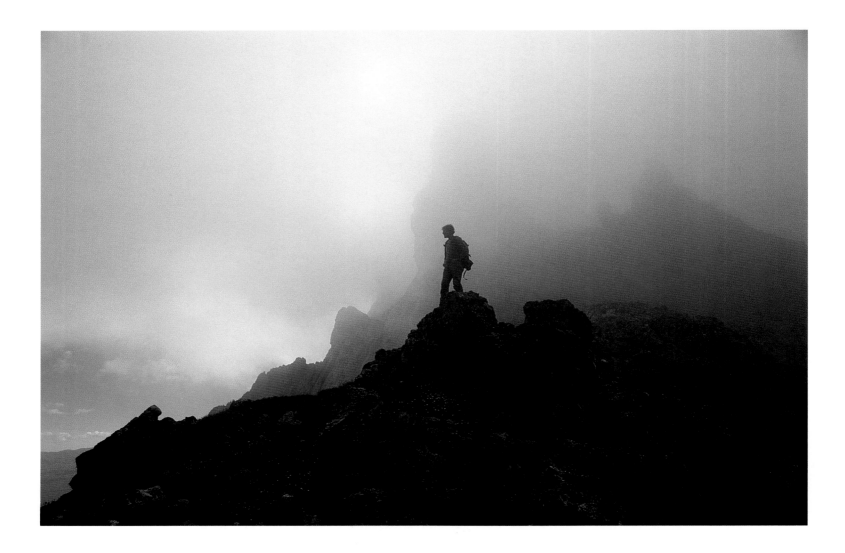

Crestone Needle in Sangre de Cristo Range. *July*

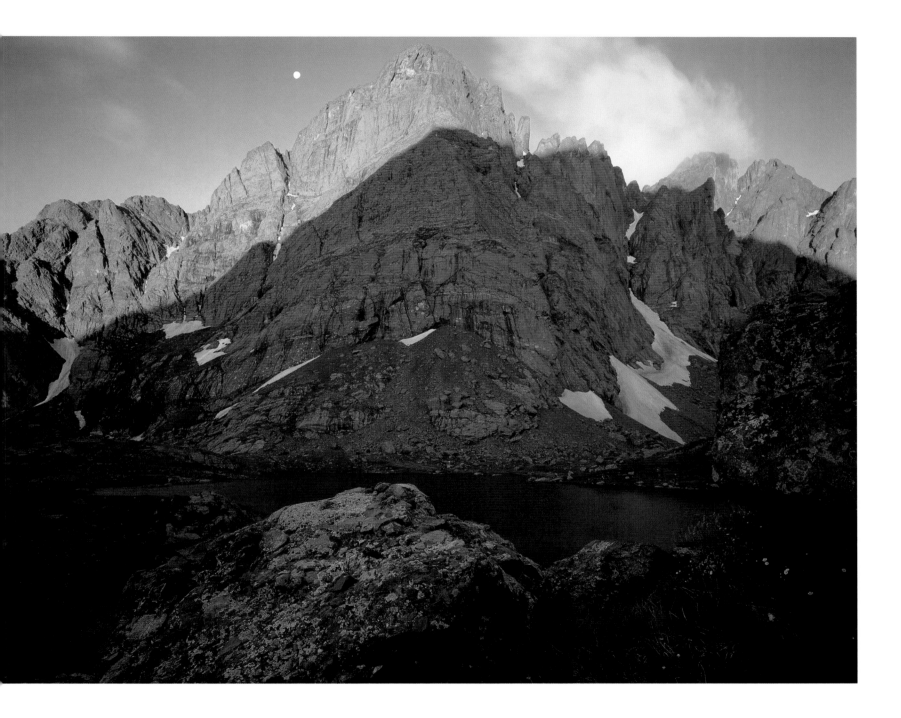

Moonset and Crestone Needle above South Colony Lakes. Sangre de Cristo. *July*

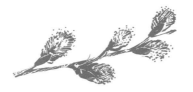

Pool with marsh marigold. Cimarron Canyon, Big Blue Wilderness. *June*

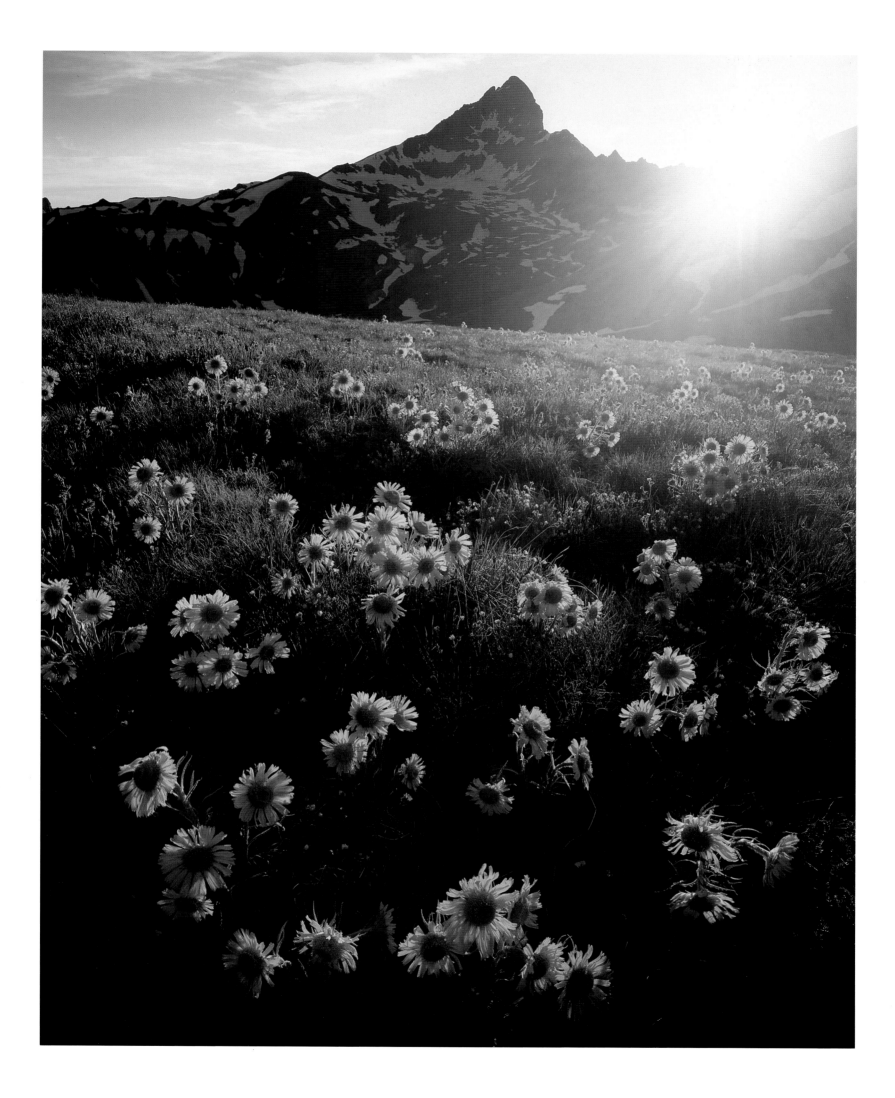

Eastward-facing rydbergia before Wetterhorn Peak. Big Blue Wilderness. *July*

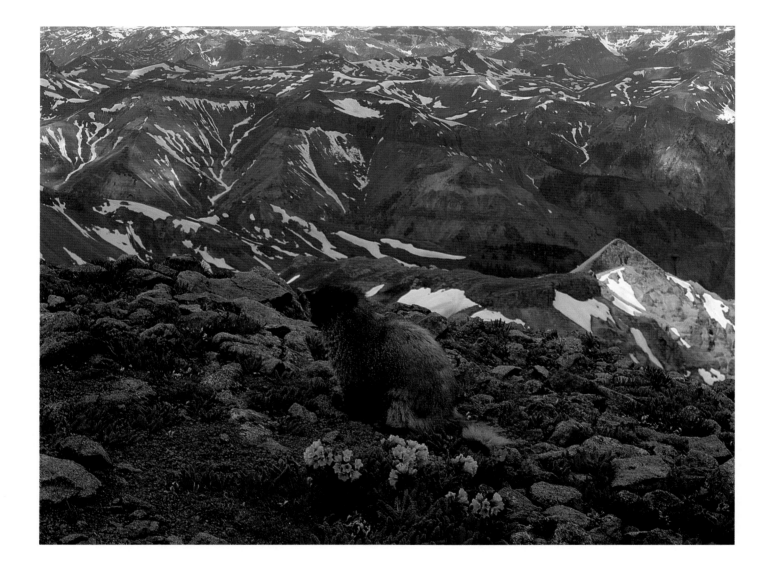

Marmot station atop Wetterhorn Peak. Big Blue Wilderness. *July*

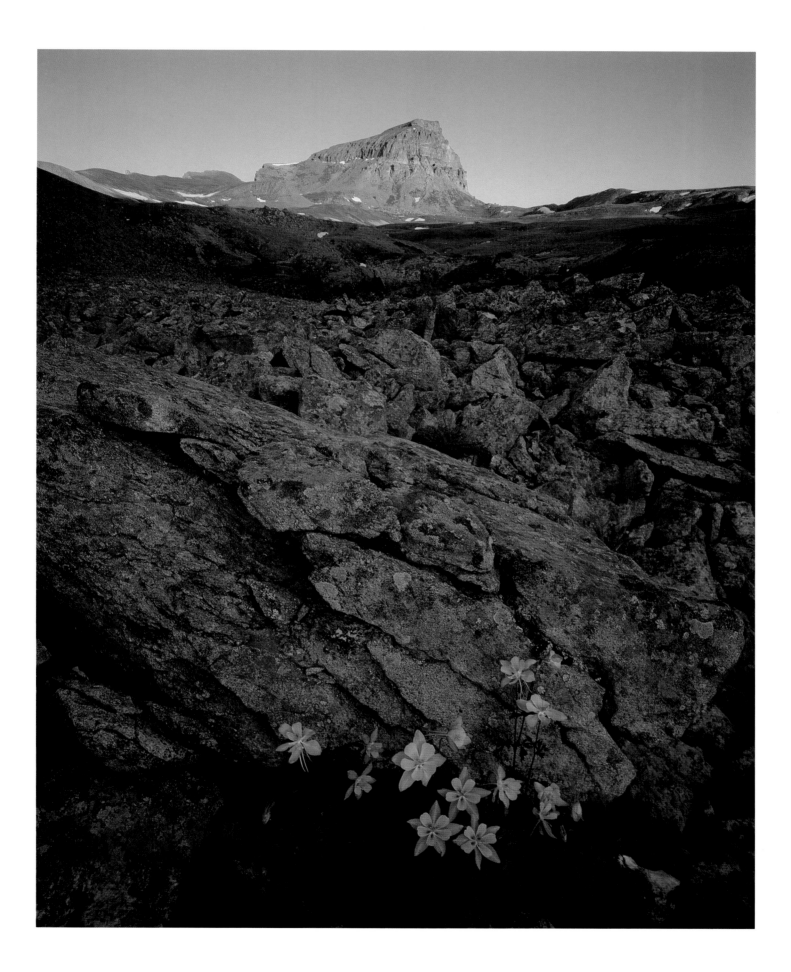

Lofty east face of Uncompahgre Peak. Big Blue Wilderness. *July*

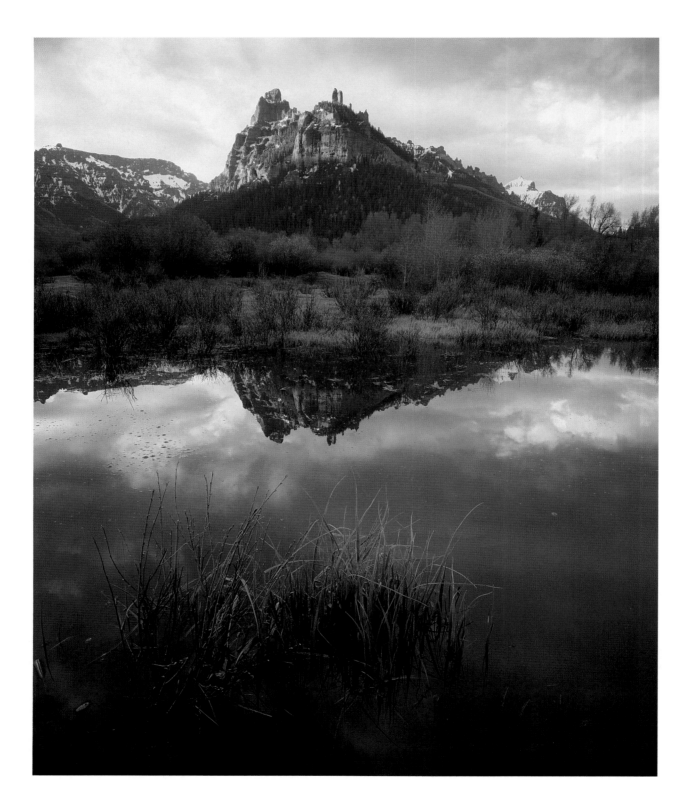

Volcanic ridge reflected in beaver pond. Big Cimarron Canyon. *June*

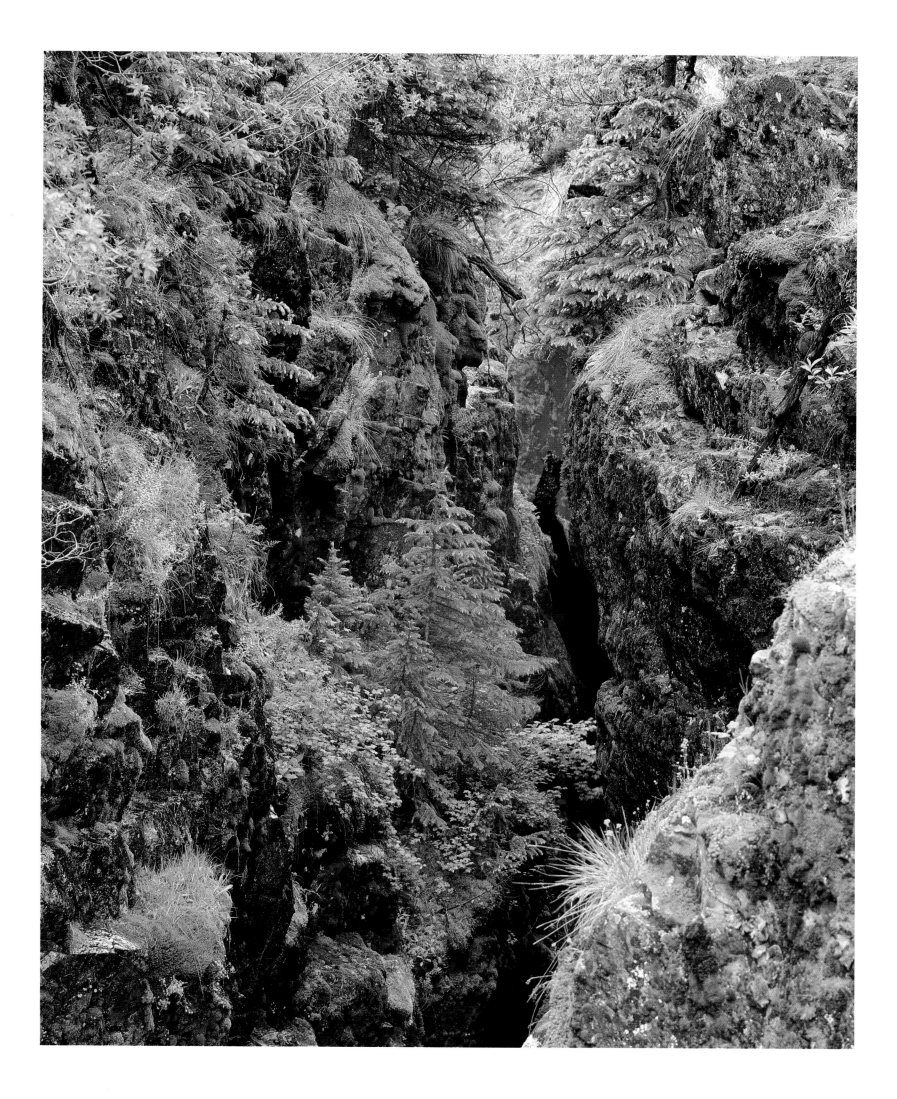

Stream-worn gorge lined with mossy greens. Hansen Creek. *July*

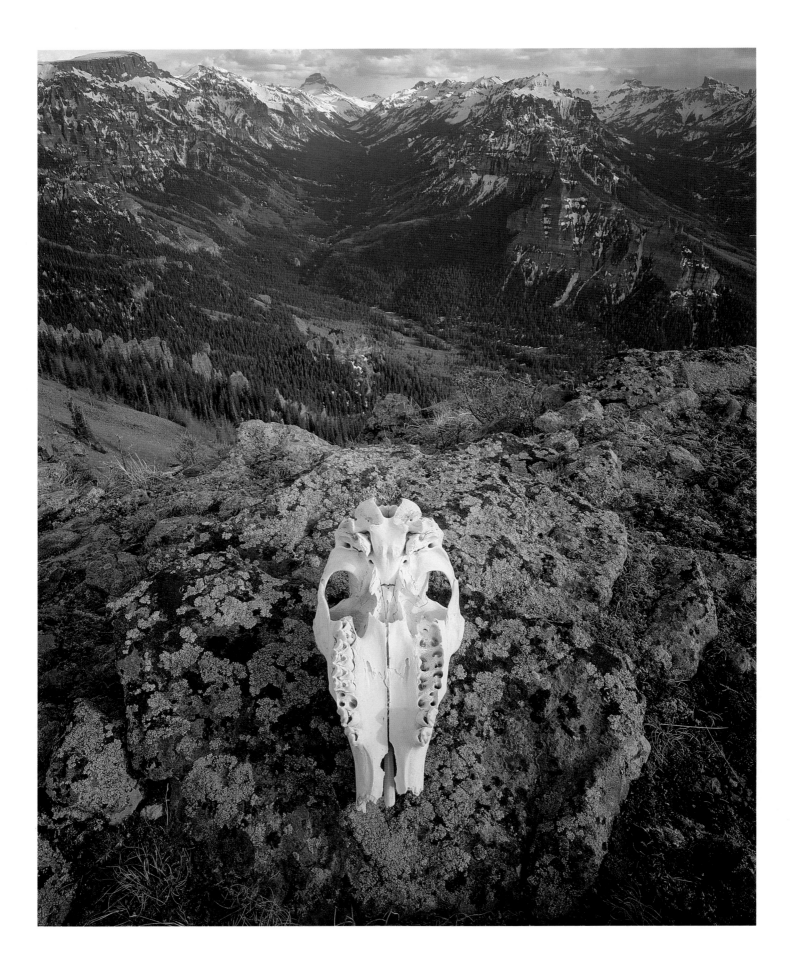

Elk skull above East Fork of Cimarron Canyon. Big Blue Wilderness. *June*

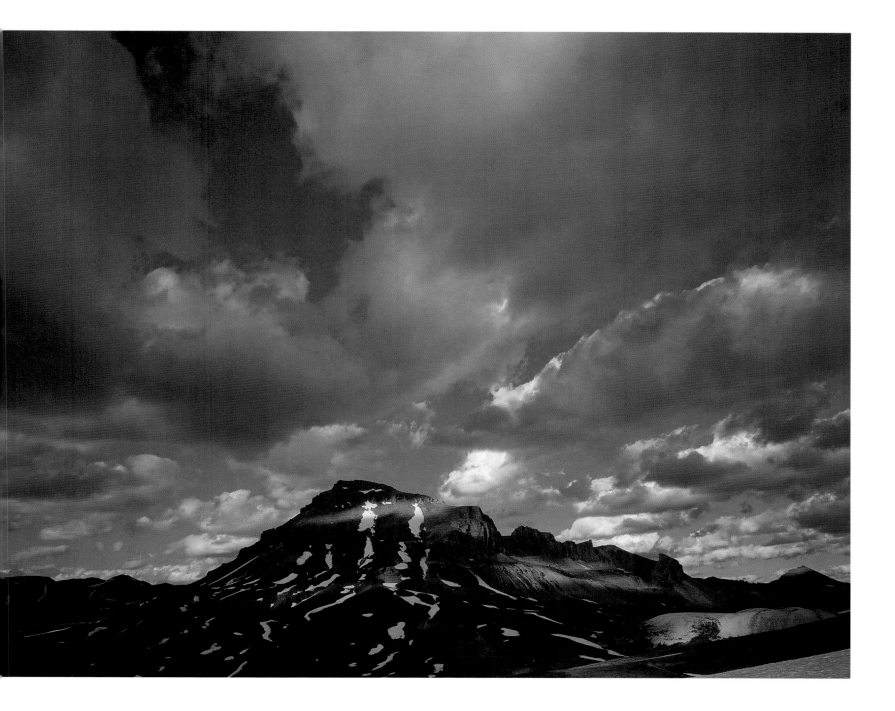

Clouded sky above Uncompahgre Peak. Big Blue Wilderness. *July*

AUTUMN AND WINTER

I respond to the slowing days by spending as many desultory hours with a butterfly net as possible, caring little whether I capture anything or not. I miss a cinnamon butterfly on a thistle head and a yellow cabbage butterfly with vivid chartreuse eyes. Blue darners are far and away most common (and that's what they are most of the time, far and away). Damselflies are all over, almost hand-catchable. Also hundreds of grasshoppers. How they land— SPLAT!—on a grass stem mystifies me. Is it good aim, accident, or playing the odds?

I peruse a Canadian thistle, worked by a rather frenetic bee, when a tiny movement catches my eye. At first I think it a tick, mahogany red and sunflower seed in size. Instead it is a spider whose legs were momentarily hidden and, at the moment of identification, it *leaps* one-half inch from the browned leaf upon which it was more or less camouflaged, grabs the bee on the head, and falls down to the next leaf where it catches and consolidates its hold. The poison must have been instant for the bee scarcely twitched before it was still.

The white thistles are all gone, only the late Canadian thistles still bloom, anathema to farmers because they are fast-spreading, webbing the soil with their roots, sneaking up water. In the mountains they are early fall's grace.

There are less than a dozen dragonflies around the pond after the clattering crowd of summer. But these are just as contentious. Several hawk far afield, far over the land, up in the lake meadow, and far into the aspen grove, flying fifteen to twenty feet up in the air when they usually fly about four feet off the ground.

Yellow alfalfa butterflies cruise low and slow. But in their company is one much faster, more erratic, higher flying. A crackling, band-winged grasshopper with yellow wings lifts out of the grass and the butterfly pursues it closely, every jittery turn. Can it be a male attracted to the yellow wings of the grasshopper, which are also edged with black? And are the slower butterflies females looking for a place to lay eggs?

Bees load the late asters and goldenrods, the clover and the sweet clover, the little love gentians. My favorite bee flies feast exclusively on the last aspen daisies where there are no bees. The asters are deeper in color, perhaps more attractive or visible to the bees? The aspen daisies, much paler than the asters, with a larger, flatter, more open disk, may be more convenient for flies who need more of a platform?

A large, black worker ant lurches its way down the slope, negotiating a thatch of dry pine needles. Its jaws are firmly clamped just behind the head of a cinnamon caddis fly which is still alive. Reaching open ground, the ant moves very quickly,

holding the fly sometimes vertically, sometimes horizontally, bobbling down the slope, its cumbersome prey waving like a banner. It is as if it were carrying away summer.

A dazzling September day, windy (is there always wind in Colorado?), light scattering fireworks on the pond, an explosion of brilliants when the wind hits and facets the surface. Auxiliary lines spray off to the side, falling slowly to shore and fading out, shooting sparkles like handfuls of diamonds—startlingly beautiful starbursts and constellations and worlds within worlds.

When I sit at the edge of the pond, the sun hides on the water in the rushes, shooting blinding white sparks. A meniscus rings each rush stem with a little collar of light. Light slides and gleams on each stalk and positively languishes on the sedges at the pond edge. Light gilds the aspen leaves, polishes every ponderosa needle, sliding, gliding up and down, as the bough bends. Everything is fresh and bright and rising out of itself to another level of beauty which dissolves the outlines of the world.

As I watch, the dark bullet head of a muskrat comes out from the north shore of the pond, moving purposefully toward the rock. On the rock, the mallard plucks and preens and its white down feathers float on the pond. The dark head plows toward the rock. The muskrat touches the underledge, shinnies up on top. The duck's movements become flustered. The muskrat slips back into the water. The duck drops off the rock. The duck climbs back on, followed by the muskrat, tail dragging, paws brushing its face. For a sparse moment, they share the rock. Then the duck is off, the muskrat is off, disappearing under water within a few seconds.

Later, the muskrat comes out of the sedges at the north edge of the pond. Two ducks roost on the rock. The muskrat goes past the rock, turns, circles counterclockwise, then clockwise. The ducks stand up, move about, look wary, appear uneasy. The muskrat crawls up on the rock. The ducks rotate so that they always turn tail to the muskrat—one would think they would face danger, but perhaps this maneuver offers them quicker egress. The female plops off and the muskrat follows—closer, closer, closercloser. The duck flaps without taking off, but expends enough energy to shoot herself ten feet ahead of her pursuer.

At the same time the duck lifts off the water, the muskrat gives a good kick and spurts ahead—but a motorboat doesn't have much chance against a sea plane. The muskrat takes up the steady pursuit again, swimming after the duck, getting closer and closer. At some predetermined "NO closer" the duck angles up out of the water and, with a beat of wings, crashes ten feet ahead with a splash and a flurry. The muskrat doggedly resumes the pursuit. But the duck can make tighter circles than the muskrat, and the muskrat gives up—veering slowly in another direction and finally returning to the pond rock, while the duck swims in slow self-congratulatory circles.

Why this game of chase? Muskrats are primarily vegetarians so food is not the reason. Elsewhere, muskrat breed all year round, although I doubt this is true at this altitude. Still, is this a young male who thinks that anything that swims is a female muskrat deserving of his attentions?

I remember last summer watching a parent muskrat patiently plowing the lake, from the old beaver lodge in which the family lived, to the opposite shore thickly stalked with sedges. It took but a few moments to garner a mouthful of sedges which then proceeded across the pond, seemingly of their own volition, disappearing underwater a few feet from their condo entrance. The

forays had been going on for more than half an hour, regular, paced, rhythmical, when there came a change in pattern.

The muskrat came to the side of the lake where I stood. There were a few rushes rooted in the shallows, and one by one, it nipped off a stalk, held it in its paws, and nibbled it straight down in sybaritic solitude and pleasure. The compact little body was rounded into a ball, the eyes closed in what I could only interpret as bliss. Its own feeding done, it returned to the sedges and the endless cutting and plying and feeding and swimming.

Can someone tell me why strapping twenty-five pounds on your back, putting on familiar boots and an old camp shirt, walking five miles straight up, and sleeping out on a night so chill and cold the moon seems stopped in its track, then hiking back down again on protesting quadriceps, to say nothing of recalcitrant knees, can bring a lifting of spirits, a renewal of all the things that have been so missing? But I don't think anyone can. Surcease from civilization belongs to those of us who do not like fences, telephone poles, or highways in our landscapes (but are quite willing to have hot baths and word processors).

Actually, the gentians start me thinking about these dichotomies. We hike up along a dashing Pine Creek to a meadow at 10,000 feet, surrounded by a prime selection of Continental Divide peaks. No matter where you sit, they look over your shoulder like kibitzers. The valley is thickly laid with grasses and in the damper places, sedges, a burnished fringe still lush and luxurious. The gentians slant toward us, so many that they pave the meadow with *Lapis lazuli*, a holy blue. A blue wildness I type onto a black screen, transfer to keys, spit out on a clacking printer to a black and white page.

Full moonrise tonight, producing a great blurred globe, a product of wishfulness and myopia and reflection. The whole quadrant of night sky glows long before the moon appears, first only as moving dots of light through the spruce branches on the ridgeline. As the moon rises, the dots coalesce, round into a disk that poises for a second on a tripod of spruce spires, then floats untrammeled and free, looking able to go wherever it wishes, tracking across the crest of the mountains, touching each peak in turn but never lingering. I sleep and wake in a meadow frosted with moonlight.

In the October mountains, one expects frost. This morning, saucers of frost patch the ground, my tent, my sleeping bag. This frost will probably finish off what was not fall. This particular year, this particular place, there are aspen with green leaves standing next to aspen with yellow leaves standing next to bare trees. It is an indecisive fall in which summer sneaks out the back door without saying goodbye and one looks around and it is gone, leaving all those unasked questions. A frittering fall, in which there never is one of those golden moments when even the air turns honey. The aspen leaves dry on the branch and never turn gold. The price of gold is too high this year.

October's warm wind coaxes the leaves down, a Pied Piper wind that lures them away from home. Aspen are the only deciduous trees in the montane zone, and they must glory in having no competition. They are the self-appointed markers of the season.

Everywhere I walk, aspen leaves soften the ground. In the woods they have pinpoints of moisture on them. They cling to my feet, giving up a damp, wet-lichen smell. In the open, the leaves crackle, and so do the grasshoppers. Grasshoppers are the leaves' animas—they do what the leaves would if they could.

Yellow jackets and small flies still busy themselves hunting for food, and a few hardy dragonflies scout the pond shores. A yellow cabbage butterfly lurks above the wiry grasses, a bit of leftover summer. I envy them their non-sentience. No matter to them the first snow, the first frost, events that sound in my life like a death knell. Nor mind they the coming months of bone-marrow cold and penetrating, killing wind. They will winter over in quiet safety, in tucked-away eggs, in snuggled larvae, in motes and whispers and silent pulsings.

Outside, the snow pellets fall, making little marks on the lake. The pellets change to snow which settles into a steady sifting, finer, softer, held aloft by air resistance, the flakes too light to fall as the pellets did. The flakes float crossways in the air, minds unmade as to where they are going to fall. Nevertheless, there is an inexorable feeling of slow but steady closing in the air: no chance to go back to summer, no shut-off valve for the snow, no place for the sun to break through.

One never writes this way about spring. Spring is fits and starts, one step forward, two steps back. Spring in Colorado is a tentative tentacle probing the cold, nipped back with the frost, darkened with snow. Not so autumn. It proceeds with steely patience, the executioner sharpening his ax, the hangsman practicing his knots.

Ice insinuates from the pond edge, dulling the water's sheen. A finger of clear water gleams black, where the north creek empties into the pond, and there must be enough flow to keep it open, but the icy hand is there, clutching and greedy.

There is something amiss with this picture, and it is a moment before I figure it out: the reflections. They are perfect in every way but one: there is no snow on the pines. When I look up, across the slope, the boughs are whitened, outlines blurred with snow. But in the water, they are dark trees. Plain dark trees, as if in the pond it is always summer. The pond gives not up. Ice may be seeping in at its edges, but the pond flaunts a warmness culled from summer days.

It is snowing. Not that in between rain-one-minute, snow-the-next. Real snow. All white. Not a lot yet, but enough to indicate a rather serious approach to winter. Some patches the ground and stays. That is the difference between fall snow and winter snow: in autumn, residual warmth melts the snow as it touches ground and even when it tries, the snow does not last. This snow will. Close by it looks sparse and thin, but looking through it, across to the far hillside, it hangs a streaming, thick curtain.

Some flakes catch on handy branches, clot the seed heads, dust the grass clumps. The white-winged juncos are back, their wings barred with symbolic snow, wearing the gray and white of a winter's day.

Ice creeps toward the center of the pond. Winter is just off-scene, ready to pounce and devour by freezing. Ice shrouds the pond, such a thin layer that it still undulates when wind ripples the surface, but thick enough that it blurs reflections and obliterates the shine of summer. As of this moment, I cannot remember summer. As of this moment, summer sings no more.

A brisk wind, stars falling, falling brilliance—Sirius, off Orion's belt, two inches above the trees. The snow creaks underfoot.

With this snow I learn the body's acceptance of cold, and in this peacefulness wonder why I so fight winter's coming. I could walk forever, following my footsteps, listening to the stars, watching the glitter. There is such a freshness and brightness of starlight that the air hummed with celestial sounds thrown out across space and my

footsteps and frosty breathing answered back, the aspiration of the lowly. I do not plan where I am going.

The stars are so bright there is no need for light. Faint shadows stripe the snow, faint whisperings all around. In all the animation of the night, I mark the absence of odor. It smells cold but winter has no scent.

During the day, high mountain horizons hide the paleness at the base of the sky and leave only the deep blue at the sky's top. Consequently, the sky seems to be one value and one hue, like a flat backdrop, and this gives it an air of artificiality, of blatant "picture postcard blue."

But this winter evening, the sky is all softness, the loveliest velvet gray, with wavering horizontal bands of pale cream and pale pink—indeed, "pink" is too strong a color for this swirling sky, the marbleized endpapers of a book I shall never write.

The ensuing night is oddly warm for January. The wind blows everywhere, sounding like waves piling upon endless beaches. I've never liked wind, but tonight its restlessness suits mine. There are times when I feel so closely connected to this wilderness world that surely my feet are rooted deep in the ground, and surely I can breathe as only the wind breathes.

I have come to have a sense of continuity in the Colorado mountains, of light fading and brightening, flowers blooming and seeding, aspen bereft of leaves or twinkling in the sunlit breeze. Maybe that is why New Year's Eve leaves me cold. That sharp, human-manufactured ending and concise beginning do not match my rhythms. My world flows. In each part is the intimation of another, world without end, for now and ever shall be.

Tonight snow falls so gently, as if it will snow tomorrow and on into next week, and one day it will reach over the tree tops. I will open the door and find snow up to the roof and will shrug my shoulders and go back to what it was I was doing.

The flakes dance onto my sleeve, hexagons wheeling through the air, coming to rest between wrist and elbow. Their spiky corners snag on edge, leaning against each other, tilted at just the right angle to remain vertical. Interlocking edges, ice to ice, chill to chill, winter to winter. Some fall already caught together, anchors for further windrows of snow on my forearm, hills of snow, crags of snow, mountains of snow, landscapes of snow. I stand, a figure inside an old-fashioned paperweight, a center of stillness with the world spinning about me.

In the air I hear a kind of heavenly whispering, as if miles away someone bowed a violin pianissimo and only the vibrations reached here, not the sound. The air quivers with snowflakes, shimmers with snowflakes. They catch on my eyelashes and blur my vision, poise on my nose, blanch my cheekbones. Whatever is out there, I can only perceive it through a scrim of snow, a whiteout that shuts away the world, shuts away sand dunes and sadnesses, spruce forests and aspen groves, muskrats and mallards, laughter and sunflowers, yesterdays and tomorrows, dragonflies and water striders. My sleeve whitens, its navy blue disappearing in a paving of white slivers shaved off the great gray block of sky, stamped-out intricacies, Lilliputian doillies, folded paper cut-outs. Each exquisite shape is a radiance of snow ornamenting my pedantic sleeve, turning me into a Snow Queen reigning over a world shuttered in white. I do not know when I have enjoyed snow so much. May it snow forever.

Gunnison National Forest. *September*

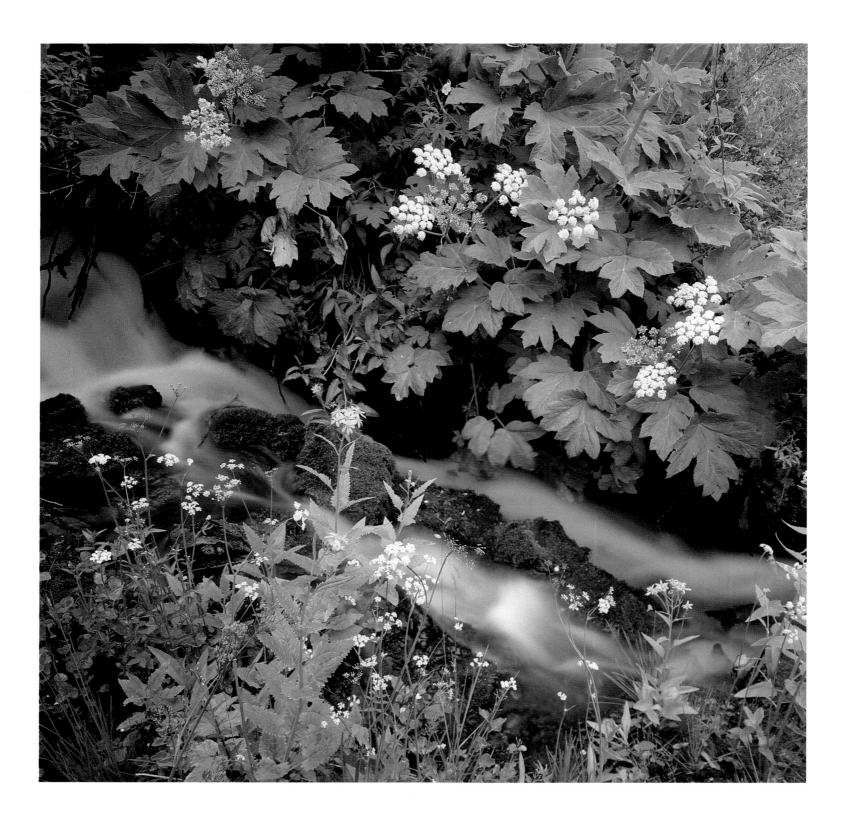

Summer greens with gentle cascade. Slate River Canyon. *August*

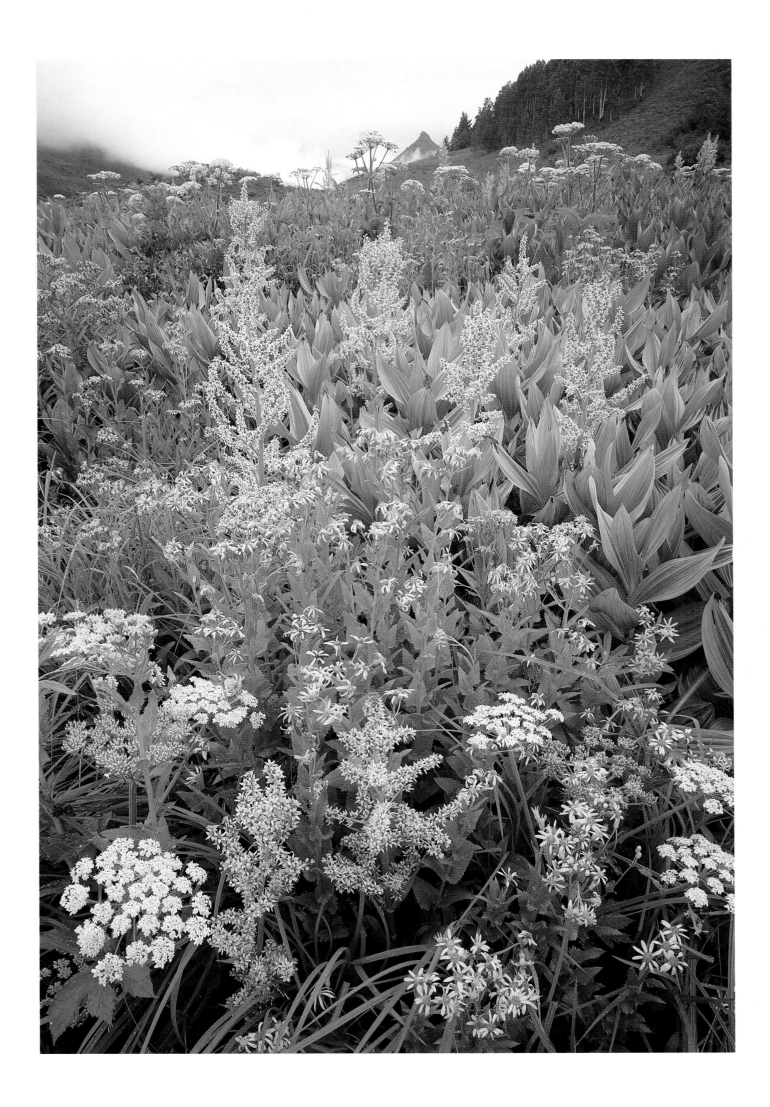

Corn husk lily and cow parsnip in moist meadow. Ruby Mountains. *August*

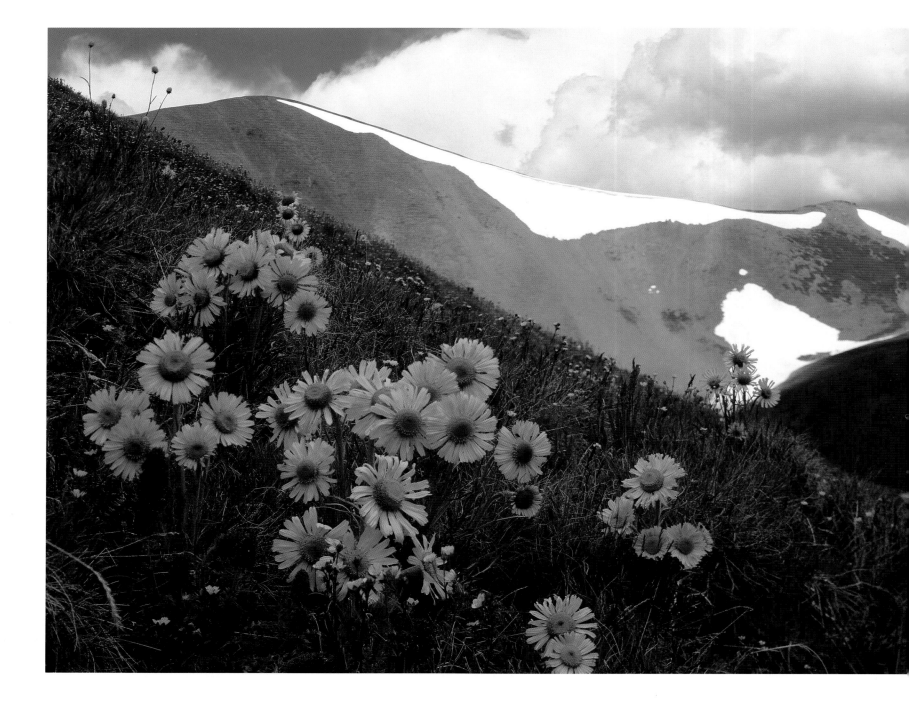

Rydbergia below San Luis Peak. La Garita Wilderness. *July*

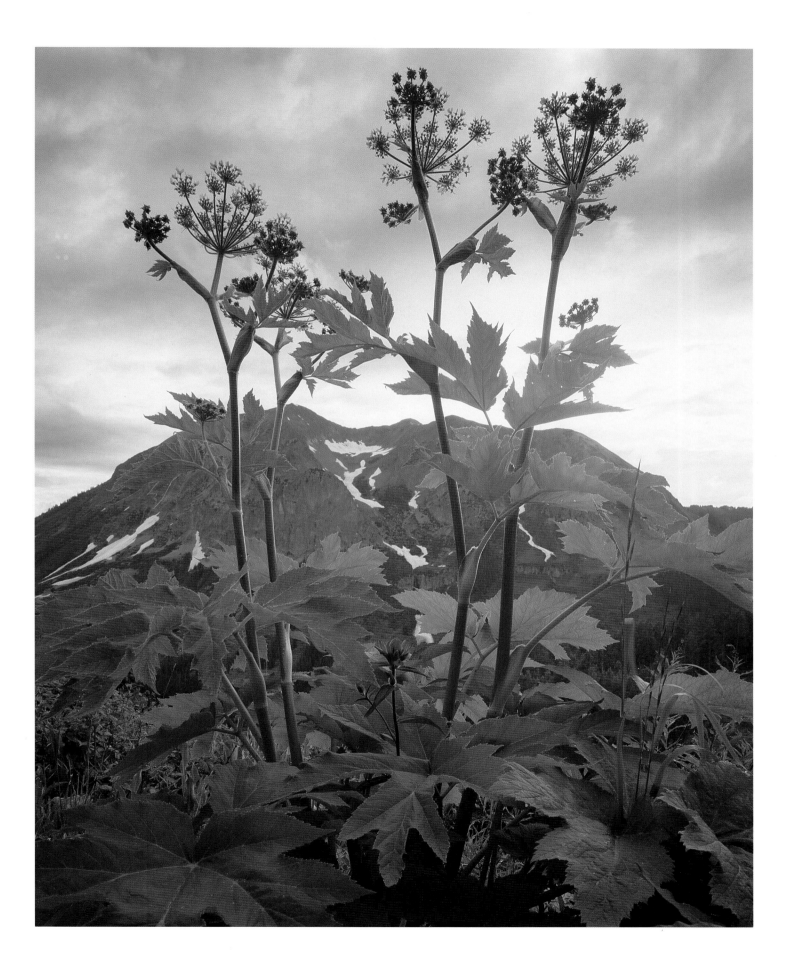

Cow parsnip greens and Gothic Mountain. Virginia Basin. *July*

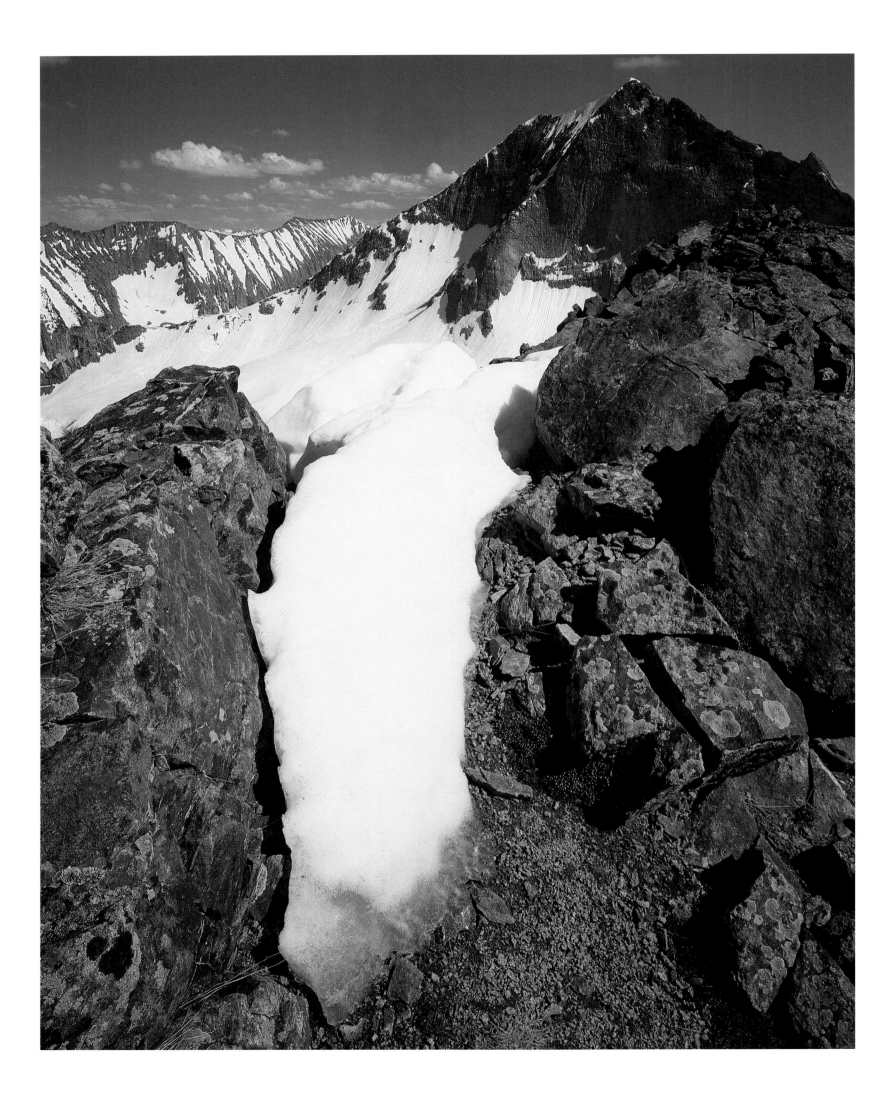

Toprock of Chair Mountain. Raggeds Wilderness. *June*

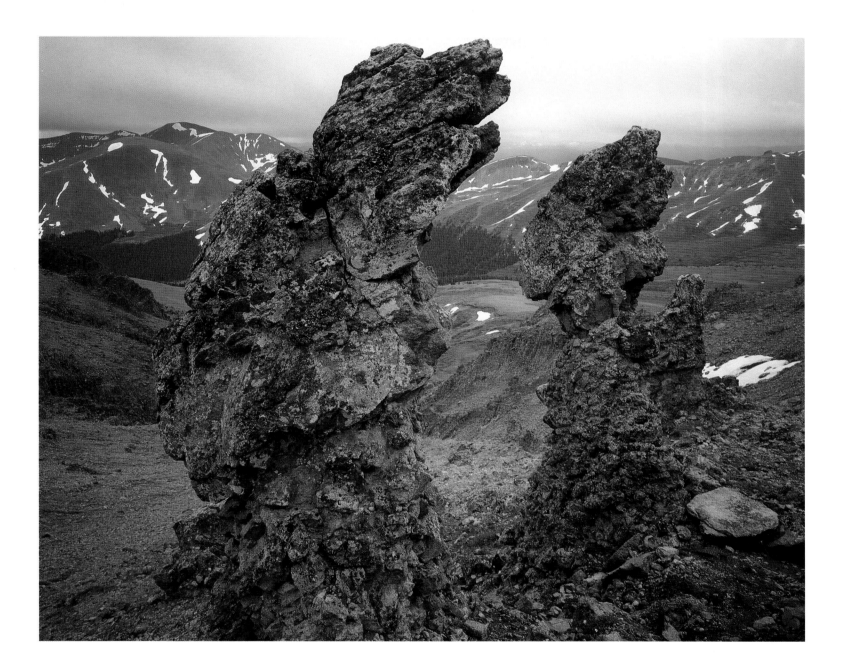

Organ Mountain with eroding volcanics. La Garita Wilderness. *August*

MESA COUNTRY

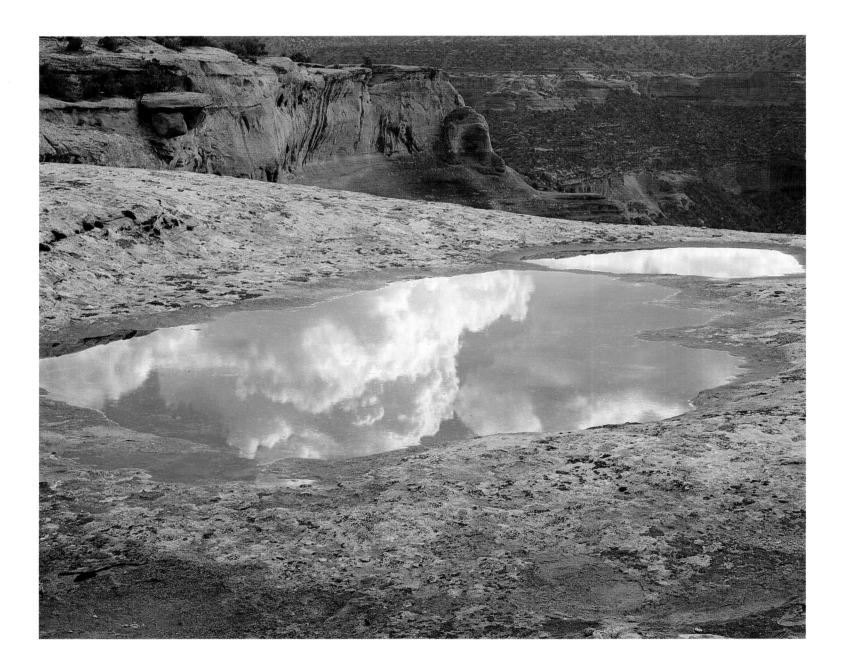

Rain pool reflections and rimrock. Rattlesnake Canyon Wild Area. *August*

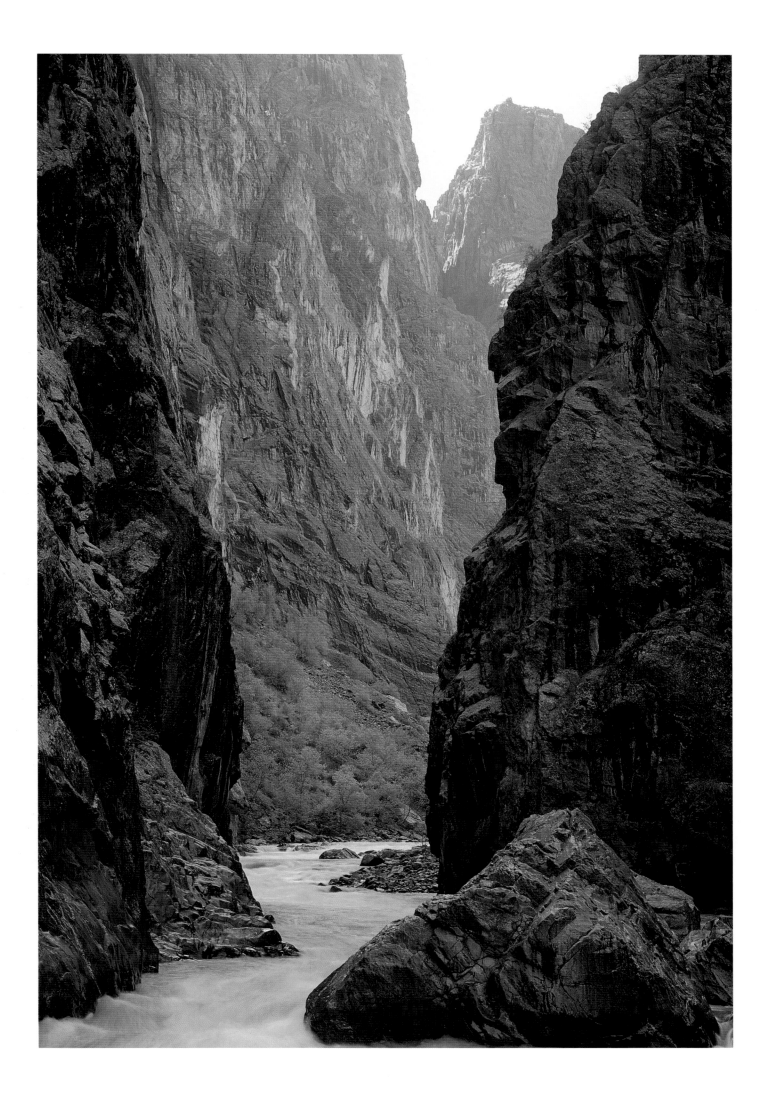

Shapes cut by the Gunnison River. Black Canyon of the Gunnison National Monument. *June*

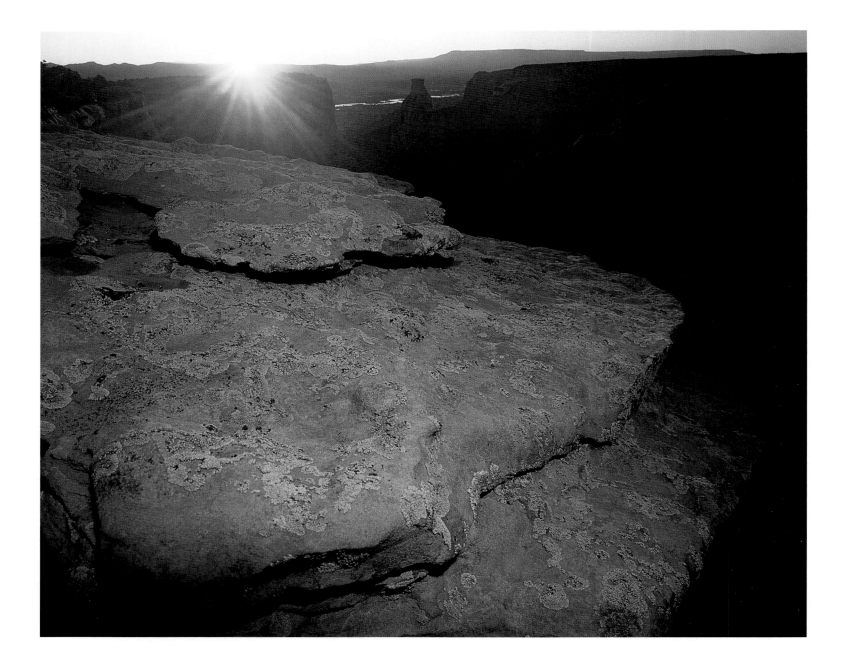

Illuminated sandstone rims. Colorado National Monument. *June*

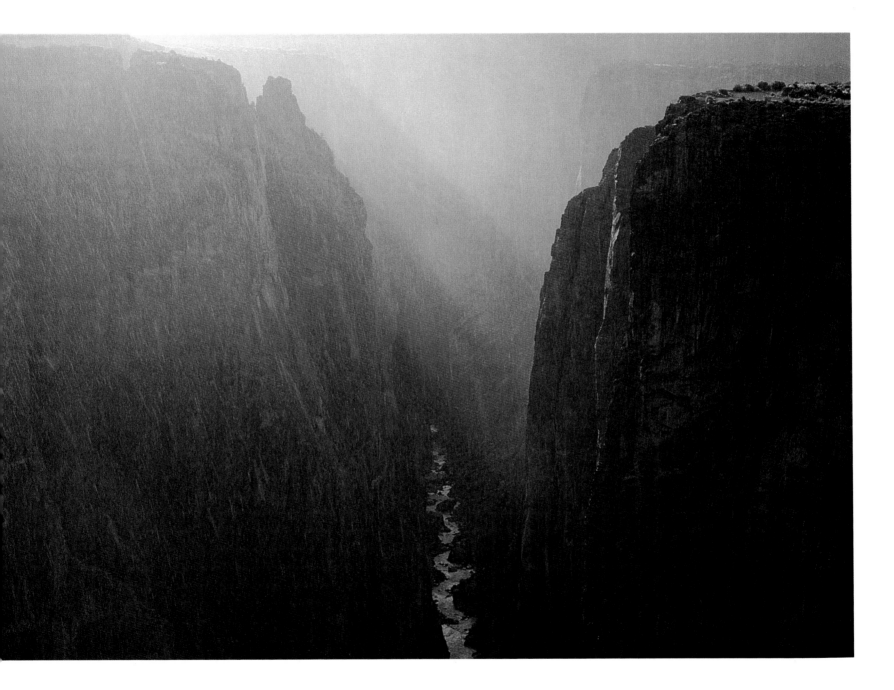

Walls of Black Canyon. The Gunnison National Monument. *May*

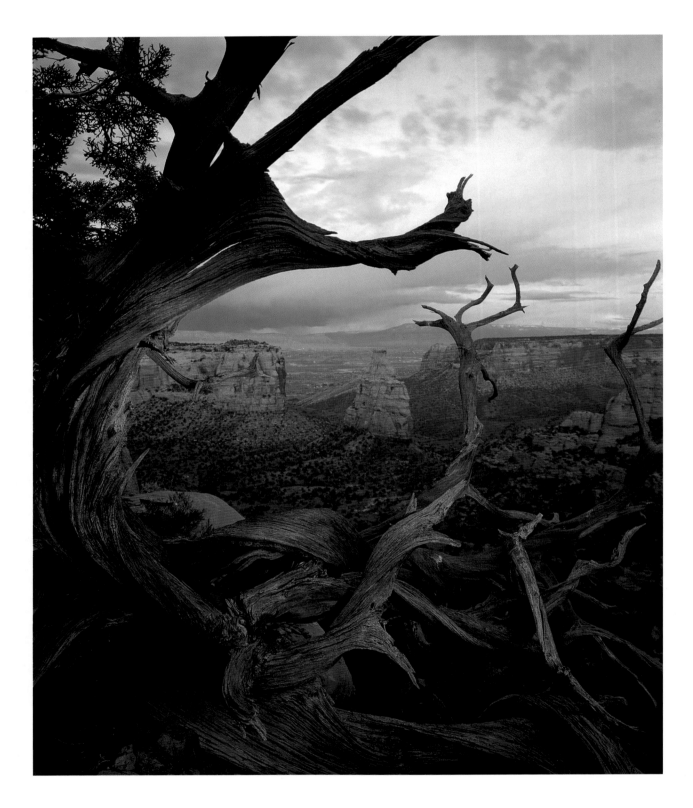

Skeleton juniper with Independence Monument. Colorado National Monument. *May*

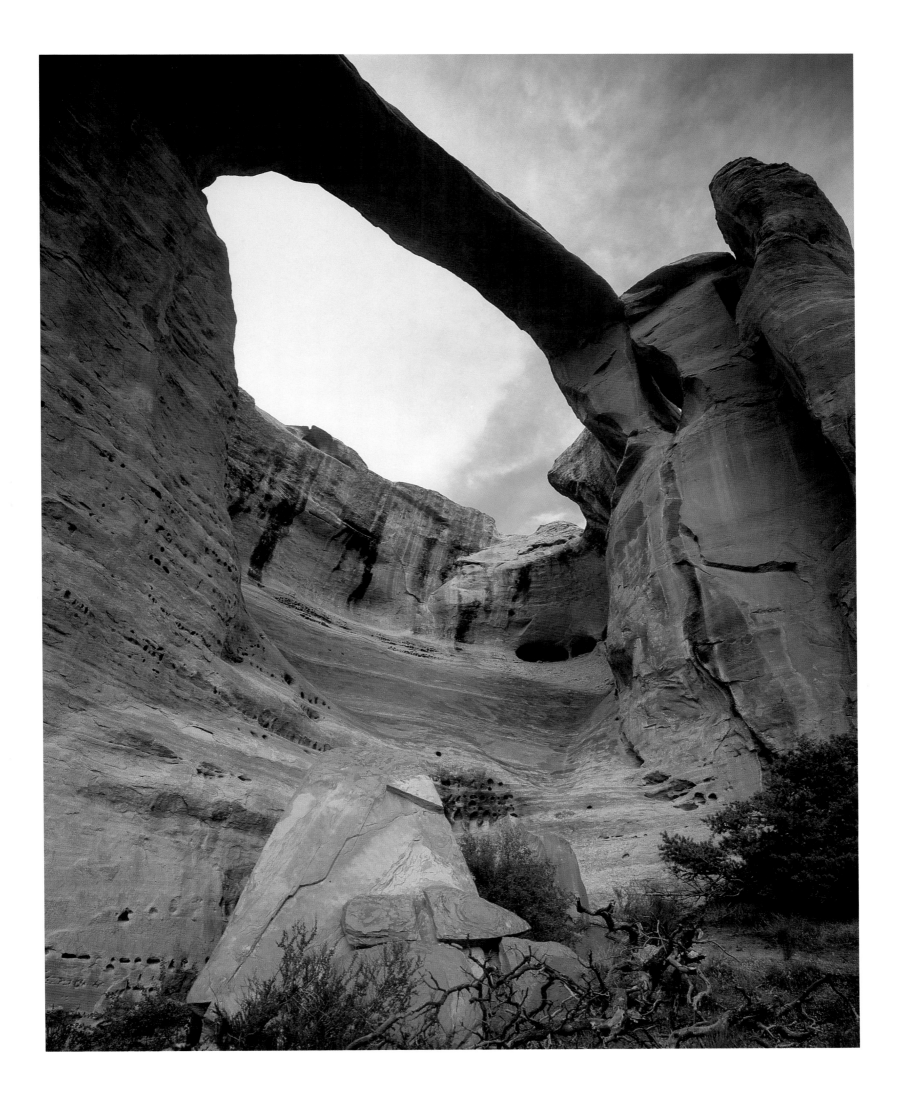

Unnamed sandstone span. Rattlesnake Canyon Wild Area. *May*

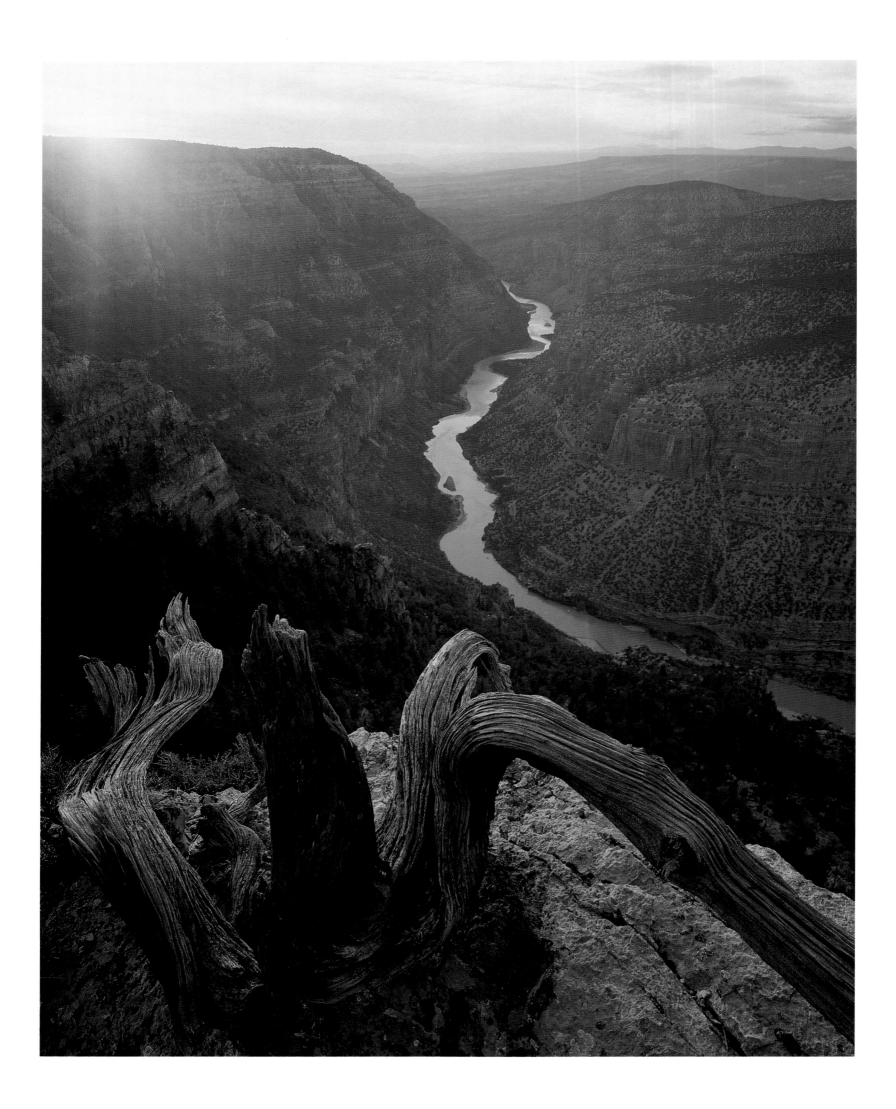

Above Whirlpool Canyon of Green River. Dinosaur National Monument. *November*

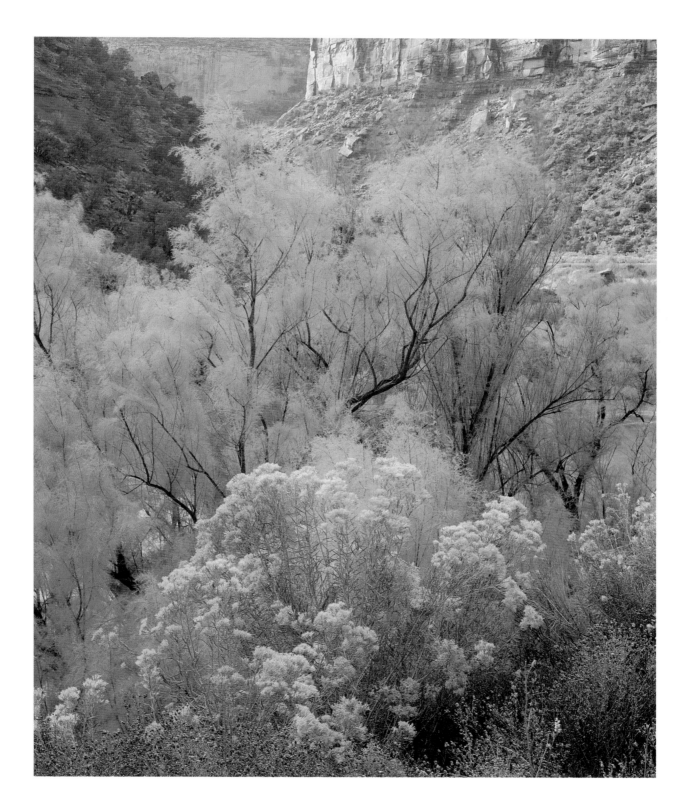

Salt cedar and rabbitbrush. Dolores River Canyon. *November*

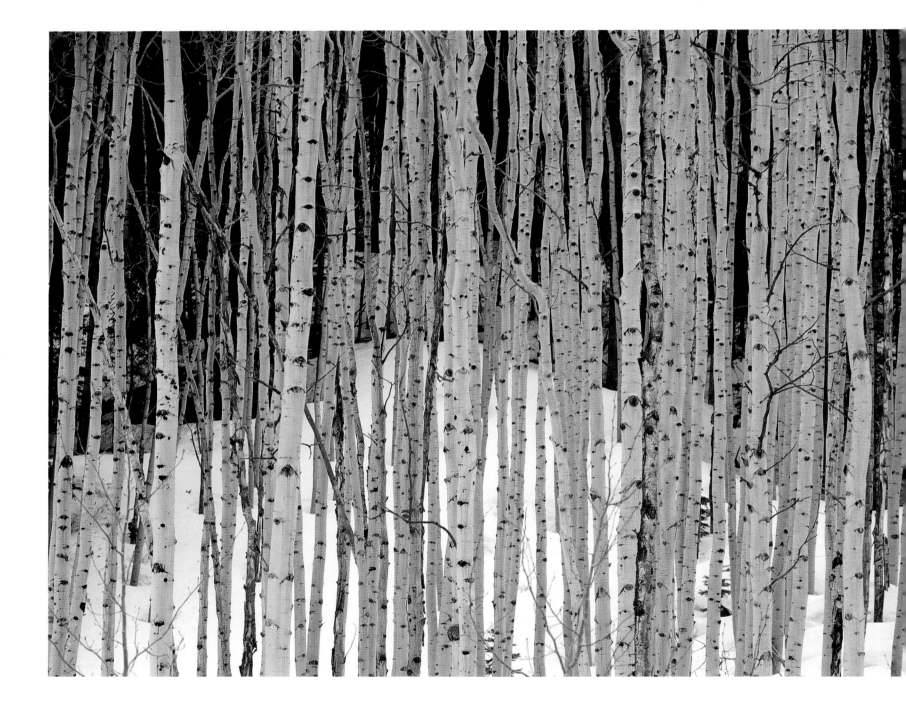

The boles of young aspen. Grand Mesa. *April*

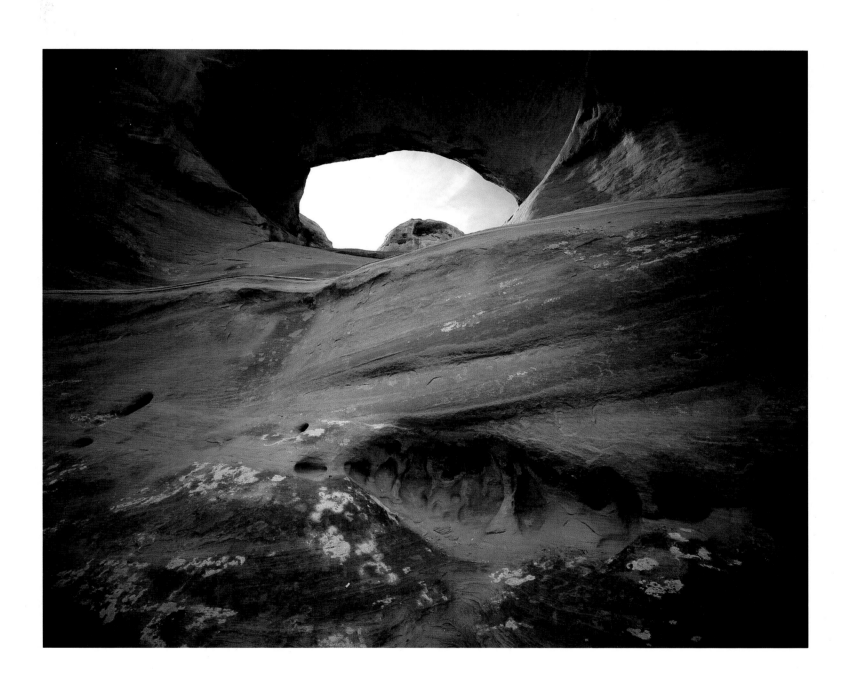

The sandstone eye of Rainbow Arch. Rattlesnake Canyon Wild Area. *April*

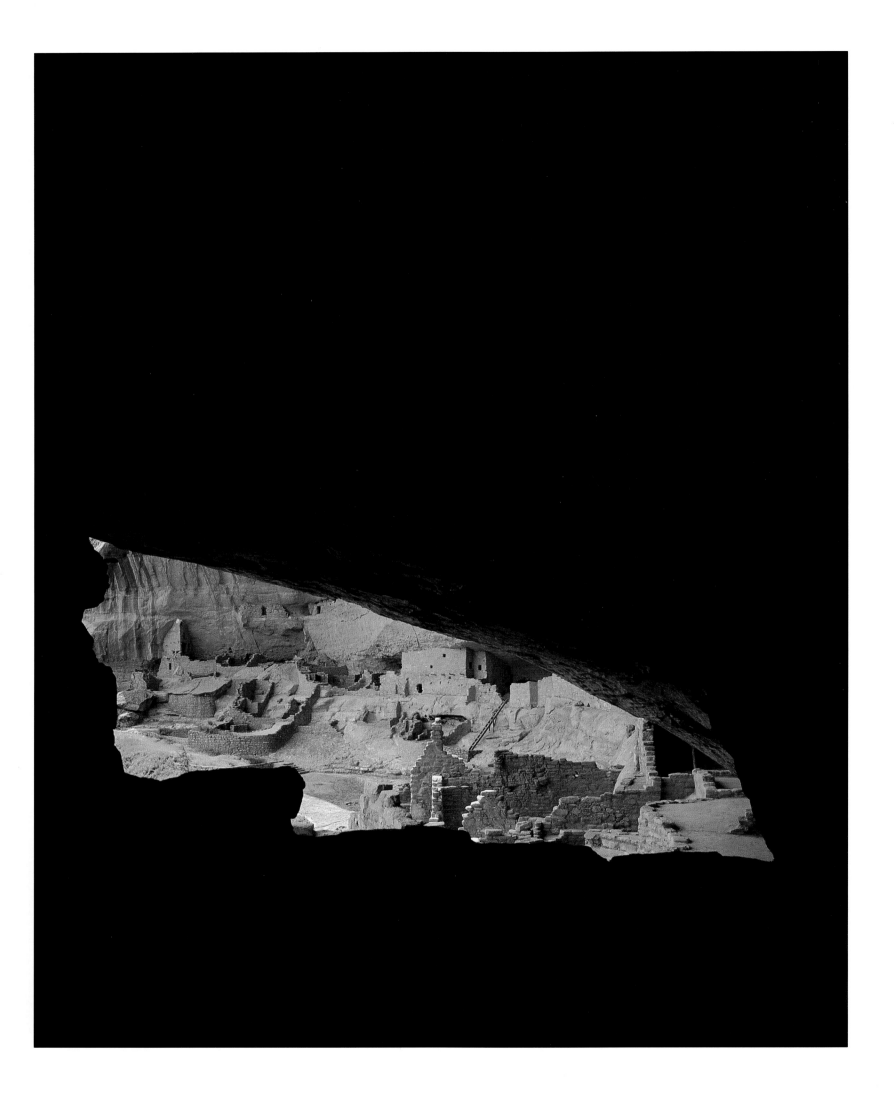

Long House Ruin of ancient Anasazi home. Mesa Verde National Park. *March*

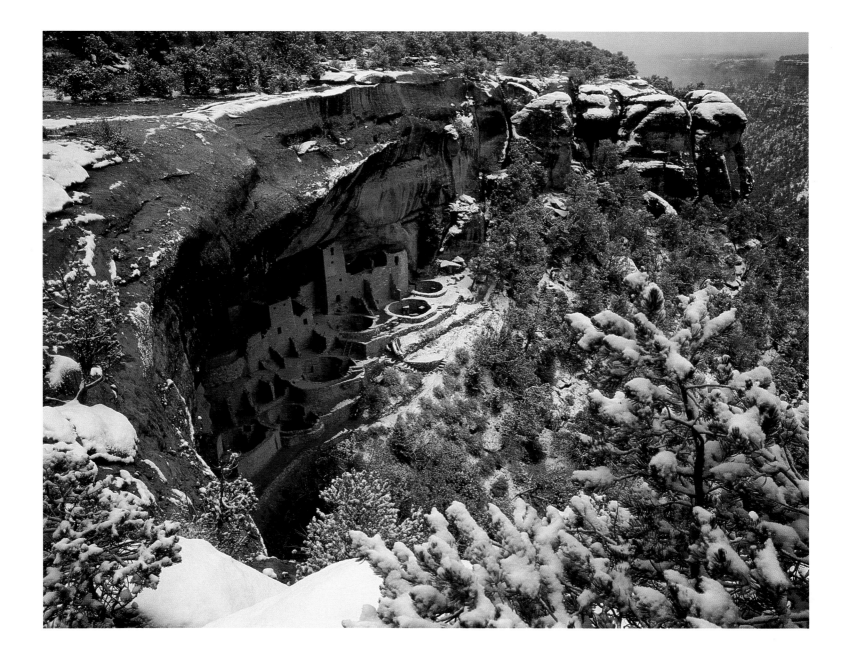

Dusting of snow on Cliff Palace Ruin. Mesa Verde National Park. *December*

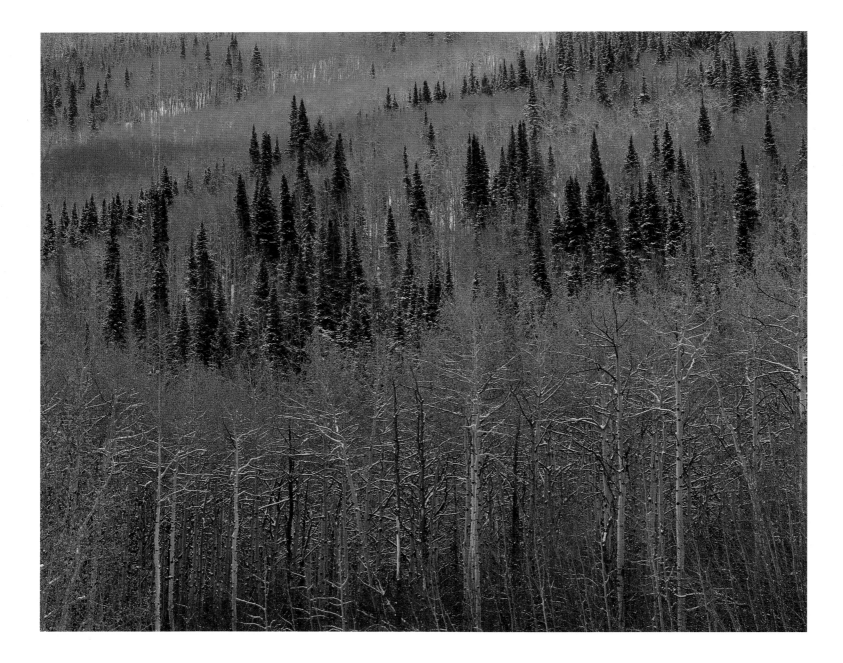

Spring on north slope. Grand Mesa. *May*

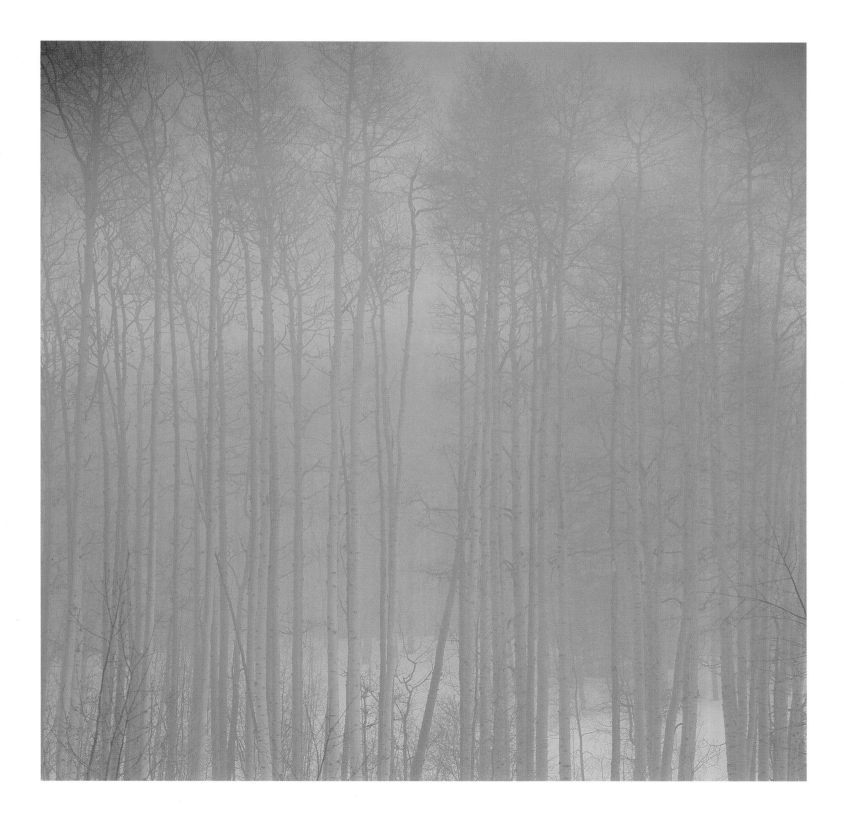

Aspen grove edge between snow flurries. Grand Mesa. *May*

WEMINUCHE WILDERNESS

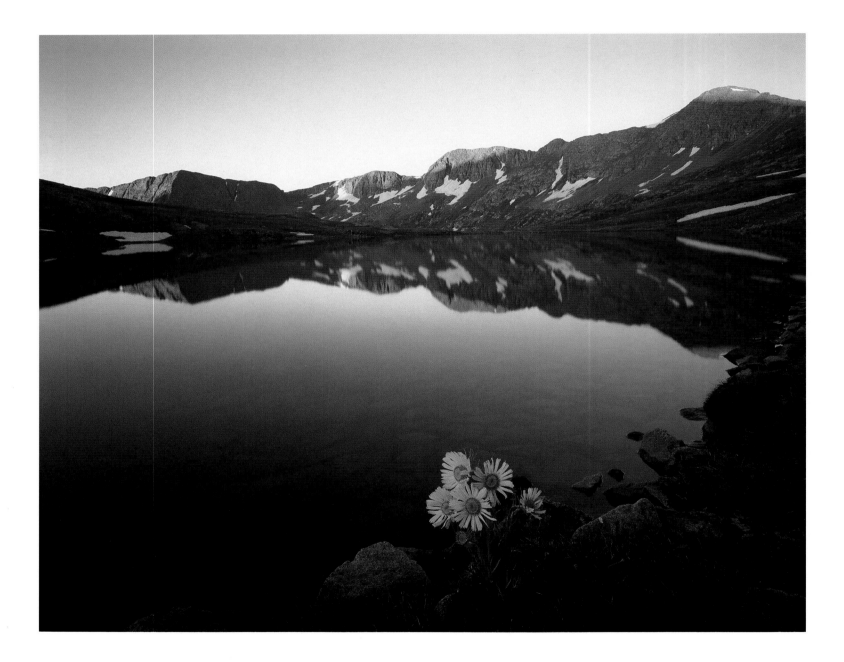

Reflections in Columbine Lake. Weminuche Wilderness. *August*

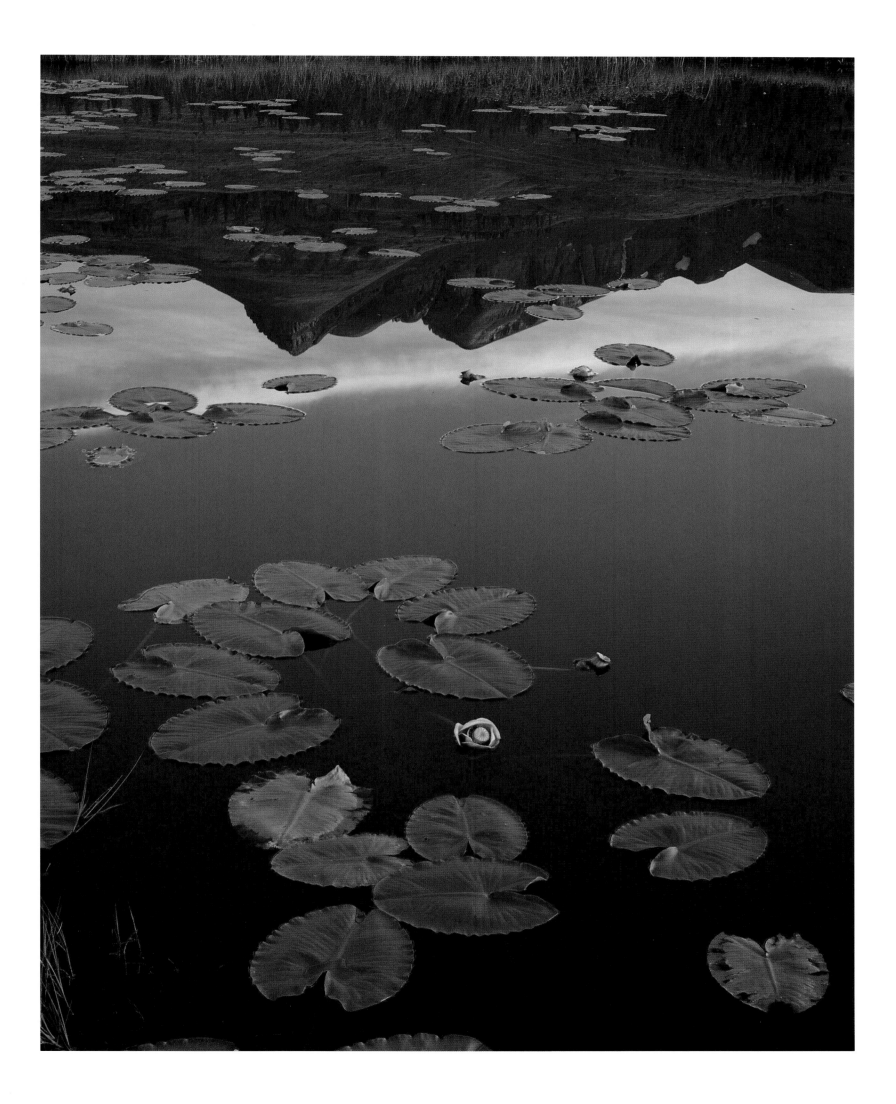

Summer pool reflections. Molas Divide. *August*

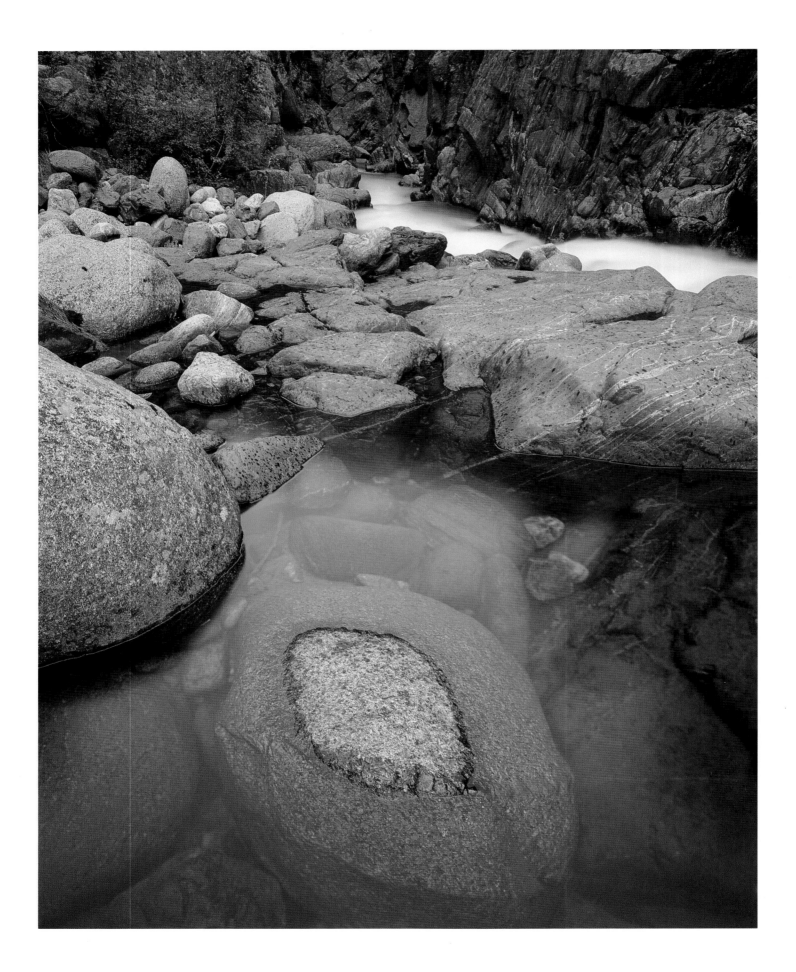

High-water designs along Vallecito Creek. Weminuche Wilderness. *August*

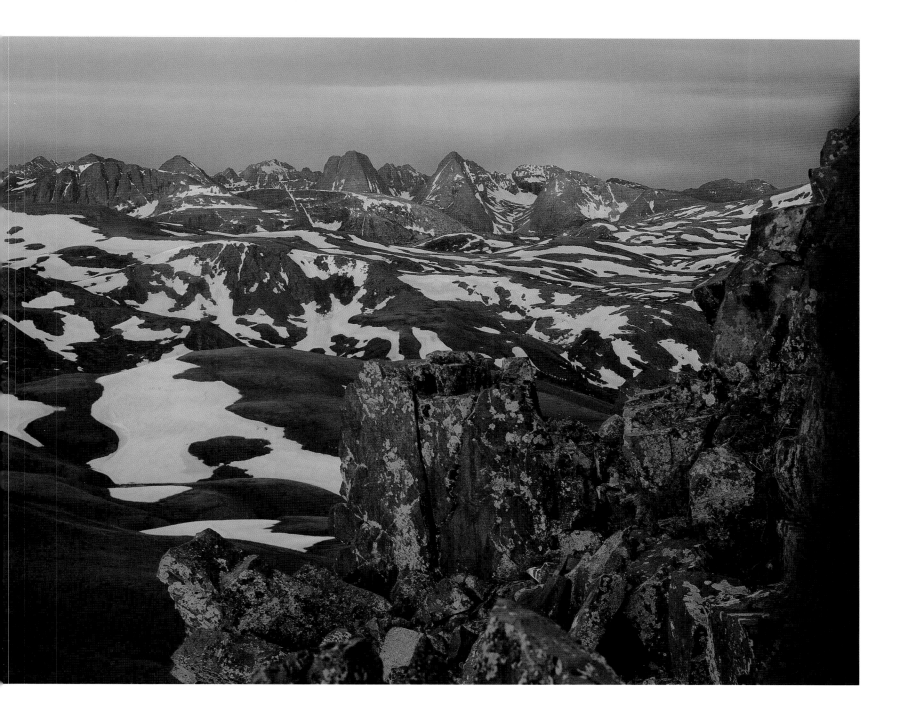

Peaks of the Grenadier Range. Weminuche Wilderness. *July*

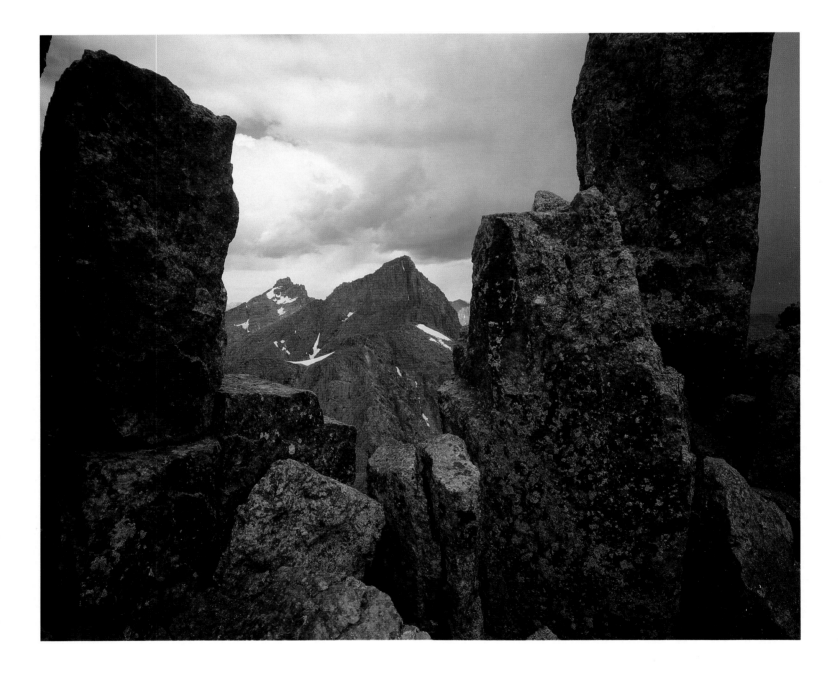

Toprock on Jupiter Mountain. Windom and Sunlight peaks in The Needles. *August*

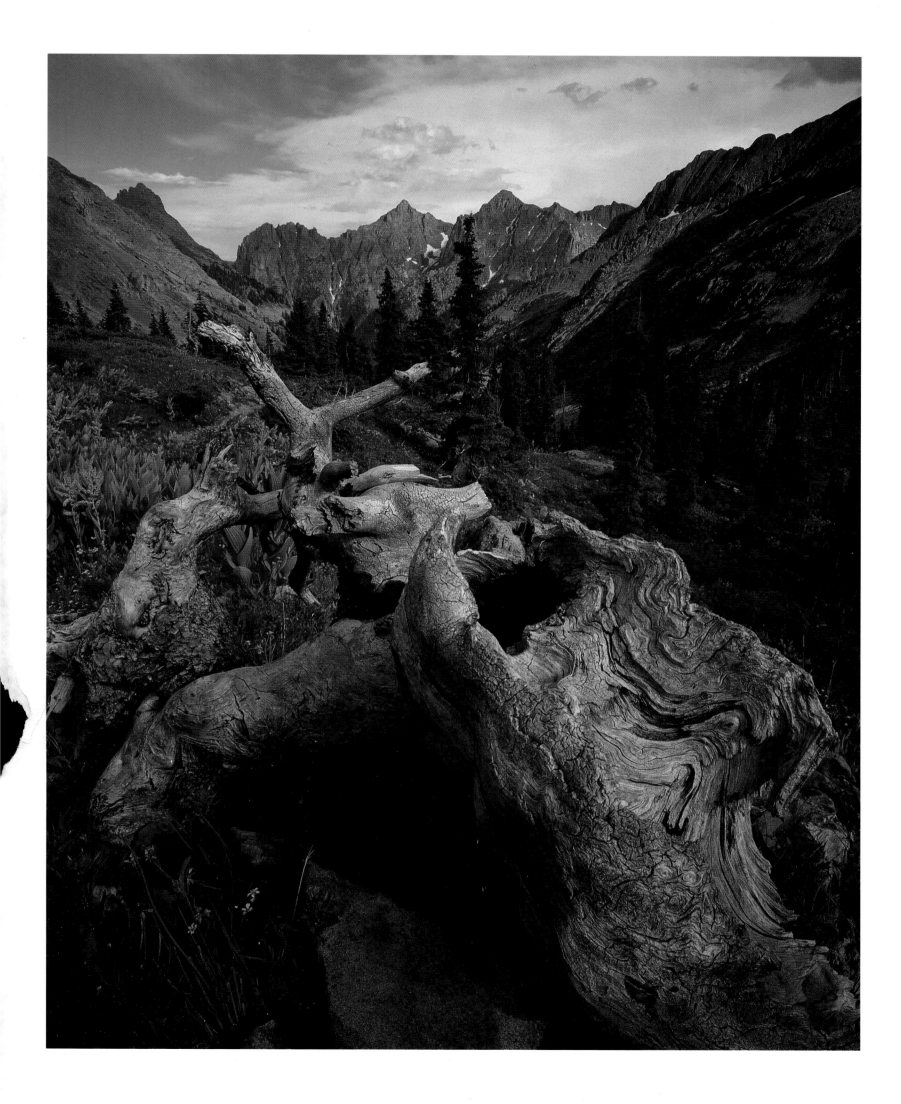

Spruce in Johnson Canyon. Needles Mountains. *August*